FIRED EARTH, WOVEN BAMBOO

Contemporary Japanese Ceramics and Bamboo Art

Donated by the
Showa Marutsutsu
Company

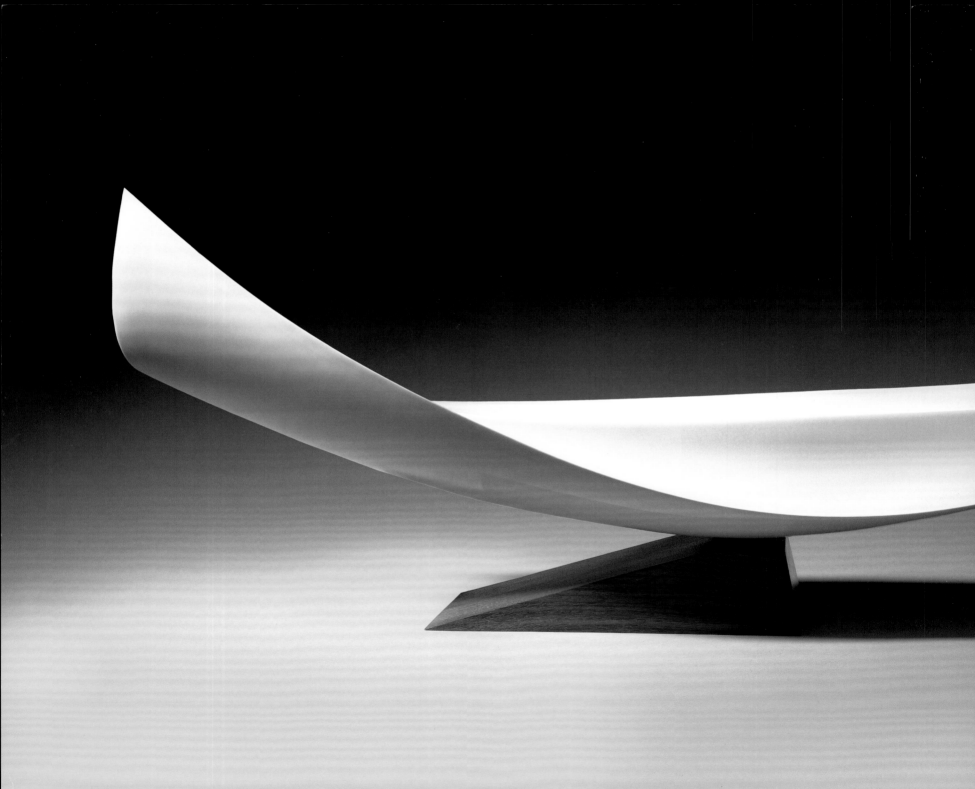

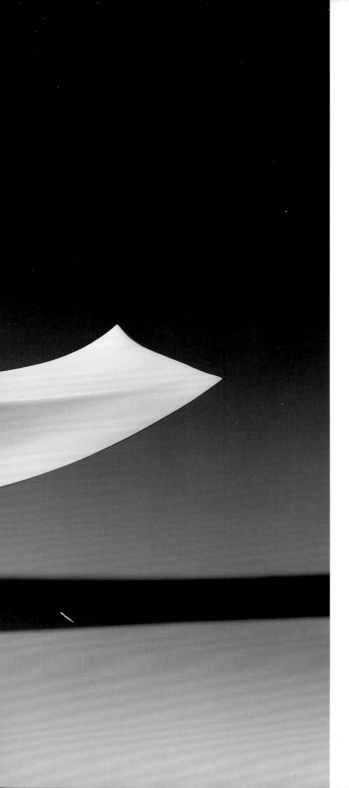

FIRED EARTH, WOVEN BAMBOO

Contemporary Japanese Ceramics and Bamboo Art
from the Stanley and Mary Ann Snider Collection

Kazuko Todate

with Anne Nishimura Morse

MFA PUBLICATIONS | MUSEUM OF FINE ARTS, BOSTON

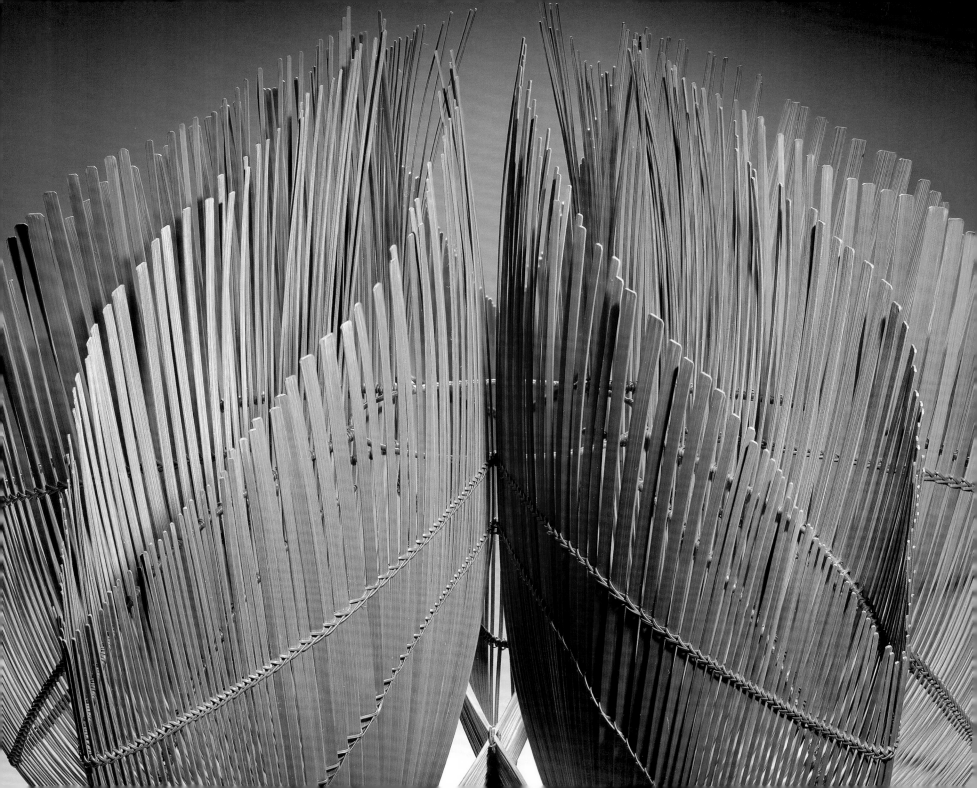

CONTENTS

DIRECTOR'S FOREWORD

The celebrated collection of Japanese art at the Museum of Fine Arts, Boston, was first established in the late nineteenth century by a generation of farsighted donors and curators that included Edward Sylvester Morse, Ernest Francisco Fenollosa, William Sturgis Bigelow, and Okakura Kakuzō. Stanley and Mary Ann Snider represent a new generation of Bostonians who want to ensure that visitors to the Museum will understand the vibrancy of Japanese ceramic and bamboo art in our own time. Introduced to Japan and its culture in the 1970s by the well-known collector John Powers, the Sniders have been schooled in the modes of traditional Japanese art appreciation. They have a profound sensitivity for the serendipitous imperfections produced by the kiln and the technical excellence of the intricate weaving of bamboo. Yet their own unerring eye for dynamic forms has been the most powerful factor in the development of their superb collection.

Several years ago, Stanley Snider challenged the Museum to become a center for contemporary Japanese decorative arts. Through the generous gift that he and Mary Ann made to the MFA in 2012 and the infectious enthusiasm that they have conveyed to others, we are now well on our way to achieving that goal. When several objects from the Sniders' collection were previously on loan to the Museum, they generated a great deal of excitement, here and in Japan, where Japanese artists were thrilled by the recognition of their art in the United States.

In the publication of this catalogue, the Museum has been fortunate to have the guiding hand of the leading scholar and critic of Japanese decorative arts Kazuko Todate. She has been willing to share with us her intimate knowledge of the ceramic and bamboo worlds in Japan, as well as the conversations she has had with the dynamic artists represented in the Stanley and Mary Ann Snider Collection.

Malcolm Rogers
Ann and Graham Gund Director
Museum of Fine Arts, Boston

COLLECTORS' PREFACE

How can we explain our enthusiastic and special appreciation for Japanese ceramics and bamboo? It arose from a happy experience in 1973, the first of our many trips to Japan. We signed on to a Young Presidents' Organization (YPO) ten-day get-to-know Japan conference held in Kyoto. Two hundred Japanese YPOers and their spouses and two hundred of their Western counterparts enrolled in an intensive program to connect Japanese culture with the booming Japanese economy. To do this, the organization's educational team concluded that American executives needed a deeper understanding of Japanese traditions. We had lectures and courses on calligraphy, Zen Buddhism, haiku poetry, *ikebana* (flower arranging), the tea ceremony, and more.

Among all these new-to-us cultural activities, the visits to Kyoto's imperial gardens of Katsura and Shugakuin, and to the Buddhist temples of Ryōan-ji and Daitoku-ji—perhaps the most famous of the hundreds of works of landscape art in and around Kyoto—struck us most profoundly. As with our response to so much of the Japanese way of life, we can't put into words why we were so taken by these gardens. But taken we were. Rocks became sculpture, and pine and maple trees opened our eyes to natural garden vistas created to be seen from indoors—a dynamic contrast to the idea of using landscaping to decorate the outside of a home.

Returning home to a new building project on Martha's Vineyard, we applied what we had learned. Not all we brought home was practical. We had appreciated the presentation of Japanese food and drink, especially the congenial pleasure of sake toasting, based on the principle of filling others' cups as they in turn filled ours.

In 1976 we returned to Japan as participants in two small group tours led by the collector and connoisseur John Powers. A retired business executive and collector of American contemporary art, after he married his wife, Kimiko, he began to spend much of his time in Japan, where he formed one of the first comprehensive private collections after the Second World War. Our conversations with him during the many hours we traveled by bus to studios and museums introduced us to the Japanese *wabi* aesthetic, which celebrates imperfections, and fostered our preference for expressive stoneware over more decorative porcelain. On a visit to Inbe, the home of Bizen pottery, we witnessed the ritualized opening of a just-fired, wood-burning *anagama* kiln. The kiln workers noted with great pleasure the accidental ash markings on the still-warm pieces,

along with other irregularities and imperfections. This experience enhanced our appreciation of unexpected outcomes in the ceramic process.

In 1978, again with John Powers, we toured workshops, galleries, and small museums on Kyushu, Japan's southernmost island, where we visited many Japanese ceramic artists in their homes and adjacent workshops. It was a special experience for us Westerners to meet with artists—and often with their families and apprentices—at work in their traditional surroundings. Frequently our artist hosts would serve green tea ritually prepared and presented in carefully chosen tea bowls of their own design. Wherever we went, John would insist we pick one object that we especially liked and explain why we chose it. He enabled us to understand our growing appreciation of the profoundly natural Japanese aesthetic. If we acquired "a good eye"—as collectors say—it comes from this challenging experience.

By now, of course, we were buying a good number of Japanese ceramics. Joe Earle, then Chair of the Department of Art of Asia, Oceania, and Africa at the MFA, came to our home to look at our incipient collection. He spotted a twisted-root-handled bamboo basket, which we had purchased in Kyoto simply because we liked it. He informed us that our basket was created by a major artist, Maeda Chikubōsai I, and encouraged us to look into contemporary bamboo. Joe also suggested we visit the Palm Beach exhibition of bamboo art by TAI Gallery of Santa Fe and meet the gallery owner, Rob Coffland. We bought four bamboo pieces on the spot, and bamboo sculpture became our second passion. Contemporary ceramics and bamboo, we discovered, fit so well side by side.

In 2005, Joe Earle curated the MFA exhibition *Contemporary Clay: Japanese Ceramics for the New Century*, highlighting the collection of Alice and Halsey North and including a few of our pieces as well. Our ensuing friendship with the Norths and their encouragement to become collectors, not just buyers, changed our approach to acquiring these artworks. Collecting adds a seriousness and responsibility different from buying just for personal pleasure. It has also given us new friends, new experiences, and great joy.

Our friendships with Bill Clark, Kurt Gitter and Alice Yelen, and the Norths, and mentoring by Rob Coffland, Koichiro Okada, Joan Mirviss, Anne Nishimura Morse, Angie Simonds, and Joe Earle are largely responsible for us being able to make this gift to the MFA. It is our hope that this collection will complement the Museum's extraordinary masterworks of Japanese art.

And so, we stumbled happily into becoming collectors of contemporary ceramics and bamboo. We wish that visitors to the Museum and readers of this catalogue will share our wonder at how a grass that grows like a tree and clay from the earth can be transformed by master craftsmen into exquisite works of art.

Stanley and Mary Ann Snider

FROM ARTISAN TO ARTIST

During the late nineteenth century and into the twentieth, ceramics and bamboo arts in Japan developed from traditional crafts into modern art forms, as those who produced them evolved from artisans into artists. This critical transition can be seen in two ceramic pieces created roughly eighty years apart. The large lantern decorated with floral arabesques in underglaze blue, now in the collection of the Setogura Museum, Aichi prefecture (fig. 1) was produced around 1878 by the internationally award-winning potter Katō Mokuzaemon II. Tomimoto Kenkichi, a leading artist and theorist who was designated an Important Intangible Cultural Property Holder (sometimes known as Living National Treasure) in 1955, made the ornamental jar decorated with four-petaled flowers in 1960 (fig. 2). Besides the obvious contrasts in form, size, and decoration, the crucial distinction between them is that one is the product of a ceramic artisan while the other is a work by an individual ceramic artist.

The long and rich tradition of Japanese ceramics reached an aesthetic high point in the pottery of the Edo period (1615–1868). When the feudal domains were abolished at the beginning of the Meiji era (1868–1912), local kilns lost their official protection and turned to the new national government for patronage. As Japan rapidly modernized and Westernized, the Meiji government promoted ceramics and other crafts as a source of national prestige. While they gained international recognition and became a symbol of Japan around the world, crafts also acquired strategic potential under the national industrial promotion policy whose slogan was "rich country, strong army" (*fukoku kyōhei*). Technically sophisticated and highly decorative Japanese ceramic products at the Vienna International Exposition in 1873, the Philadelphia Centennial International Exhibition in 1876, and the Paris Universal Exposition in 1878 set off a craze for things Japanese and soon thereafter began to be exported in large quantities.

During this time, ceramics were considered commercial products made for the foreign market, not works of art. Creative control was exercised by kiln and workshop heads and factory owners, and sometimes even through national government design directives. The production system relied on a division of labor, with many craftsmen contributing to the manufacture of each piece.

The lantern made by Katō Mokuzaemon II exemplifies this process. Katō was a major kiln owner and the head of a family that spanned three generations in Seto, one of Japan's most important ceramic production areas, near Nagoya. The lantern's size and highly detailed, intricate design indicate that it was made for export to the West in the late 1870s or early 1880s. The inscription on the bottom of the piece states, "Made by Katō Mokuza in Seto, Japan."[1]

However, Katō's name on the piece does not necessarily indicate that he himself actually handled the clay and painted the decoration. As a manager and director, he assembled a team of

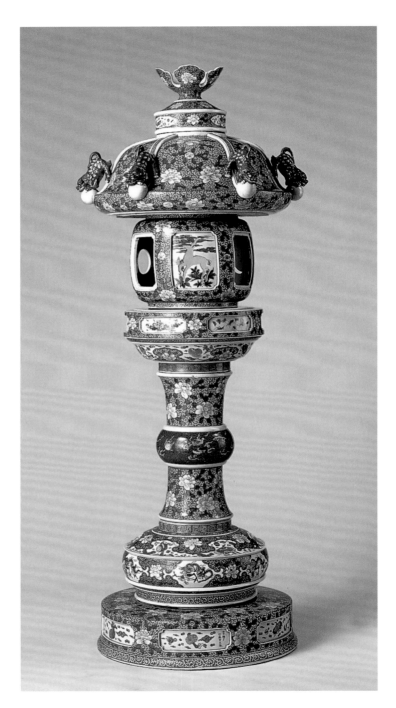

Fig. 1
Katō Mokuzaemon II
(1832–1900)
Large lantern with under-
glaze and flower arabesque,
around 1878
H. 191 cm (75¼ in.)
Setogura Museum

Fig. 2
Tomimoto Kenkichi
(1886–1963)
Ornamental jar with decoration
of four-petaled flowers, 1960
23 x 27 cm (9 x 10⅝ in.)
Museum of Modern Ceramic Art,
Gifu

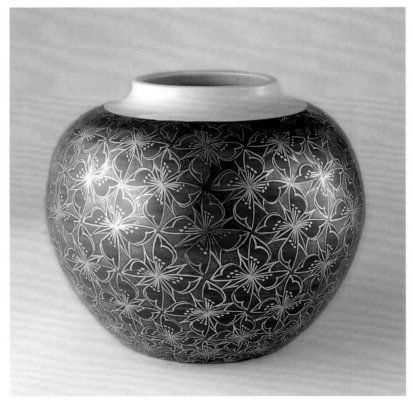

artisans: according to a record from 1883, Katō employed nine potters, eleven painters, and two assistant craftsmen to do the preparatory work.[2] In Katō's era, the "artist" was the person in charge of production. The organizational power of such groups of highly skilled artisans was the true strength of Meiji ceramic makers.[3]

In the manufacture of pieces such as the lantern, Katō probably was not concerned with creating an original ceramic work. The peony arabesque used for the overall pattern and the dragon and lion are standard Chinese motifs, and the form of the lantern is traditional. Katō's aim was not expression but production, and the chief reason for making the piece was to sell it. A very similar piece by Katō is at Zenkō-ji, a large temple complex in Nagano; economic logic called for the production of multiple pieces with a uniform standard.

Bamboo baskets made at this time were also considered commercial products rather than forms of artistic expression. Basketry had become a well-developed cottage industry by the second half of the nineteenth century and was also produced in large workshops. Four individual makers did win prizes for their baskets at the 1873 Vienna exposition; Yamaguchi prefecture also received a collective award. A producing region could be recognized as a "maker" at this time. In addition, artists such as Hayakawa Shōkosai I (1815–1897), working in Osaka, began to sign their names to their baskets in the mid-nineteenth century, signaling an early awareness of individuality in the bamboo arts. However, they remained master craftsmen rather than creative artists, and most of the baskets that were exported overseas were for functional use. They were concentric in form, with a fine and close mesh—a style made popular by elegant contemporary Chinese flower baskets displayed during ceremonies for serving *sencha* (steeped green tea).

As modernization continued in the first half of the twentieth century, individual craft artists of all genres began to assume creative control over the works that they produced. The paradigm of a producer or director leading an enterprise such as a kiln or workshop was increasingly rivaled by that of an individual creator designing and working hands-on with the material. Through the process of creating work with their own hands, based on their own ideas, Japanese artisans gained a sense of the value of individuality, and of individual artistic expression. Their creativity fueled by public and private exhibitions, makers evolved into craft artists, voicing individuality and originality through their media.

Some of these artists began with a creative idea and then gained the hands-on skills and techniques needed to express it. In ceramics, Tomimoto Kenkichi became one of the leading figures during this period. An important theorist as well as a practicing artist, he famously stated in a 1913 conversation with the British potter Bernard Leach (1887–1979) that "one should not create a design based on another design"—instructing ceramicists not to imitate other ceramicists or

use existing patterns, but to design their own patterns based on their own sketches.[4] Tomimoto created his designs from his observations of nature; the flower pattern of the illustrated jar is from his own sketch of star jasmine (*teikakazura*) in his home garden.

Tomimoto also insisted on using the potter's wheel with his own hands, rather than handing a design on paper to a craftsman to produce. As he said, "I always turn the pottery wheel by myself, though I am not so good at it."[5] This practice set him apart from other ceramicists of his era such as Itaya Hazan (1872–1963), who employed a craftsman to use the potter's wheel in his studio. Tomimoto entered into a personal battle to find the best outline for a vessel as he threw it on the wheel. This struggle to choose the best form from countless possibilities he called a "battle of lines."[6] Tomimoto refused to recognize artists who "didn't mind letting someone else do the wheel forming, the most important process in making the ceramic vessel, which is a plastic form."[7] He created new works by connecting his own original design idea with his own process of making, achieving self-expression through physical manipulation of materials. This attitude of individualistic artists of the Taishō era (1912–26), such as Tomimoto, is the origin of contemporary Japanese crafts.

Tomimoto, who had gone to England to study the work of William Morris and members of the Arts and Crafts Movement, and Leach, who had discovered a love of clay in Japan, were close friends. As Leach wrote, "Pottery was a vocation in which we sought truth of contemporary expression as artists and as craftsmen, inheriting traditions not only from our respective native backgrounds but also from the other side of the world. We knew that we stood on new ground with an unknown journey to make."[8] Yet they were quite different types of artist, reflecting the difference between the Arts and Crafts Movement in England and the Japanese crafts movement. In England, the aim was to establish a good relationship between designers and craftsmen, whereas in Japan the craftsmen tried to become designers while designers aspired to become craft artists. Thus Leach attached importance to producing excellent designs for both everyday ceramics and his own art pieces. Tomimoto considered that the artist's hands and skills contributed as much to ceramic artworks as did his ideas and designs.

The other route to becoming a craft artist was one in which artisans already in command of craft skills (often those from multigenerational ceramic-producing families) cultivated the newfound ability to come up with their own ideas. This path of artistic development from technician to artist, which was first seen in the 1920s, became more common in the decade following the end of World War II. The concept of tradition, which during the Meiji era had meant handing down knowledge and techniques in order to reproduce works in the same style as in the past, gained a fresh connotation: that of working with time-honored materials and techniques to express something new. Kaneshige Tōyō (1896–1967), known for his Bizen-style works, and Arakawa Toyozō

(1894–1985), acclaimed for his Shino wares, are examples of artists who followed this path. So, too, is Ishiguro Munemaro, who immersed himself in mastering early Chinese techniques and then gradually came to express his own original ideas.

The concepts of individuality, originality, and creativity (*sōsaku*) that emerged in early twentieth-century Japan were imported and adapted from Western modern art movements. As early as 1910, the magazine of the literary circle White Birch (Shirakaba) advocated the importance of individualism in art and introduced such Western artists as William Blake, Rodin, and the Postimpressionists. One figure who was greatly influenced by the ideas first given expression by Shirakaba was Takamura Kōtarō (1883–1956), a modern Japanese sculptor. He asserted absolute priority of the self in expression in his essay "The Green Sun": "I seek absolute *Freiheit* [freedom] in the art world. Therefore, I want to recognize an infinite authority in the *Persönlichkeit* [personality]. In every sense, I'd like to think of the artist as a single human being. I'd like to regard his *Persönlichkeit* as the starting point and *schätzen* [appreciate] his work."[9]

Around this time individual creativity also gained recognition in ceramics and other fields of craft, art, and design. In 1913 the Ministry of Agriculture, Forestry, and Commercial Design and Applied Work Exhibition (Noten)—the first official show to include both industrial and artistic crafts without making distinctions between them—adopted creativity as a standard of evaluation.[10] In 1918, a group of young Japanese-style painters from Kyoto left the Ministry of Education Art Exhibition (Bunten) and founded the National Painting Creation Association. Their manifesto, reflecting the influence of Western art, asserted that "We have to say that the creation of individuality is the life of artwork. . . . Each member takes as his commitment the freedom of individual creation."[11] Kusube Yaichi (1897–1984), a Kyoto ceramicist, was inspired by this development to form the ceramic artists' group Red Clay (Sekido) in 1920. Their manifesto proclaims, "It would be a great tragedy if we did not become conscious of ourselves and continued to admire the way artisans are addicted to producing works of conventional style. The members of Red Clay will study and pursue the depths of natural beauty and through a demonstration of individual intention, which gives expression to a true beauty of ceramics that is eternal, will seek and give birth to a mystical light."[12]

Tomimoto Kenkichi's advocacy for individuality reached beyond ceramic production. As an example, for the covers of Taishō-era magazines he made woodblock prints that he designed and carved himself as part of the "creative print" (*sōsaku hanga*) movement. *Sōsaku* artists designed, carved, and printed images themselves, eschewing the traditional division of labor that produced prints such as *ukiyo-e*, with their teams of publishers, carvers, and printers. Tomimoto was not a professional graphic artist, but he promoted *sōsaku hanga* as another form of hands-on art.

The term *sōsaku* came to be adopted by a variety of artists. In 1921, Kawai Kanjirō (1890–1966) presented the first Sōsaku tōjiten (Creative Ceramics Exhibition), and Ogō Tomonosuke

(1898–1966), a dye artist, organized the Zuan sōsakusha (Creative Design Association). In 1925 the graphic designer Sugiura Hisui (1876–1965) organized the Seven Persons' Society and began using the phrase *sōsaku zuan* (creative design), which was taken up by other craft artists, including Tomimoto.

In 1927 the Eighth Imperial Art Exhibition (Teiten) added an artistic craft section, which allowed ceramic and other craft artists to show their work on equal terms with painters and sculptors in an official government exhibition. In reviews of the Eastern Ceramics Association, (Tōtōkai), which mainly consisted of members in the Kantō area (eastern Japan) of the Imperial Art Exhibition, it became common to use words like *originality* and *creativity*.[13] Such praise of originality, refusal to copy, and antagonism toward imitation helped spread the idea that individual creativity is a basic condition of being an artist.

Once personal creativity had become a norm in Japan, the expression of this individuality necessitated the transition from group collaboration to almost unassisted production.[14] Craft artists had to integrate the roles of the creative designer and the actual handler of materials— positions that had been separate in traditional crafts—to establish their own individuality and originality. To be recognized as independent artists or to make crafts into a medium for creative expression, they needed to work the materials with their own hands. Those who had lived in the world of crafts had to decide whether to be artisans or independent artists. Choosing to be a craft artist meant taking on everything from making the original design to handling the materials. This was a radical shift from the production process of the nineteenth century.

The development of ceramics as art objects, divorced from functional form or use, began after the Second World War. Previously, Tomimoto Kenkichi had stated that "the shapes of ceramics are the most abstract among all forms of sculpture," indicating that a ceramic vessel was not merely a container but a three-dimensional work of art.[15] However, Tomimoto named and categorized his own works as vessels, not free-style ceramic objects. The titles of the works, given by the artist himself, always include functional terms such as "jar," "box," or "plate," even if they were rarely used as such.

The vigorous postwar recovery provided an atmosphere of buoyant excitement for artistic endeavors, including painting, sculpture, ceramics, flower arranging, photography, and design. Flower arranging (*ikebana*) led the way, as practitioners of this art who had absorbed avant-garde influences of the West began applying the word *obuje* (from *objet d'art*, taken from Dadaism, surrealism, and abstract art) to their works. Progressive *ikebana* groups, such as the Mishō, Ohara, and Sōgetsu schools, encouraged ceramic artists to create works that would be impossible to use for flower arrangement.

Ceramics artists also applied the word *obuje* to their efforts, but in a different sense. The *obuje* of *ikebana* artists, and of the Western avant-garde who inspired them, were composed of ready-made items. For the *ikebana* artists, ideas and concepts were much more important than manual skills. In contrast, for the ceramic artists the *obuje*, created by kneading, hand-forming, drying, and firing clay, required the artist's knowledge of materials and experiences as well as ideas and concepts.

Hayashi Yasuo's handbuilt *Cloud* (1948), submitted to the second annual exhibition of the Society of Four Harvests (Shikōkai) in Kyoto, was the first memorable, autonomous ceramic work of art in modern Japanese ceramics (fig. 3).[16] Hayashi said, "At first, I started to make something like a human body. But it was gradually becoming a form like a cloud while I was making it, and so I named it *Cloud*. At the time, ceramics was viewed as a second-class art form, but I wanted it to be seen as a

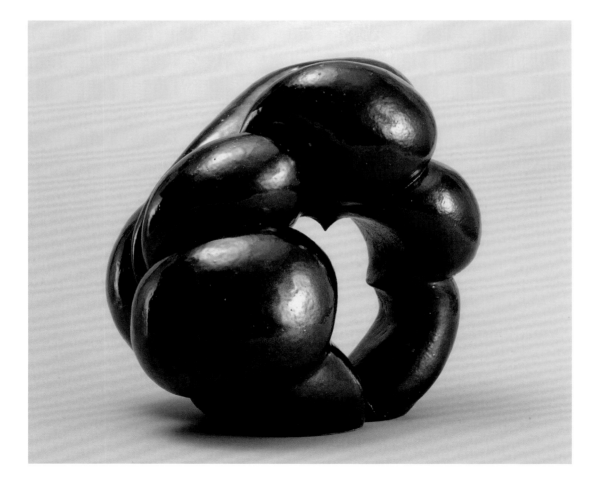

Fig. 3
Hayashi Yasuo (b. 1928)
Cloud, 1948
33.7 x 33 x 27.5 cm
(13¼ x 13 x 10⅞ in.)
Misho Ryu Nakayama
Bunpo kai

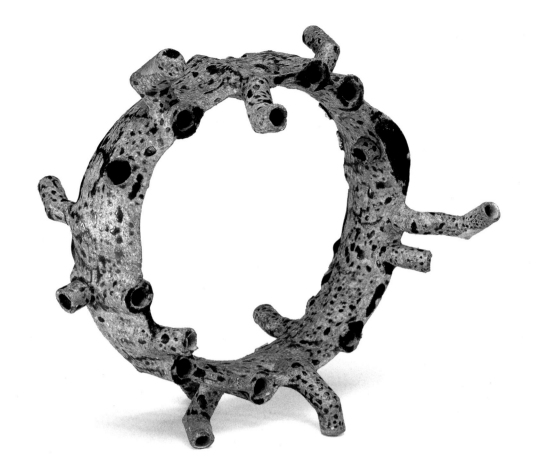

Fig. 4
Yagi Kazuo (1918–1979)
Mr. Samsa's Walk, 1954
27.5 x 27 x 14 cm
(10⅞ x 10⅝ x 5½ in.)
Private collection

mode of expression on a par with painting and sculpture."[17] The Society's manifesto of December 1947 says, "Here we peaceful young ceramic artists have been able to rise up in the wilderness under everyone's support. We are trained by mother clay, and we will be devoted to expressing ourselves with clay and will keep making ceramics seriously to explore the poetic beauty of naturalness, simplicity, and modesty. We will do our best day and night to contribute to establishing a cultural society with integration of life and beauty."[18] The title *Cloud* is significant for another reason: it refers only to an image and does not include the name of a container, such as "vase" or "plate." In addition, the work's exploration of biomorphic form influenced later artists, such as Nakashima Harumi (b. 1950) and Shigematsu Ayumi (b. 1958).

Another famous ceramic object, *Mr. Samsa's Walk*, by Yagi Kazuo, was shown at the Form Gallery in Tokyo in 1954 (fig. 4). Yagi was a founding member of the Crawling Through Mud Association (Sōdeisha), whose rather abstract manifesto of July 1948 says, "The birds that fly away

from a fictional forest will find themselves at a fountain of truth. Our collective is not a 'dreaming hotbed,' but is truly life under an intense sun."[19]

The distinction between functional ceramics and objects is not absolute. As long as they are made of pottery, three-dimensional ceramic objects necessarily have a hollow structure or thin walls because of the nature of the materials and requirements of the process used to make them. Even forms such as plates and tiles require consideration of the relationship between size and thickness. Sculptors bend materials to their will, focusing on the form they want to make; if clay is not appropriate to the form, they can choose another material. But ceramic artists are bound by the material nature of the clay, experimenting with thickness and size to learn if their forms can survive drying and firing. Eventually, ceramicists came to view all forms of pottery as a means of artistic expression, regardless of an object's size or the presence of an opening that meant it could be used as a vessel.

Ceramic artists such as Yanagihara Mutsuo (b. 1934), Morino Hiroaki Taimei (see pp. 50–51), Nakamura Kinpei (b. 1935), and Miwa Ryōsaku (b. 1940; currently known as Miwa Kyūsetsu XII) represent the second generation of avant-garde ceramics, coming after the members of Shikōkai and Sōdeisha. From the end of the 1970s, large-scale ceramics came into vogue, and the medium became a mode of self-expression in its own right, exhibited in every corner of the art world. For example, Fukami Sueharu (see p. 65) showed a three-by-four-meter installation composed of multiple ribbons of porcelain in Kyoto in 1978. Tashima Etsuko (b. 1959) showed a huge ceramic installation like a botanical garden at *Art Now '87*, an exhibition dedicated to contemporary art, at the Hyōgo Prefectural Museum of Art.

Women artists also joined in the development of the craft in the postwar era. Historically, in Japan women had generally been excluded from the key processes of ceramic production and were even forbidden to approach kilns for fear of polluting them. There were only a few exceptions from the Edo period and Meiji era. One such was Ōtagaki Rengetsu (1791–1875), a nun and literati artist who made teaware, and another was Koren (Hattori Tsuna; active 1878–86), a maker of small, lidded vessels favored by early foreign collectors. In the Taishō era, the celadon artist Suwa Sozan II (1890–1977), who succeeded her father, Suwa Sozan I, showed works at exhibitions in Kyoto.

Among the first modern figures were two students of Tomimoto Kenkichi, Tsuji Teruko (b. 1920) and Tsuboi Asuka (b. 1932). Tsuji Teruko's father had a taste for antique ceramics and allowed his children to study art and to make pottery; her brother, Tsuji Seimei (1927–2008), was also a ceramicist. She asked to study privately with Tomimoto in 1938. Tsuboi Asuka studied sculpture in school and in the 1950s began exhibiting with the collective New Craft Artists Association (Shinshōkai) that Tomimoto had organized in 1947. She went on to found the female ceramicists' collective Women's Association of Ceramic Art (Joryū tōgei) in 1957.

These female ceramicists did not produce manifestos like those of Shikōkai and Sōdeisha. According to Tsuboi, "We thought we would be freer to create if we had no such doctrine. We wanted the Women's Association to be the sort of group where someone who produced good work could be recognized today, without regard for hierarchy or order, whether or not she had an established career. Members were free to do as they pleased, on the one condition that they had to view ceramics not as a hobby, but as a profession."[20] With its unfettered approach, this group gave momentum to the careers of many female ceramic artists, such as Fujino Sachiko, who won the grand prize at a show the group sponsored that was open to the public, or Kishi Eiko, who also won several prizes (see pp. 80–81, 83).

The Kyoto City University of Arts began accepting female students in 1945. Later that year, the government approved new guidelines for women's education that instructed universities to begin admitting women. Women students arrived at Tokyo University of the Arts and other national universities in 1946, which led to a significant increase in the number of female ceramic artists. Shigematsu Ayumi (b. 1958), a graduate of the Kyoto City University of Arts, became the first woman to be a full-time ceramics teacher at her alma mater in 2002. Her works are characterized by their mysterious, handbuilt structures and pastel colors. Since the 1980s, women artists such as Nakaigawa Yūki and Tashima Etsuko (both b. 1959) have explored techniques that violate traditional taboos in the making of ceramics: Nakaigawa fits together separate pottery parts with nuts and bolts, and Tashima joins pieces of different materials (such as glass) with glue.

While the fundamental principles of fashioning and firing clay have remained unchanged since the prehistoric Jōmon period, contemporary ceramic artists, working directly with materials and learning production processes through hands-on experience, continue to adapt them to their own expressive purposes. Like their female colleagues, some of the male artists who worked toward the end of the twentieth century also adopted radical techniques, such as sandblasting or break-forming pieces after glost firing (a second high-temperature firing that fuses the glazes), which is usually the final stage of production.

Practitioners of the bamboo arts in the twentieth century traced a similar trajectory to that of ceramicists, from artisans to artists. Bamboo arts are fundamentally rooted in fashioning the body of a basket, which helped establish the hands-on material basis for the medium as it evolved from commercial products to artistic expression. Early individual creative artists in the field included Iizuka Rōkansai (1890–1958), Shōno Shōunsai, and Tanabe Chikuunsai II. The works of Iizuka Rōkansai are characterized by harmonious, balanced forms, whether the technique is ornate like *tabane-ami* (bundled plaiting) or restrained like *kushime-ami* (comb plaiting). He sometimes made uniquely shaped functional pieces, such as a tray in the shape of a banana leaf (about 1935;

Tochigi Prefectural Museum of Art) and *Wall Vase Bagworm* (about 1942; Idemitsu Museum of Art). Earlier than any other bamboo artist, Shōno Shōunsai expressed his creativity in sculptural forms with dynamic curved lines and surfaces. Tanabe Chikuunsai II was renowned for his sensitive and refined baskets. His works are marked by simple yet sophisticated concentric forms.

From the 1950s onward, bamboo artists began to make highly original pieces that transcended the utilitarian role of vessels. This was particularly true of artists affiliated with the Japan Art Exhibition (Nitten). In 1961, the Japan Contemporary Arts and Crafts Artists Association (Nihon gendai kōgei bijutsuka kyōkai) was established mainly by crafts artists who belonged to the Nitten, and in 1978, the Japan New Crafts Artists Association (Nihon shin kōgeika renmei) was founded by Nitten artists who were interested in crafts for everyday life. Bamboo artists such as Tanabe Chikuunsai II sometimes participated in all of those groups' exhibitions.

Among the first to create works meant primarily for aesthetic appreciation was Shōno Shōunsai, who in his 1956 application submitting *Bamboo Vase, Raging Waves* to the Twelfth Nitten said, "With a motif of rough waves in the sea, I make sophisticated use of the material and focus on strength, movement, and beauty so as to give effective voice to the natural rhythm of the bamboo."[21] He received a Hokuto prize (sponsored by the Hokkoku Shinbun company) at the exhibition for this celebrated piece (now in the National Museum of Modern Art, Tokyo, in revised form).

Yamaguchi Ryūun, an apprentice of Shōno Shōunsai, inherited the dynamism of Shōunsai's works and incorporates it into the development of his daring new objects. Shōno Tokuzō, the son of Shōunsai, carries forward the lively expressiveness of his father's work in innovative objects made using a minimum of weaving and bundling.

The development of bamboo works as art objects freed entirely from functional form or use began in the 1960s following Shōunsai's innovative *Undaunted General* (1962; Ōita Prefectural Art Center). One of the artists representing this trend is Honma Kazuaki (b. 1930). He created energetic forms by assertively bending thick bamboo. His son, Honma Hideaki, following his example, builds even stronger forms with long pieces of bamboo on a grand scale.

Bamboo expression expanded further with the introduction of undulating forms by Torii Ippō; great, swelling forms by Honda Shōryū; and light, organic forms by Morigami Jin. These artists no longer weave and construct their forms only from the bottom to the top, but work in multiple directions. Nagakura Ken'ichi has challenged conventional ideas that bamboo works should be built with a net-structure by creating a new style in which he sometimes buries the bamboo form in a mudlike material. One of the youngest artists, Sugiura Noriyoshi, who pursues the multiple potential of the art, says, "I am thrilled to find a new bamboo form I've never seen."

In addition to expanding the exploration of nonfunctional objects, postwar bamboo artists also expressed their creativity in vessel forms. Many skilled artists, including Monden Kōgyoku,

Fig. 5
Shōno Shōunsai (1904–1974)
Sōzen-style flower basket,
1955–65
27.9 x 19.1 x 29.2 cm
(11 x 7½ x 11½ in.)
Museum of Fine Arts, Boston

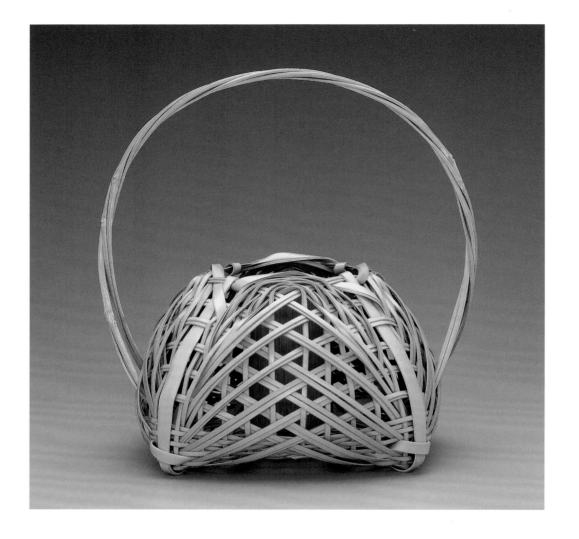

Hatakeyama Seidō, Fujinuma Noboru, Sugita Jōzan, and Yako Hōdō, have submitted their creative baskets to the Japan Traditional Art Crafts Exhibition (Nihon dentō kōgeiten), which started in 1954. Certain artists who have participated in the exhibition, such as Fujitsuka Shōsei, sometimes make nonfunctional objects. All of them demonstrate that the word *dentō* (tradition) means not only the transmission of historical materials and techniques but also the creation of new works based on those materials and techniques. A system of recognizing outstanding craftspeople that began in 1954 supports this concept of *dentō*. Craftspeople who have acquired expert skills and also shown new creativity are designated by the Japanese Min-

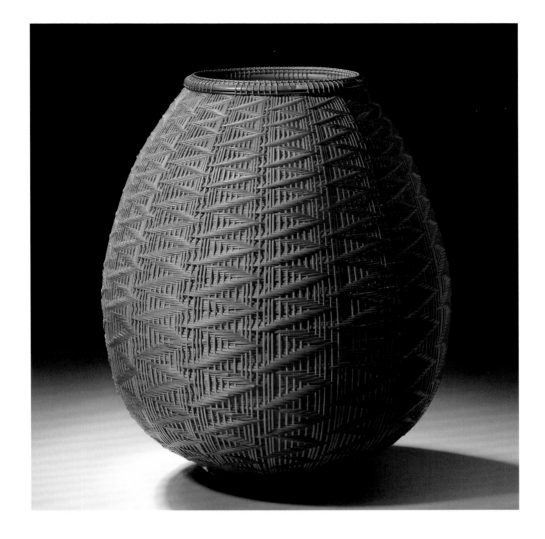

Fig. 6
Kajiwara Aya (b. 1941)
Autumn Memory, 2009
36.8 x 30.5 cm
(14½ x 12 in.)
Museum of Fine Arts, Boston

istry of Education as Important Intangible Cultural Property Holders. Shōno Shōunsai was the first bamboo artist so designated, in 1967. Today his creative works, whether baskets or other objects, are appreciated throughout the world (fig. 5). Fujinuma Noboru, the most recent recipient, received the title in 2012.

Women, long engaged in bamboo basketry as a cottage industry, also began to exhibit their work as artists in the 1980s, through participation in exhibitions such as the Japan Traditional Art Crafts Exhibition and its affiliates. Ōno Yasuko (b. 1943) submitted a richly full-formed flower basket to the Japan Traditional Wood and Bamboo Art Crafts

Exhibition (Nihon dentō kōgei mokuchikuten) in 1985. Kajiwara Aya, who has worked as an assistant to her husband, the bamboo artist Kajiwara Kōhō (b. 1935), began to create her own works in the mid-1980s (fig. 6). She submitted an elegantly designed basket to the Japan Traditional Art Crafts Exhibition that received the President's Prize in 1994. Isohi Setsuko (b. 1964) was awarded the same prize in 2010.

Whether working in ceramics or bamboo, contemporary craft artists in Japan share the characteristics of creativity, originality, and hands-on engagement with their materials. This can be seen as countering a series of developments in the mainstream of contemporary art that includes ready-mades, quotations or appropriations, and factory production—trends that started with Picasso and Braque and were carried on by such artists as Duchamp, Warhol, Lichtenstein, and Murakami Takashi. Contemporary craft artists choose instead to express their ideas through materials and processes. This choice has led to a new Japanese approach to plastic arts, supported by an awareness of texture, detail, and the acuity of all five senses.

This approach can impose limitations and risks, especially in ceramics. But it is still chosen by artists because it embodies a powerful and promising principle—not just a style, but a fundamental artistic concept that the creators themselves derive from their creative process. Rather than a radical movement, which begins with loud assertions but dwindles quickly, this is a sturdy body of thought and a concrete, creative attitude that has been handed down and reinforced by generations of artists and teachers. The historical evolution from makers to artists allows contemporary craft artists to engage in a process of working directly with materials and creating with a hands-on, on-site approach—making adjustments, modifications, and discoveries that are then applied to the next step, and the next work. The advantages of this process are evident in the challenging and beautiful works of art assembled in the Stanley and Mary Ann Snider Collection.

Notes

1. Katō used various names, including Katō Mokuza and simply Mokuza. This piece was discovered in London and subsequently returned to its hometown and added to the collection of the Seto City Folk Historical Material Museum (now the Setogura Museum).

2. Research by Yamashita Takashi at the Seto City Folk Historical Material Museum.

3. Edward Sylvester Morse describes the people and processes of the Kyoto potteries he visited in the 1870s in *Japan Day by Day* (Boston: Houghton Mifflin, 1917), vol. 2, pp. 184–90. He went on to become one of the founding donors of the Japanese collection at the Museum of Fine Arts, Boston.

4. Tomimoto Kenkichi, "Seitō yōgen," *Seitō yoroku* (Shōshinsha Publishing, 1940), p. 114. The evidence for dating this statement to 1913 appears in Yamamoto Shigeo, "Moyō kara moyō o tsukurazu sankō," *Gendai no me*, no. 443, National Museum of Art, Tokyo, October 1991.

5. Tomimoto Kenkichi, "Hakuji no tsubo," *Tomimoto Kenkichi chosakushū* [Collected Writings of Tomimoto Kenkichi] (Gogatsu Shobō Publishing, 1981), p. 354.

6. Tomimoto Kenkichi, "Sūko no tōhen," ibid., p. 489.

7. Ibid., p. 14.

8. Bernard Leach, *Beyond East and West: Memoirs, Portraits, and Essays* (New York: Watson-Guptil Publications, 1978), p. 128.

9. Takamura Kōtarō, *A Brief History of Imbecility: Poetry and Prose of Takamura Kōtarō*, trans. Hiroaki Sato (Honolulu: University of Hawaii Press, 1992), p. 180.

10. For example, see Shiba Ranzō, review of the Noten exhibition, in *Chūō bijutsu* (Art of the Center), November 1916, p. 66.

11. *The Kokuga sōsaku kyokai Manifesto*, January 1918.

12. *The Sekido Manifesto*, February 1920.

13. For example, an exhibition review in *Tōtō* (The Journal of the Eastern Ceramics Society, or *Tōtōkai*), June 1930, p. 14, commented on the work of Inoue Ryosai: "one would hope for something more creative, based on a modern sensibility." The Eastern Ceramics Association was organized in 1927 by Itaya Hazan, who worked toward establishing the crafts section of the Nitten and later served as a judge for the section.

14. This need was strongest in fields involving complicated production processes. See Todate Kazuko, *Nakamura Katsuma and Genealogy of Tokyo Yūzen: The Establishment and Development of Dyeing as a Material-Based Expression by an Independent Artist* (Senshoku to seikatsu sha, 2007).

15. Tomimoto Kenkichi, "Waga tōkizukuri," *Tomimoto Kenkichi chosakushū* [Collected Writings of Tomimoto Kenkichi] (Gogatsu Shobō Publishing, 1981), p. 32.

16. See Todate Kazuko, "The Introduction of 'Object' and the Creation of Nonfunctional Formative Objects in Japanese Ceramic History: *Zamuza shi no sanpo* and the Artistry of Yagi Kazuo," Japan Society of Oriental Ceramic Studies, *Tōyō tōji* (Oriental Ceramics) 35 (2005–6).

17. Hayashi Yasuo, interview with the author, Kyoto, May 22, 2012.

18. Author's translation from *The Shikōkai Manifesto*, December 1947.

19. Author's translation from *The Sōdeisha Manifesto*, July 1948.

20. Tsuboi Asuka, interview with the author, Kyoto, March 5, 2007.

21. Shōno Shōunsai, "Application to Show Work in the Nitten Exhibition," 1956.

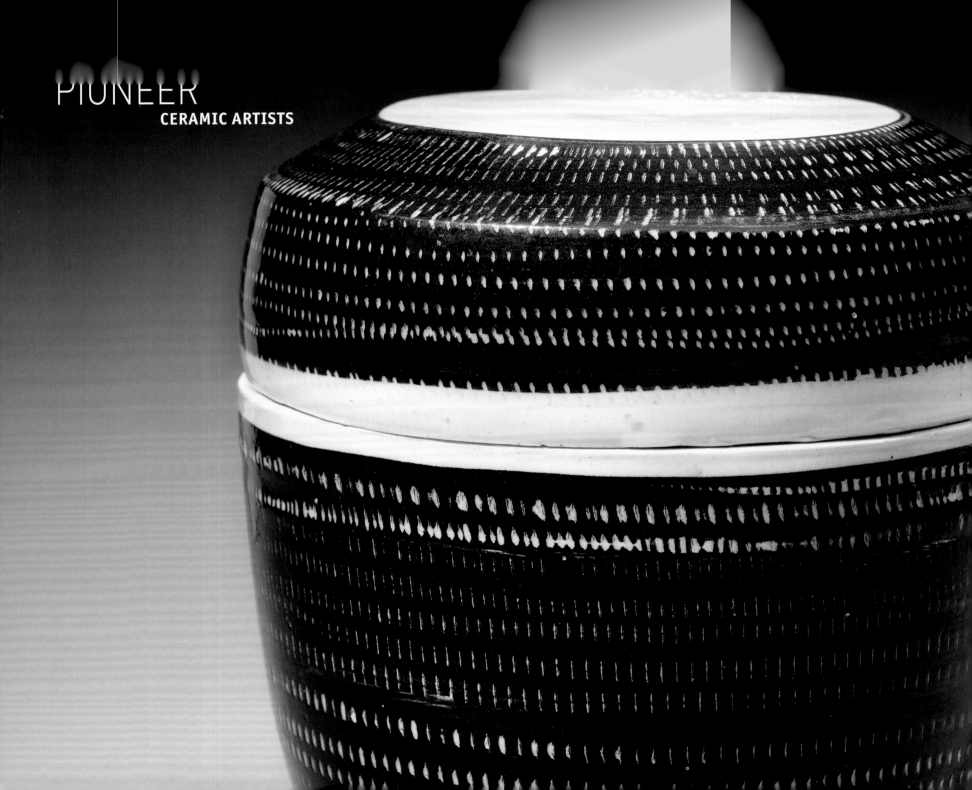

The earliest generation of contemporary ceramic artists lived through a major turning point in the history of the medium: a shift in creative control from kiln foreman or craftsman to artist, and the ensuing evolution of ceramics from commercial products to works of art. Beginning in the early twentieth century, leading ceramicists, while still influenced by traditional approaches, explored the medium as a means of self-expression and gave shape to their own aesthetic sensibilities by working directly with the materials. Tomimoto Kenkichi, a founding figure of modern ceramics, observed that the flourishing of the art form gained momentum from interest in the history of Chinese and Japanese ceramics.[1] Tomimoto's ethos, summed up in his famous statement that "one should not create a design based on another design," is exemplified in works such as his box with a decoration of wild grapes, which features a pattern of grape leaves executed in concise strokes based on his own sketches rather than on an arrangement of existing patterns (p. 29). The inscription on the paulownia-wood box that accompanies the work, by Kondō Yūzō (1902–1985), designated an Important Intangible Cultural Property Holder for his work in the underglaze cobalt technique, testifies to Kondō's close association with Tomimoto.

Ishiguro Munemaro, while strongly influenced by traditional ceramics, including those of China, made pieces with a contemporary edge. His lidded vessel's lyrical and rhythmic decorative pattern of countless small dots and the unusually shaped lid evince modern sensibilities (p. 30). Ishiguro said, "The artist pours his state of mind, personality, and thought into the limited confines of the vessel format. That's ceramics."[2] Another artist, Kawai Kanjirō, who with the philosopher Yanagi Muneyoshi (Sōetsu, 1889–1961) and the potter Hamada Shōji (1894–1978) founded the Folkcraft or Mingei movement, turned the easygoing, rustic character of folk art toward fiercely individualistic expression. Kawai's hexagonal pedestal vase conveys an idiosyncratic worldview through a simplified pattern of flowers and vegetation decorating a sturdy, sharp-edged form (p. 33). "I speak of myself through shape," Kawai has stated.[3] Meanwhile, Kitaōji Rosanjin's dishes with iris designs employ the traditional techniques of yellow Seto ware, yet they form an intentionally irregular dish set—illustrating the wit of its creator, a restaurateur turned ceramic artist who strongly influenced the world of contemporary Japanese tableware. His work draws on antique ceramics of the Momoyama era, such as Shino, Ki-seto, and Oribe, and of the Edo period, such as the overglazed enamels by Ogata Kenzan (1663–1743).

Tamura Kōichi was designated an Important Intangible Cultural Property Holder for his mastery of the iron underglaze painting (*tetsu-e*) technique; nonetheless, the appeal of his white-glazed box is not the surface decoration but the loose, relaxed quality of the potting (p. 36). His fundamental philosophy was that "the form of a piece of pottery is like the naked human body, which, while it may be unadorned, is of fundamental importance. The glaze is like a kimono, which may be splendidly decorated but will not be beautiful if the body beneath it is ungainly."[4] One of Tamura's contemporaries, the ceramics scholar Koyama Fujio, had close ties with ceramicists of his day; in his later years he became an accomplished artist in his own right, establishing his own kiln in Gifu prefecture, where he created works such as his square flower vessel (p. 37).

1. *Tomimoto Kenkichi chosakushū* [Collected Writings of Tomimoto Kenkichi] (Gogatsu Shobō Publishing, 1981), p. 29.
2. *Asahi shinbun*, February 28, 1961.
3. *Mingei* magazine, vol. 132, 1963, p. 44.
4. *Tochigi shinbun*, January 8, 1971.

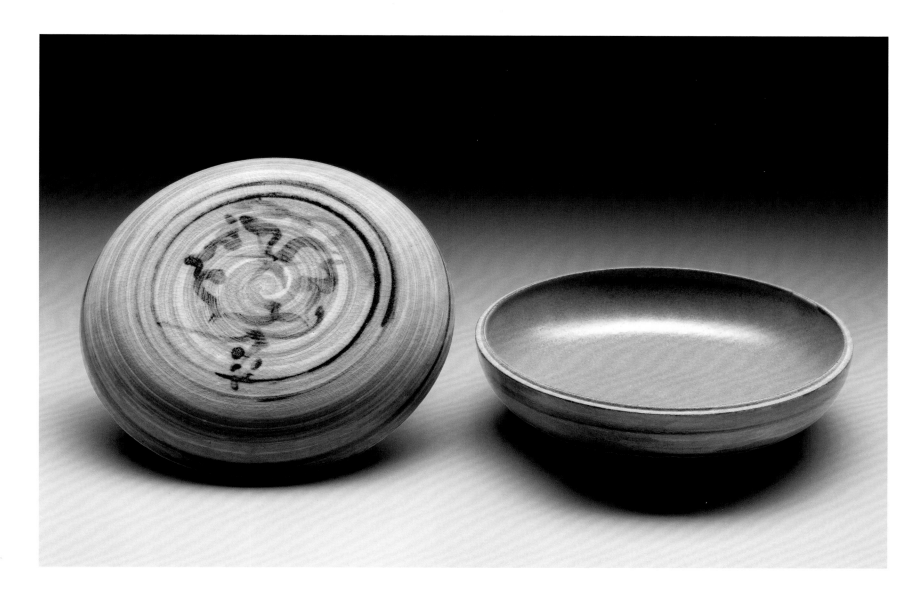

Tomimoto Kenkichi
Box with decoration of wild grapes,
1928
7.6 x 18 cm (3 x 7⅛ in.)

Ishiguro Munemaro
Lidded vessel, 1940s–1950s
16.1 x 15.2 cm
(6³⁄₈ x 6 in.)

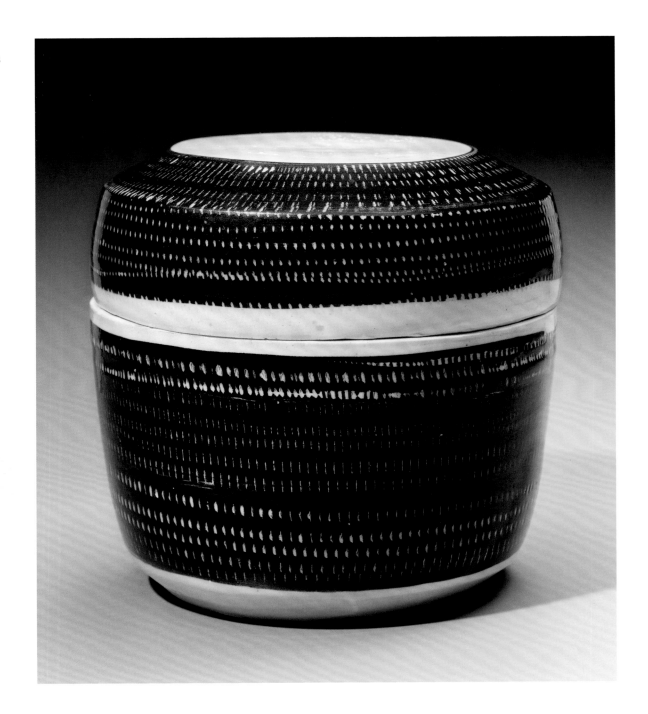

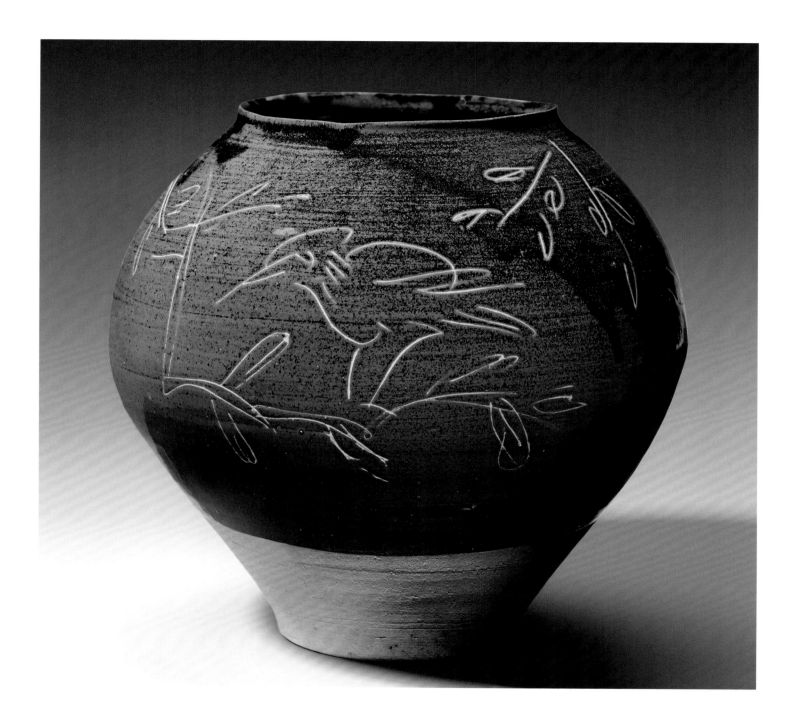

Ishiguro Munemaro
Jar with incised
decoration of birds,
1930s–1940s
27.9 x 76.2 cm
(11 x 30 in.)

Kawai Kanjirō
Vase in the shape of a flask,
1950s
20 x 15 x 14 cm
(7⅞ x 5⅞ x 5½ in.)

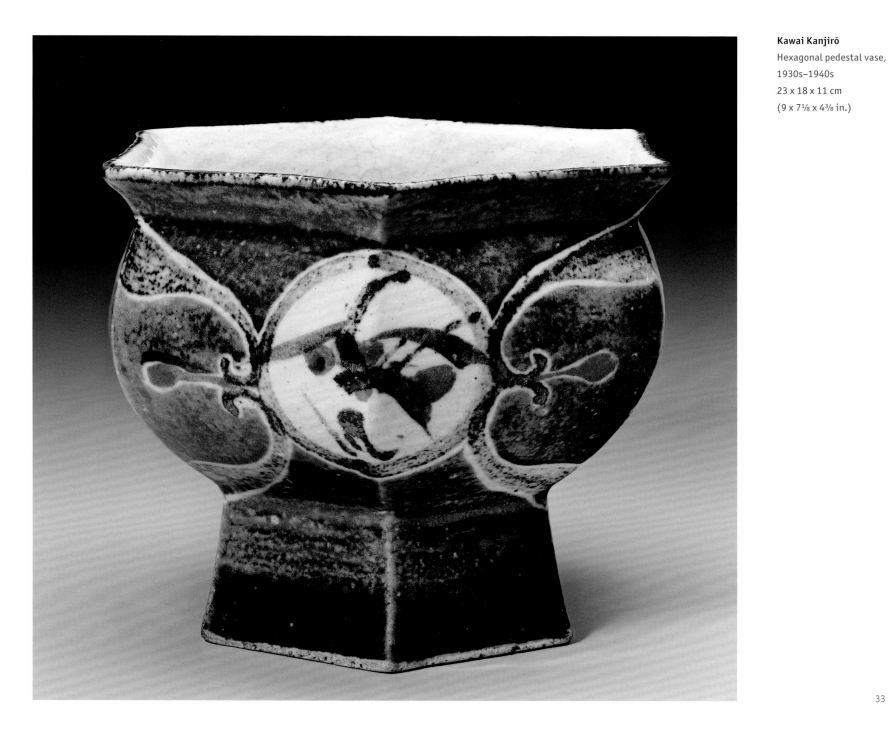

Kawai Kanjirō
Hexagonal pedestal vase,
1930s–1940s
23 x 18 x 11 cm
(9 x 7⅛ x 4⅜ in.)

Kitaōji Rosanjin
Yellow Seto-style plates
with design of iris,
about 1951
Each: 7 x 20 x 20 cm
(1¼ x 7⅞ x 7⅞ in.)

Tamura Kōichi
Box, about 1970
8.9 x 15.2 x 12.7 cm
(3½ x 6 x 5 in.)

Koyama Fujio
Square iron-slip flower
vessel, 1986
19 x 16 x 15.2 cm
(7½ x 6¼ x 6 in.)

THE FIRST
AVANT-GARDE
GENERATION

The Kyoto ceramicist Hayashi Yasuo, a founding member of the Society of Four Harvests (Shikōkai) collective and later a participant in the Crawling Through Mud Association (Sōdeisha), introduced the first nonfunctional objects in 1948 to a world that had long considered ceramics synonymous with vessels. Most ceramicists of his generation are no longer alive, but Hayashi is still actively producing work in Kyoto and serving as a precious living witness to the dawn of avant-garde ceramics in Japan. His first objects were biomorphic, evoking clouds or birds, but he later created pieces such as *Slant and Front* and *Screen*, in which a three-dimensional object and a flat surface seem to intertwine. According to Hayashi, this series, beginning in the 1980s, sprang from a period "when I felt I had lost my command of shape. I decided to revert to the basic form of a cube, taking it as a starting point in creating illusory objects of this kind."*

Yamada Hikaru and Suzuki Osamu were also members of the Crawling Through Mud Association, a group central to the development of postwar ceramics. Suzuki referred to his own designs from the 1960s onward as "mud images." Among these, *Winter Day* is noteworthy for having been fired in an *anagama*—an archaic single-chamber, wood-fired kiln—that the artist created from the soil of Shigaraki in 1988. The piece's plain form sets off a surface achievable only through that type of firing. This richly nuanced surface enhances Suzuki's emphasis on "shapes that can be created with clay but not the potter's wheel" and his declaration that "Porcelain is shapes added to shapes, but clay is simply a material to be shaped."

From the 1960s onward, Yamada Hikaru was engaged in making "thin-walled forms," and starting in the 1980s he produced screens in the *heitao* (Chinese black pottery) style, including a smoke-blackened screen (p. 43). He followed with pieces such as a silver-glazed screen that incorporates silver paint (p. 42). Yamada characterized this series as "beginning with a fascination with thinness, and then going through gradual modifications." The focus on thin-walled autonomous objects, rather than tiles or ceramic panels, is a unique characteristic of the artist's work.

Kiyomizu Rokubey VII is also well known as a sculptor, working primarily in aluminum, under the name Kiyomizu Kyūbey. The geometric abstract forms that characterize his sculpture are also seen in his pottery. In the untitled work shown here, the softness of clay can be glimpsed in features such as the cut and deformed surface (p. 45). In line with Kiyomizu's professed "attachment to Kyoto's rows of *machiya* townhouse rooftops," there is a softness and friendliness to the compositions of his pottery despite the objects' seemingly cold and inorganic surfaces.

*All quotations are from interviews with the artists conducted by the author.

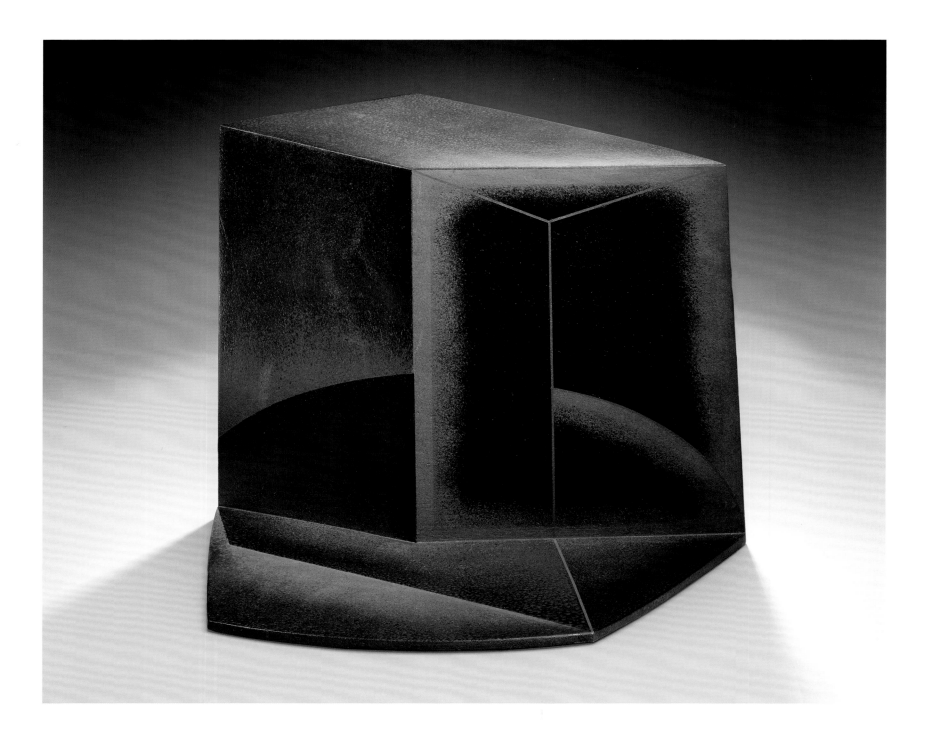

Hayashi Yasuo
Slant and Front, 1989
32 x 36.8 x 35.6 cm
(12⅝ x 14½ x 14 in.)

Hayashi Yasuo
Screen, 1995
35.6 x 30.5 x 12.7 cm
(14 x 12 x 5 in.)

Yamada Hikaru
Silver-glazed screen,
about 1993
39.7 x 61 x 8.9 cm
(15⅝ x 24 x 3½ in.)

Yamada Hikaru
Smoke-blackened screen,
1983
47.9 x 41.3 x 7 cm
(18⅞ x 16¼ x 2¾ in.)

**Kiyomizu Rokubey VII
(Kiyomizu Kyūbey)**
Untitled, 1998
30.5 x 30.5 x 10.2 cm
(12 x 12 x 4 in.)

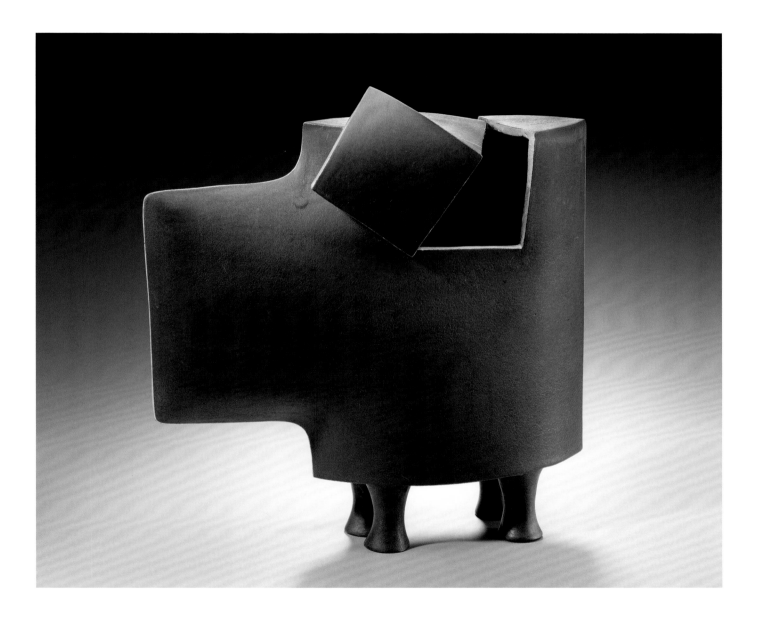

BETWEEN TRADITION
AND AVANT-GARDE

Active from the 1970s onward, when nonfunctional ceramics became commonplace, the Kyoto ceramicist Morino Hiroaki Taimei (as he is known in America) is among the more prominent of the second wave of avant-garde ceramic artists. Morino fashions highly original forms, whether vessels or nonfunctional objects, that also betray the influence of time-honored traditions. The works are often glazed in his preferred cool blues and greens, with glazes he compounds himself. In his words, "Young people today are free to create any kind of pottery they wish, and in many cases there's no telling the top of the piece from the bottom. In the pottery of my generation, however, there's usually a clearly defined top, bottom, front, and back, and the work is fired all in one piece. We place it in the kiln facing the correct way when we fire it." Morino has consistently adhered to this credo in all his work, from his early cubes and freestanding screens to pieces like *Floating Cloud* and *Crest of a Wave*.

Morino's fellow artists in this second wave also engage in freewheeling explorations of design, although by and large their work cleaves to various ceramic traditions. Morino's credo could serve as the creative foundation for a stylistically diverse range of works by other artists. These include the vividly gradated object *The Indication of Ascension* by the Kyoto ceramicist Miyashita Zenji; the plate with Oribe-style decoration and the Shigaraki-style flower containers by Suzuki Gorō, who lives near Seto and works in styles such as Oribe and *yakishime* (unglazed stoneware) while turning the "free, flexible movement of clay" toward the creation of bold forms (pp. 52 and 53); works such as the vases by Ōtani Shirō that exploit the firing properties of the Shigaraki kiln (pp. 54 and 55); the unglazed stoneware vase in the Bizen tradition by Harada Shūroku (p. 56); and a box with a decoration of sparrows on a branch, rendered in colorful representative painting in the Kutani style, by Takegoshi Jun (p. 57). Takegoshi always starts with the eyes when painting birds, making his depictions full of life. The principles of shaping a piece starting at the bottom and placing it upright in the kiln to be fired as one piece also apply to other works: the primordially powerful *Archaic Vessel*, by Koinuma Michio; the vases by Nishihata Tadashi, which harness the unadorned charm of clay and the mudlike slip and engobe materials (pp. 60 and 61); and the vase by the Tokoname potter Hirano Yūichi (p. 59).

Morino has also declared that "Pottery may be exhibited in a museum or gallery at first, but in the end it is something that belongs in the home, part and parcel of daily life." The works of these artists evoke the *tokonoma* alcove in a traditional Japanese house, where

such objects are displayed. Morino adds an agricultural comparison for types of ceramic artists. Those that lay their hands on clay for the first time at universities and learn ceramics only in a carefully orchestrated educational environment—the case for many in the generation born after World War II—he calls "hothouse-grown artists," while the prewar generation that grew up in pottery-producing regions, observing artisans at work, are "field-grown artists." He himself is halfway between the two: he was born into a ceramicist's household yet educated at art school, where he studied under teachers who had learned the trade hands-on in ceramics-producing areas.

Other artists in this second wave are likewise borderline figures. They have a modern sense of their role as artists and create work to be publicly exhibited, and at the same time draw on practical technical know-how and understanding of cherished traditions gleaned in pottery-producing regions such as Kyoto, Seto, Shigaraki, Bizen, Kutani, Mashiko, Tanba, and Tokoname.

Miyashita Zenji

The Indication of Ascension,
2003
56.5 x 28.6 x 14.6 cm
(22¼ x 11¼ x 5¾ in.)

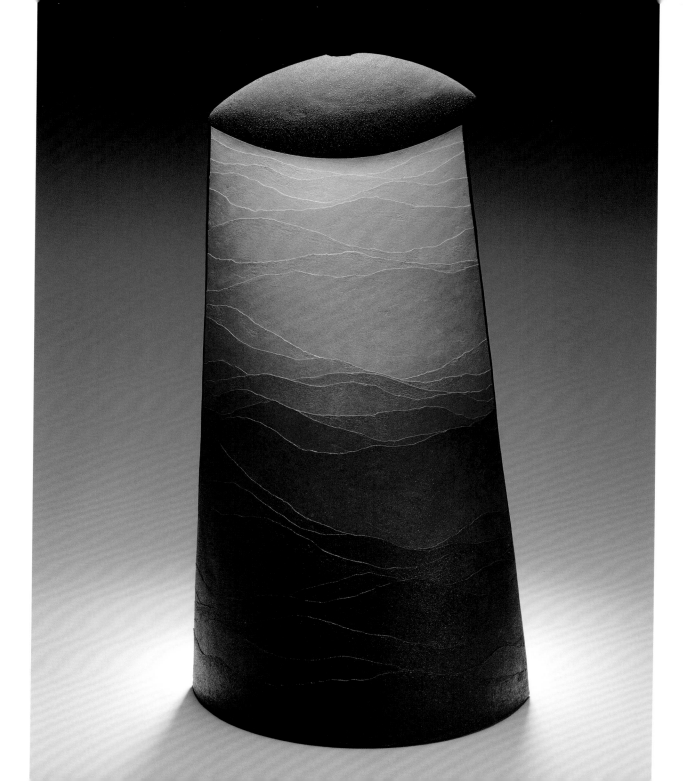

Morino Hiroaki Taimei
Floating Cloud, 2005
43.2 x 29.2 x 15.9 cm
(17 x 11½ x 6¼ in.)

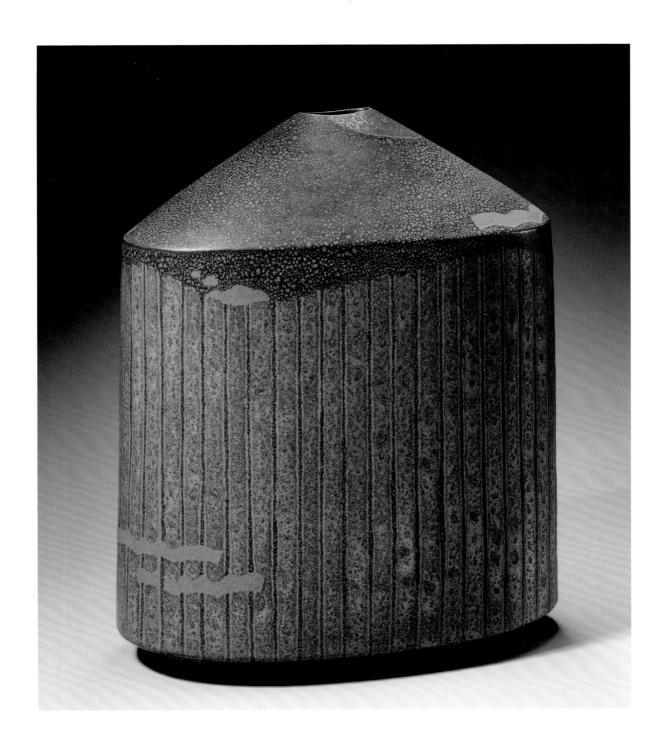

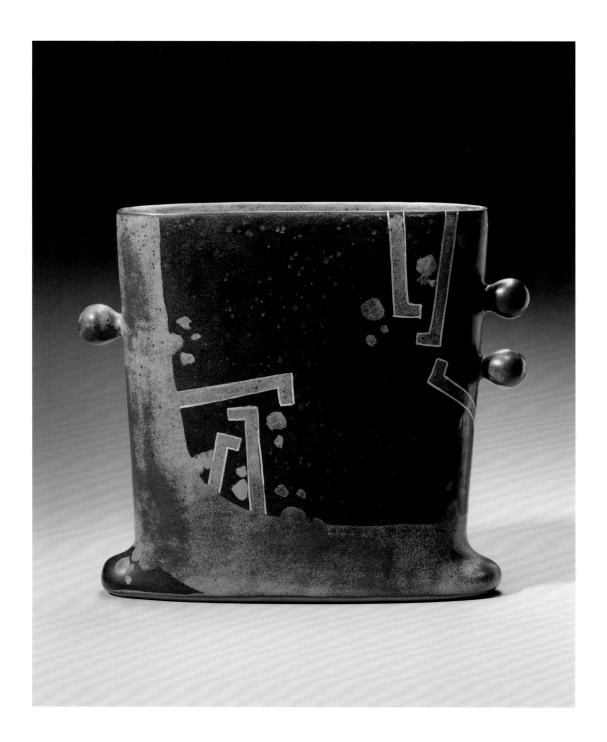

Morino Hiroaki Taimei
Crest of a Wave, 2003
19.1 x 16.5 x 5.7 cm
(7½ x 6½ x 2¼ in.)

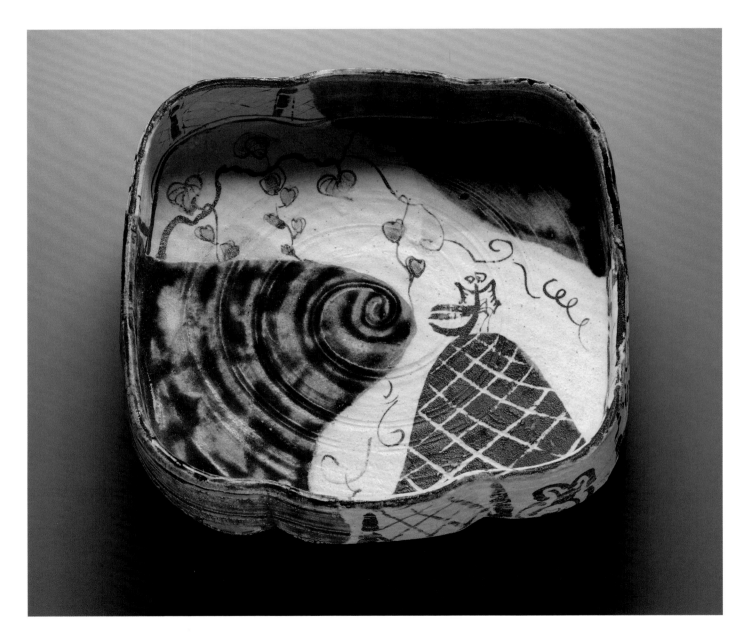

Suzuki Gorō
Plate with Oribe-style
decoration, 1980s
5.5 x 32 x 33 cm
(2⅛ x 12⅝ x 13 in.)

Suzuki Gorō
Shigaraki-style flower
container, 1980s
26 x 19.1 x 24.1 cm
(10¼ x 10¾ x 9½ in.)

Suzuki Gorō
Shigaraki-style flower
container, 1980s
27 x 17.8 x 14 cm
(10⅝ x 7 x 5½ in.)

Ōtani Shirō
Vase, before 2006
31.8 x 19.1 x 13.3 cm
(12½ x 7½ x 5¼ in.)

Ōtani Shirō
Vase, before 2006
31.8 x 16.5 x 13.3 cm
(12½ x 6½ x 5¼ in.)

Ōtani Shirō
Vase, before 2006
40.6 x 35.6 x 25.4 cm
(16 x 14 x 10 in.)

Harada Shūroku
Vase, 2006
25.4 x 12.7 x 14 cm
(10 x 5 x 5½ in.)

**Takegoshi Jun
(Takegoshi Taizan IV)**
Box with decoration of
sparrows perched on a
branch, 2010
6.4 x 20.6 x 9.8 cm
(2½ x 8⅛ x 3⅞ in.)

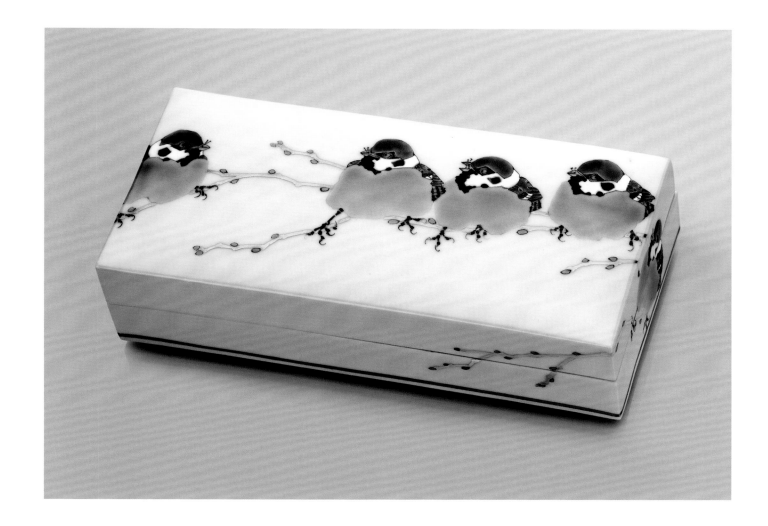

Koinuma Michio
Archaic Vessel, 2011
34.6 x 15.2 x 12.7 cm
(13⅝ x 6 x 5 in.)

Hirano Yūichi
Vase, 2006
43.2 x 38.1 x 31.8 cm
(17 x 15 x 12½ in.)

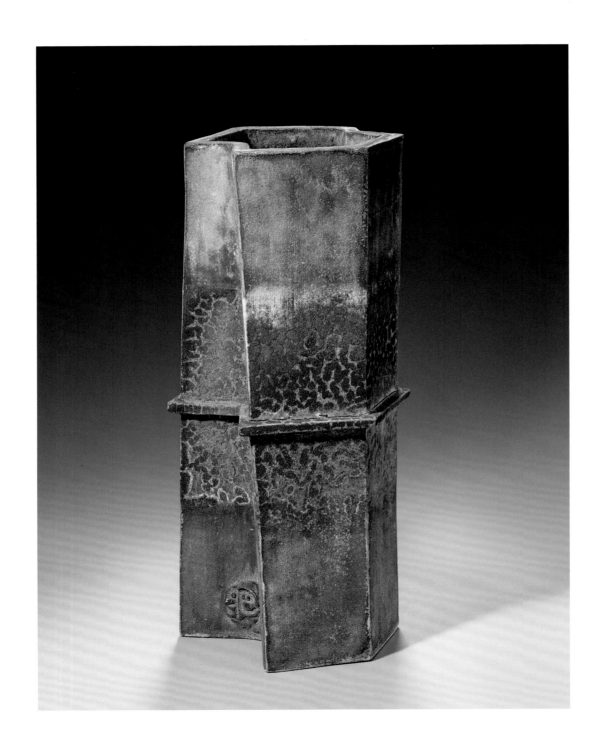

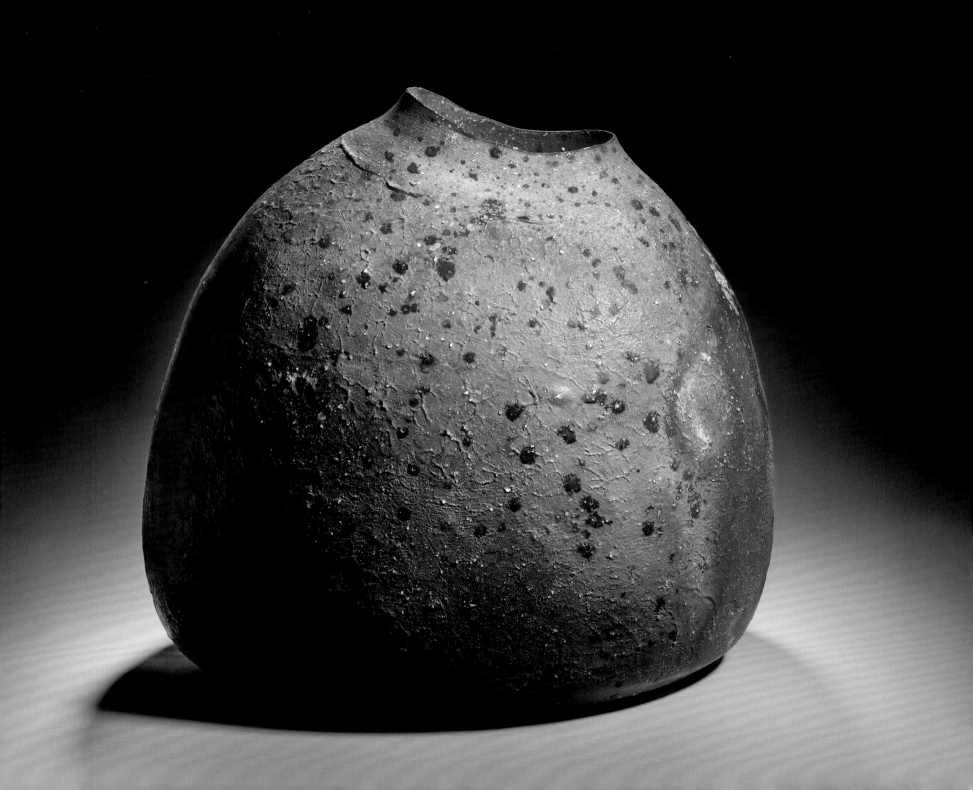

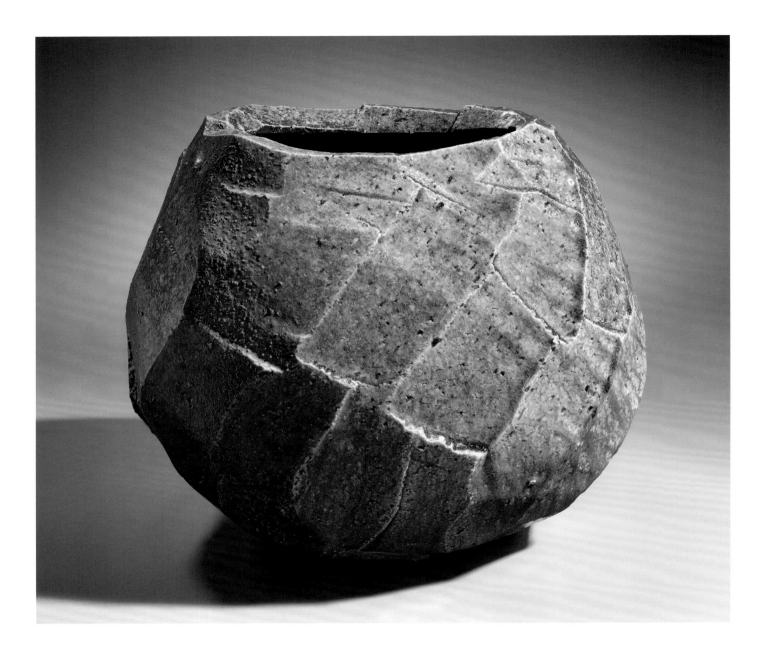

Nishihata Tadashi
Vase, 2002
28.3 x 32.7 x 29.8 cm
(11⅛ x 12⅞ x 11¾ in.)

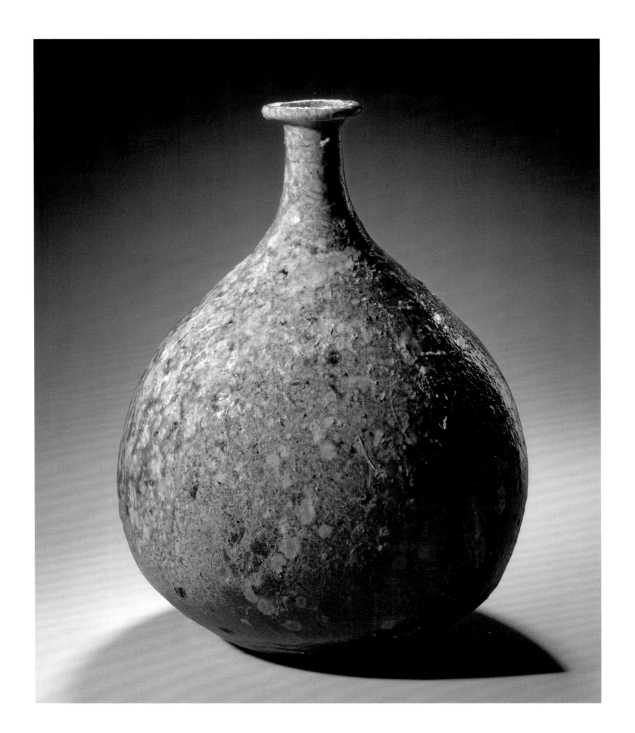

Nishihata Tadashi
Red slip-glazed vase,
2005
32.4 x 24.1 cm
(12¾ x 9½ in.)

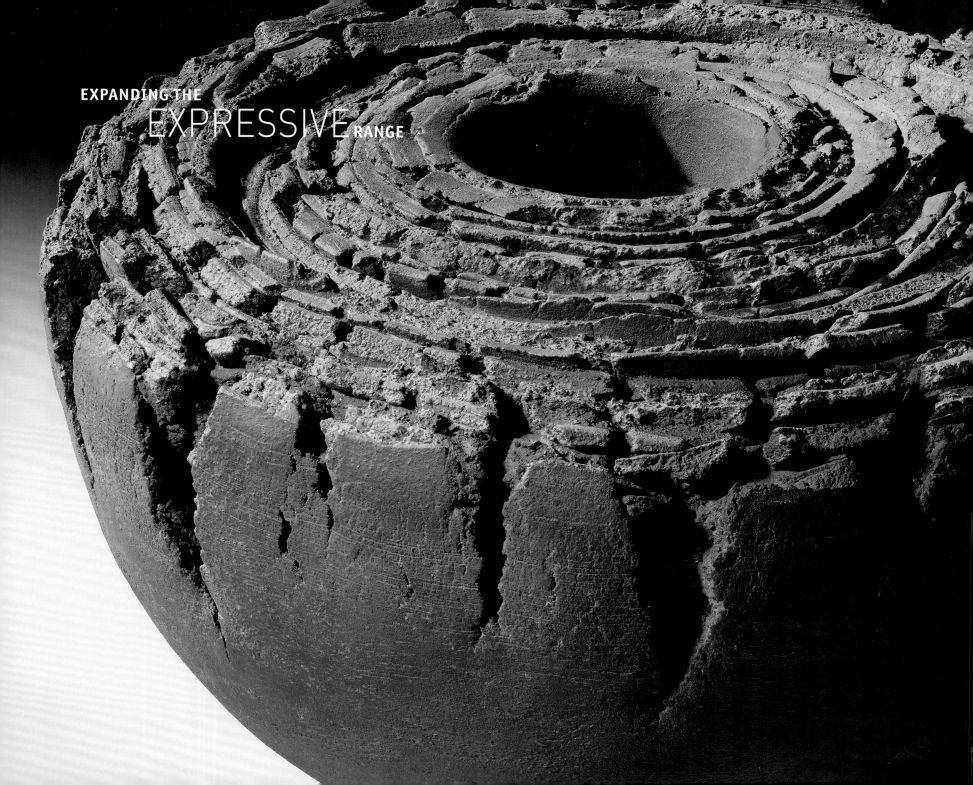

EXPANDING THE
EXPRESSIVE RANGE

Well into the second half of the twentieth century, a compact *"tokonoma* (alcove)-sized" sense of scale prevailed in Japanese ceramics, showing the enduring influence of the tea ceremony aesthetic. Beginning in the late 1970s, however, artists began to make ceramic artworks whose sense of scale and space approached the realm of contemporary sculpture, encompassing nearly human-sized pieces and installation art. Chief among these artists are Fukami Sueharu and Akiyama Yō, who have brought Japanese ceramic artists to global attention. Fukami's *The Moment (Shun)* is a keenly edged abstract form, slicing through space like a knife. The artist has spoken of his desire "to push the limits of what can be fired as a single piece." Akiyama often produces massive pieces assembled from multiple parts. His *Untitled MV-1019* from the *Metavoid* series, which intentionally employs cracks in the clay, is not extremely large, but like his monumental pieces it has a density that seems to convey the compressed vibrations of the earth itself. According to the artist, "There are pressurized spaces that exist even in the gaps between folds created by the potter's wheel."

Even when these artists' works grow enormous in scale and become more like installations than objects, something fundamentally sets them apart from sculpture. As a rule, people are meant to stand back from sculpture and admire it from a fair distance. By contrast ceramic works, even if their scale is huge, are enjoyed for their details and surfaces as well as their overall form and appreciated from any distance, near or far. As a three-dimensional artwork, a ceramic's shape and outline are essential to its appeal, but it is also to be enjoyed for its material properties. As Akiyama's statement that "the clay reigns supreme" conveys, the chief delight of ceramics lies in their hands-on nature, inseparable from the material with which the artist grapples at close range. Artistic expression through ceramics is inextricably tied to the material and the processes of forming and firing.

The artists who participated in this development focus on images and avoid using the word vessel or its equivalent in the titles of their works. For instance, Kohyama Yasuhisa gives concrete form to natural phenomena in pieces with titles such as *Wind Form #1*.

One of Japan's main ceramic centers since medieval times, Bizen in modern-day Okayama prefecture is known for its wares made of iron-rich clay shaped on wheels and fired in *anagama* (tunnel) kilns. Among Bizen ceramics, Momoyama tea wares are perhaps the best known. When Kakurezaki Ryūichi moved from Nagasaki to Bizen, he brought a revolutionary approach to forming pottery. His vase here, while among the more functional pieces in his

highly diverse oeuvre, has a wholly original shape despite being made with the time-honored Bizen materials and techniques (p. 75). Achieved through the artist's "nearly acrobatic setting of pottery in the kiln," this form resulted from the opposite of the traditional practice of *kama-makase*, or "leaving it up to the kiln."

The work of this generation of artists has brought new transformations to the relationship between vessel and design. Wada Morihiro, who declared that "the design shapes the form of the piece," said of his own vessel with abstract motifs in red that it was "intended to give concrete shape to the contrast between red and black" (p. 73). This represents a departure from the conventional process in which a vessel is first shaped, and then decorated with a pattern. Here the autonomous development of the decoration helps to determine the shape of the vessel, in a new paradigm that links shape and pattern inseparably and synergistically.

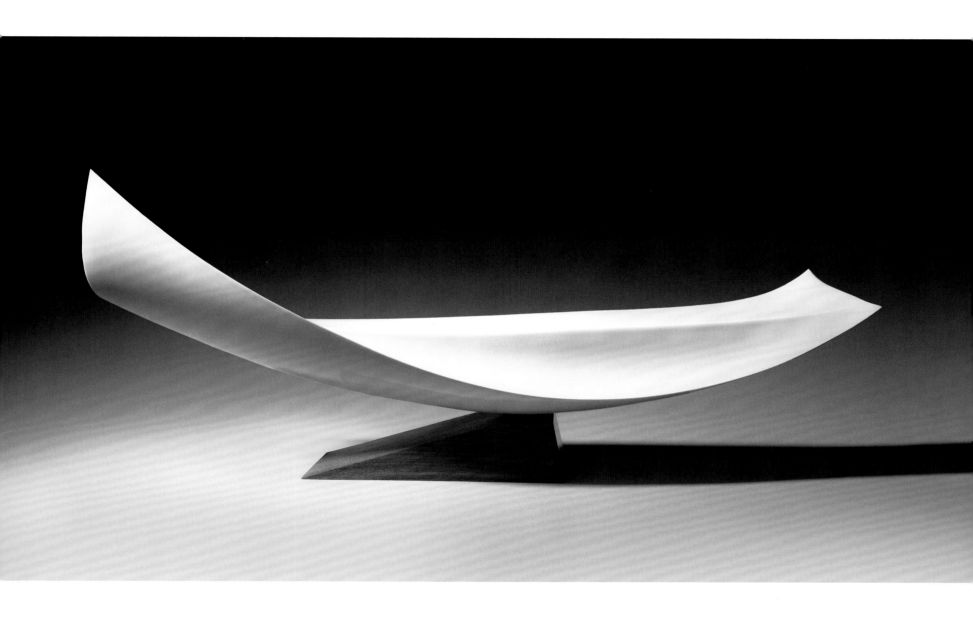

Fukami Sueharu

The Moment (Shun),
1998
42.5 x 101 x 20 cm
(16¾ x 39¾ x 7⅞ in.)

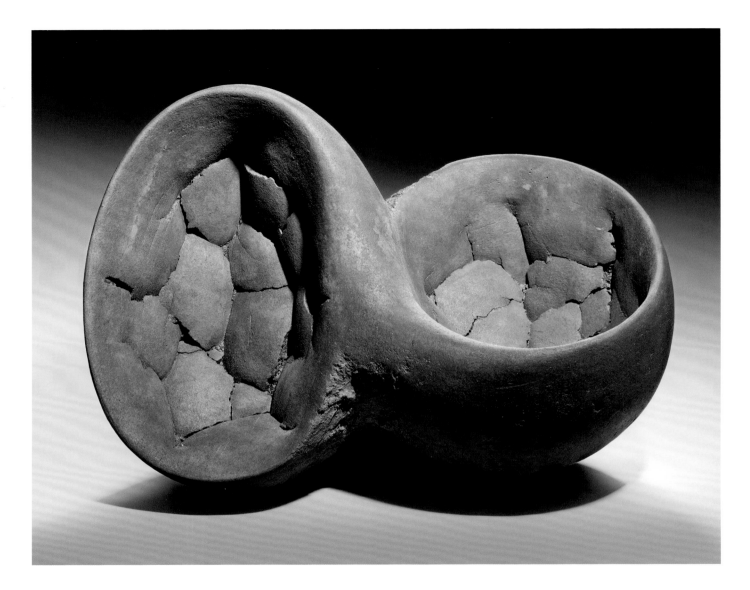

Akiyama Yō
Untitled T-610, 2006
33 x 46 x 31 cm
(13 x 18⅛ x 12¼ in.)

Akiyama Yō
Untitled MV-1019 from the
Metavoid series, 2010
20.3 x 32.1 cm
(8 x 12⅝ in.)

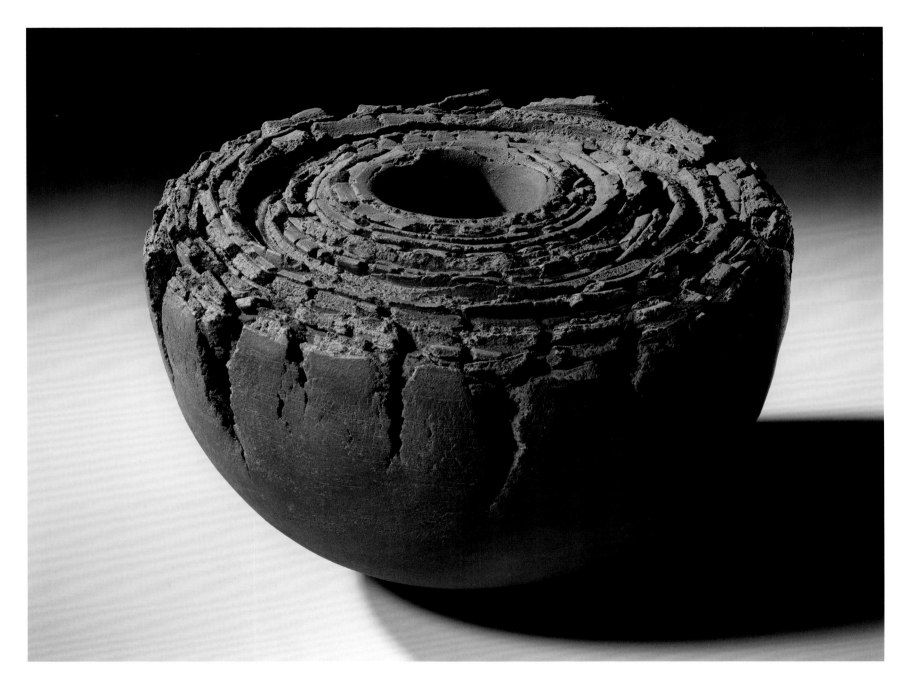

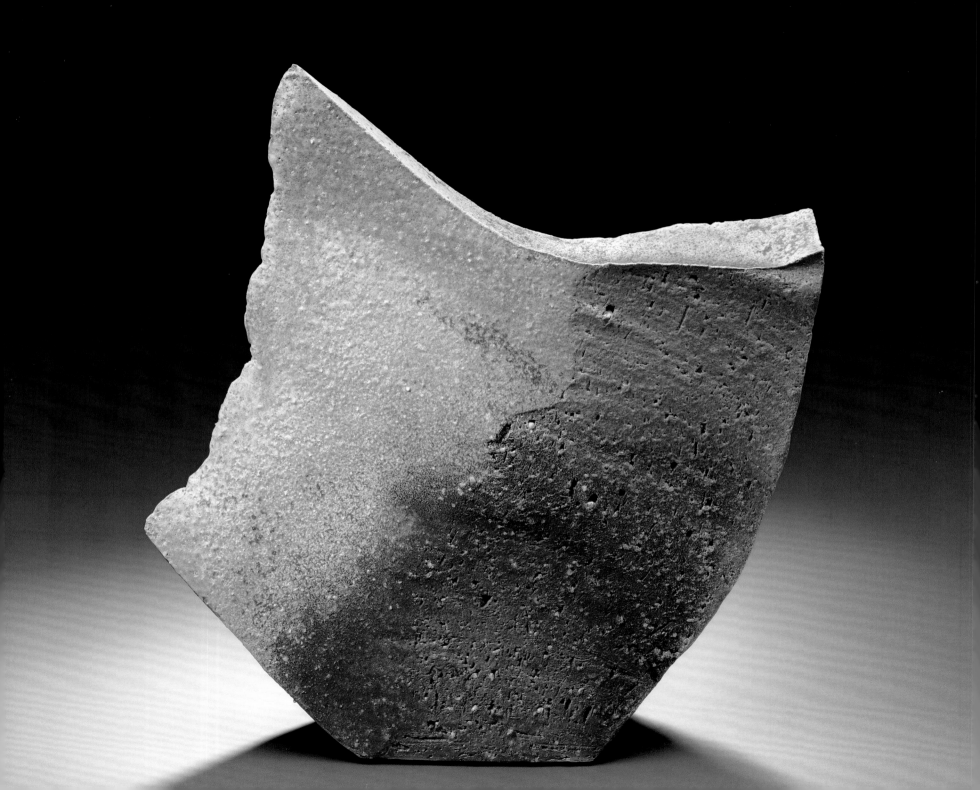

Kohyama Yasuhisa

Wind Form #1, 2009

43.8 x 43.2 x 14 cm

(17¼ x 17 x 5½ in.)

Kohyama Yasuhisa

Sculptural Form #2, 2007

35 x 46.6 x 12.4 cm

(13¾ x 18⅜ x 4⅞ in.)

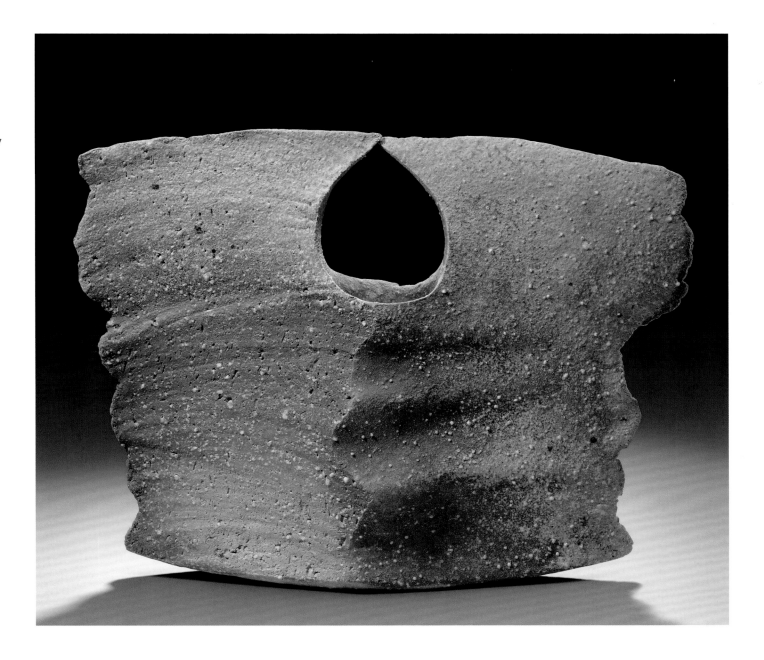

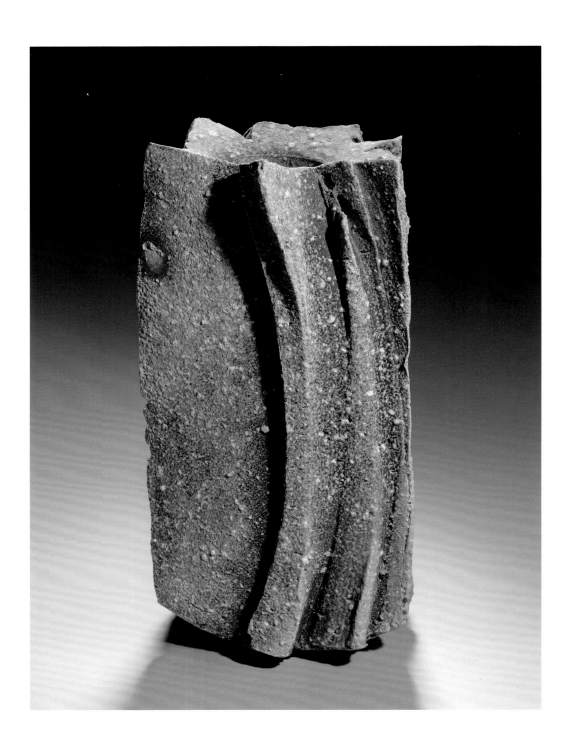

Kohyama Yasuhisa
Carved with Moon, 2010
31.8 x 16.5 x 14 cm
(12½ x 6½ x 5½ in.)

Kohyama Yasuhisa
Slice of Earth, 2010
15.2 x 84.8 x 24.9 cm
(6 x 33⅜ x 9⅞ in.)

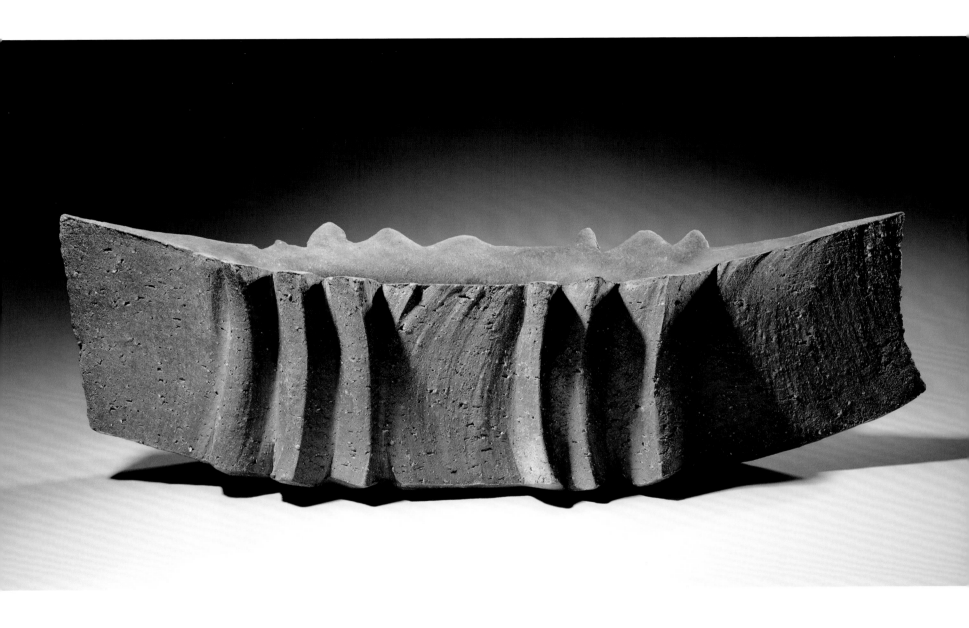

Wada Morihiro
Vase, 1993
34.9 x 14 x 15.2 cm
(13¾ x 5½ x 6 in.)

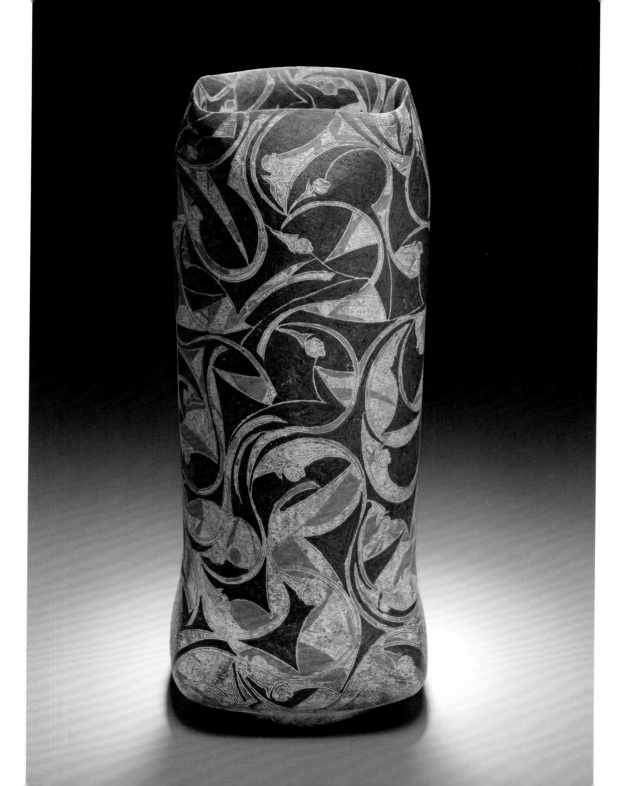

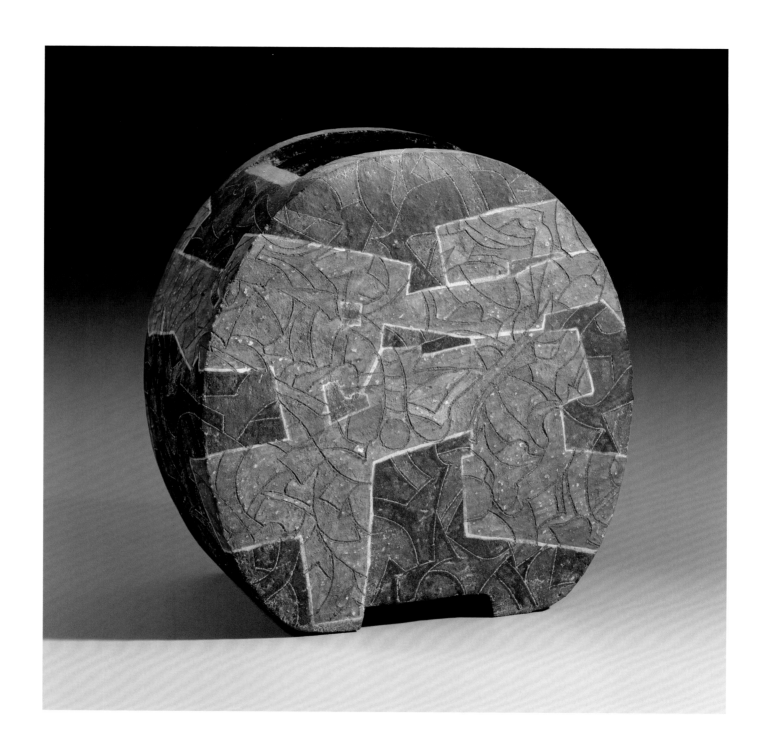

Wada Morihiro
Vessel with decoration of
curvilinear patterns, 2006
57.2 x 35.6 x 21 cm
(22½ x 14 x 8¼ in.)

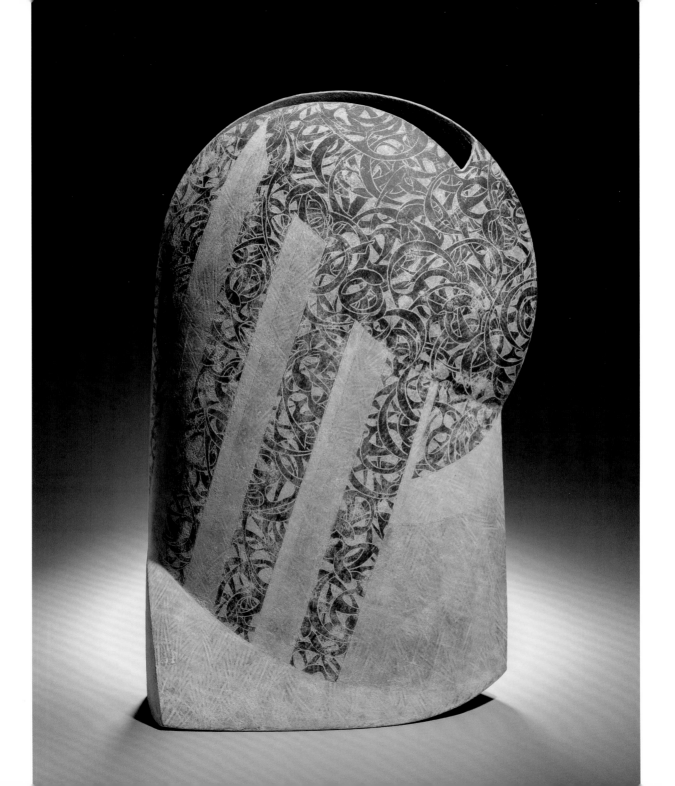

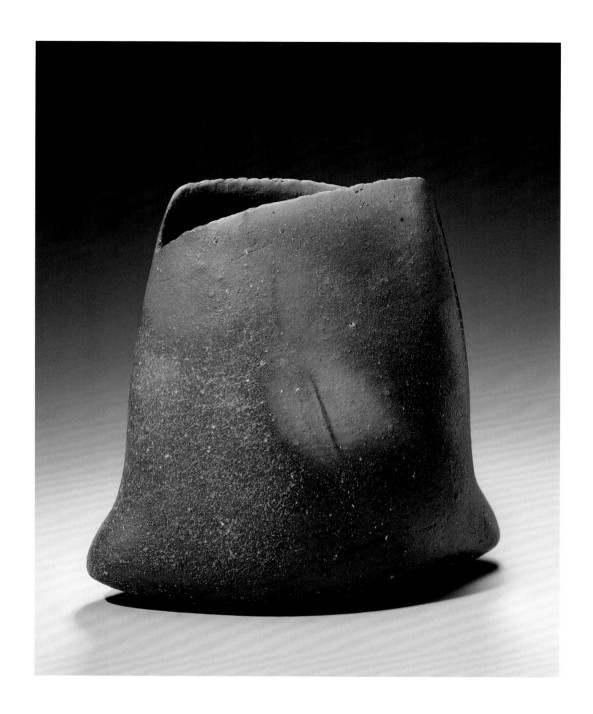

Kakurezaki Ryūichi
Vase, 2006
27.9 x 27.6 x 15.9 cm
(11 x 10⅞ x 6¼ in.)

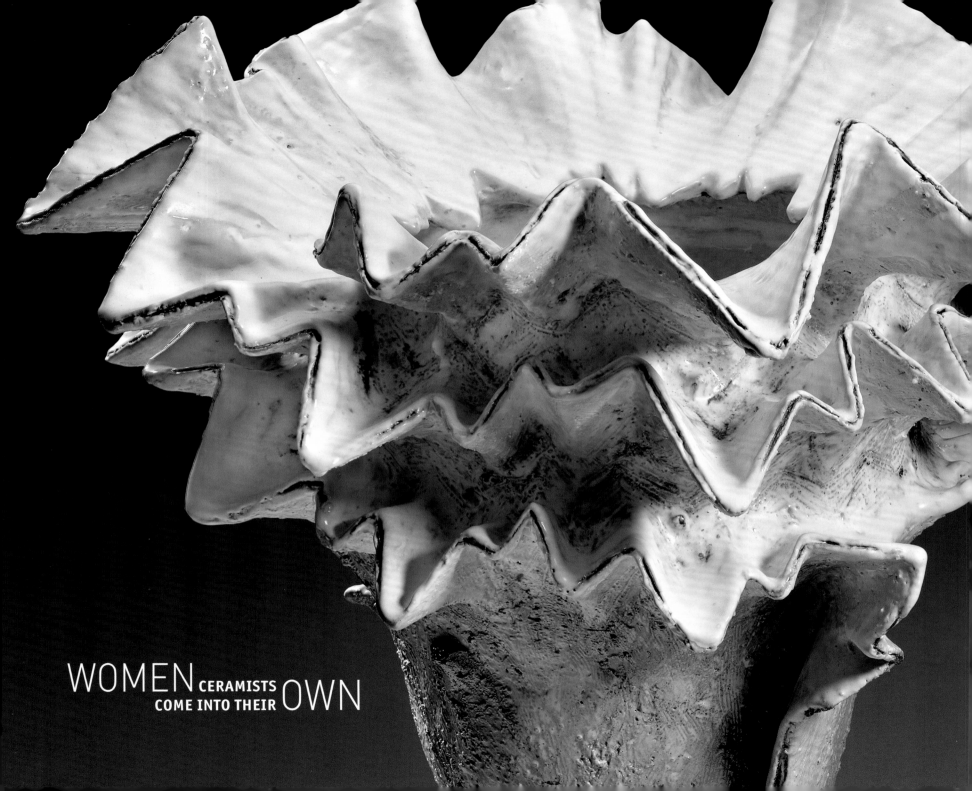

WOMEN CERAMISTS
COME INTO THEIR OWN

Women ceramic artists gained entrance to the art world in Japan after the war by two main routes: exhibitions and art schools. Before the war, few women had submitted work to the Nikakai and other group shows, but 1957 saw the formation of the exclusively female ceramics collective Women's Association of Ceramic Art (Joryū tōgei). Through it, ambitious female artists such as Fujino Sachiko and Kishi Eiko exhibited work, won prizes, and made names for themselves. Newspaper companies also sponsored an increasing number of public-invitation shows. These provided impetus to ceramicists like Hoshino Kayoko, who got her start in such shows as the Asahi Modern Craft Exhibition.

Art schools began accepting women students in 1945. This development contributed to the exponential growth in the number of women ceramic artists. Koike Shōko, Kitamura Junko, Tokumaru Kyōko, and Sakurai Yasuko are among the women who first worked with clay on the relatively neutral turf of the university campus.

From the very early stages, the work of female ceramicists shared notable formal traits not derived from the potter's wheel. The character of their diverse vessel forms, unconcerned with maintaining symmetry, could be broadly defined as biomorphic.

Koike Shōko began throwing her *Shell 95* on a wheel and then made bold alterations to its shape, molding it into a paean to the sea. According to the artist, the work takes water and seashells as its point of departure. The inner surface of the form, which appears to be brimming with water, is a deep and vivid blue that can be achieved only through reduction firing. The pioneer Fujino Sachiko stated that she wanted "to accept and work with the plasticity and vulnerability of clay, and be able to harness the persuasive power inherent within the material." With a keen sensitivity to weight and volume, her *White Hour* elicits the sensation that something is about to be generated from nothing.

Hoshino Kayoko described slicing the surface of her untitled work with a wire: "The movement of the hands holding the wire has serendipity with the softness and heft of the clay that produces unpredictable forms" (p. 82). Many Japanese ceramicists approach the fabrication of work as a collaboration with the clay itself, a process that gives rise to the warped and slightly distorted rather than mathematical polyhedrons that Hoshino creates. Kishi Eiko's *No. 4* features clay with eight or nine varieties of previously fired and ground colored clay kneaded into it, shaped through slab-building and twisting techniques. According to the artist, the resulting surface conveys "the thrill of seeing the carapace of an insect or a

fragment of stone through a magnifying glass"; the work is a finely textured exploration of the "sharp-edged shapes of the self." Kishi's works, while geometric, are delicately expressive, and "they are never left to others to carry out."

Kitamura Junko employs the traditional Mishima inlaying technique in her *Vessel*. She describes it as "making sharp indentations one by one in the smooth surface of the clay with a bamboo rod, an action one wants to perform for the same reason one wants to tread on the surface of virgin snow and leave footprints in it." The allover pattern is formed by the marks, inlaid with white slip on a deep gray background. Tokumaru Kyōko's *Germination*, assembled from porcelain parts, is intended to be "an object with artificial texture, yet conveying the organic energy and softness of a living organism." It projects "shimmering movement, as if the air around the piece had turned to water." The themes of Sakurai Yasuko's *Vertical Flower* are light and shadow. According to the artist, "the large number of holes in the piece is meant to create an atmosphere that changes with shifting light and shadow. The shadows are also part of the work. I enjoy creating work with forms that make the viewer aware of light."

Koike Shōko

Shell 95, 1995

57.2 x 52.1 x 54.6 cm

(22½ x 20½ x 21½ in.)

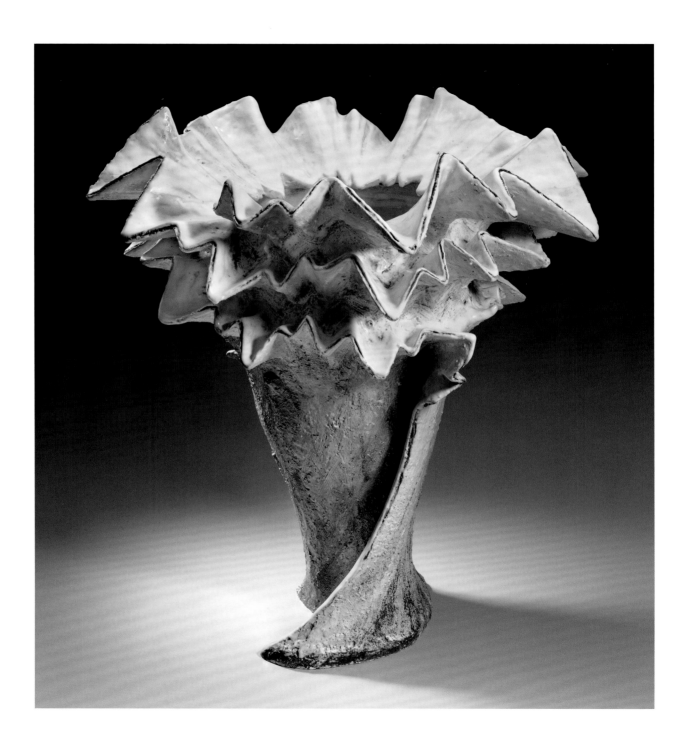

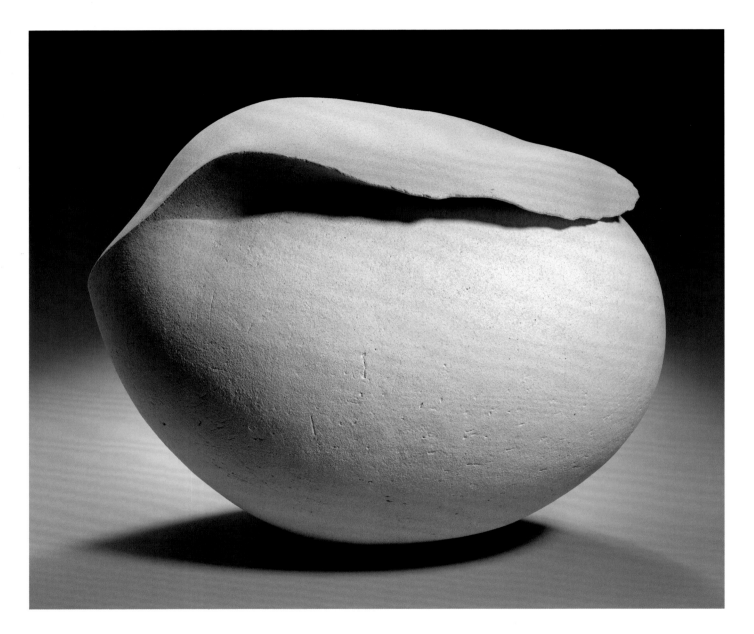

Fujino Sachiko
White Hour, 2006
30.5 x 35.6 x 15.2 cm
(12 x 14 x 6 in.)

Fujino Sachiko
Bud Casing II, 2011
39.1 x 60.3 x 39.1 cm
(15³⁄₈ x 23³⁄₄ x 15³⁄₈ x in.)

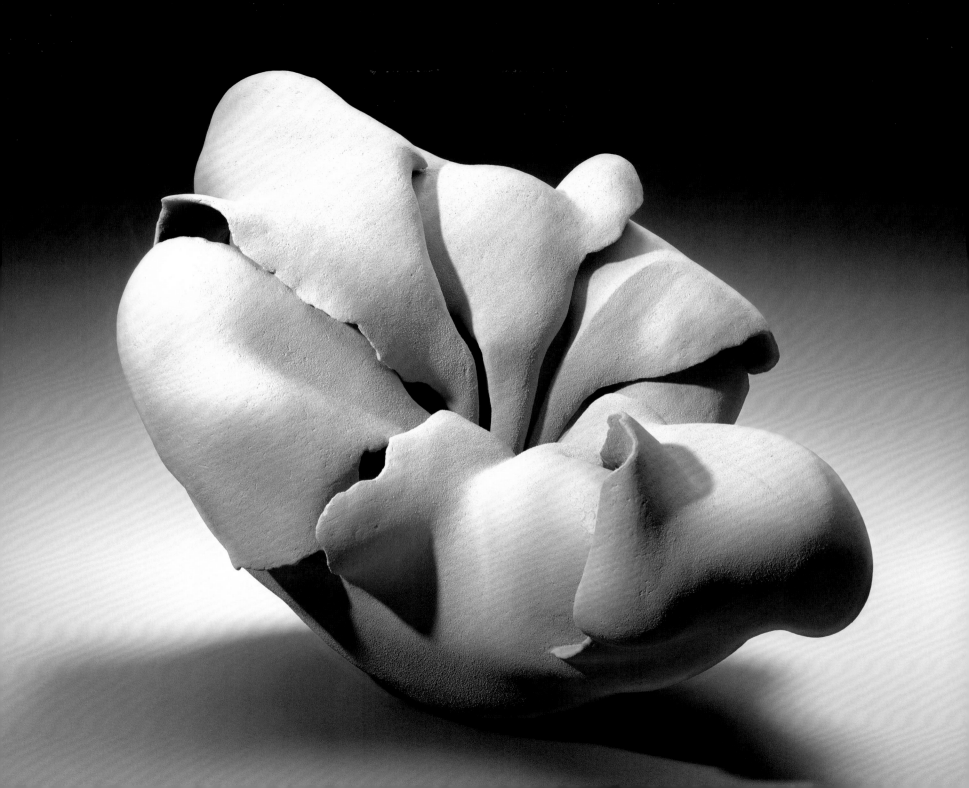

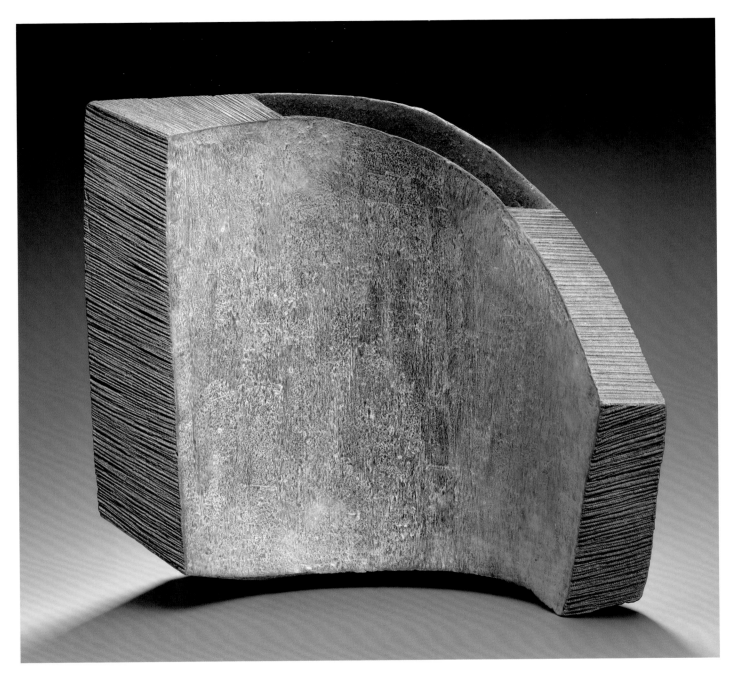

Hoshino Kayoko
Untitled, 2006
38.1 x 41.3 x 25.4 cm
(15 x 16¼ x 10 in.)

Kishi Eiko
No. 4, 2004
47.6 x 66.7 x 8.5 cm
(18¾ x 26¼ x 3⅜ in.)

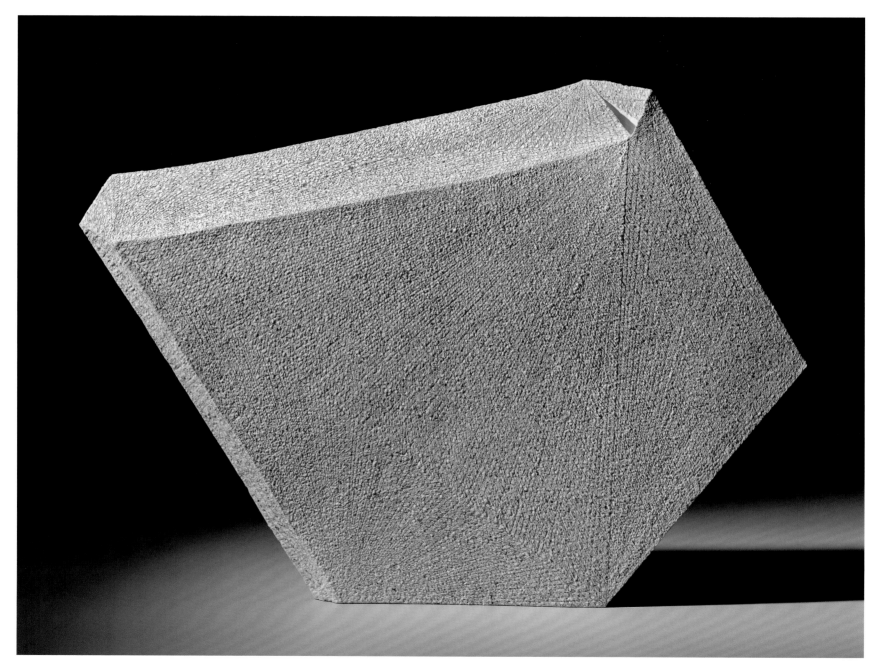

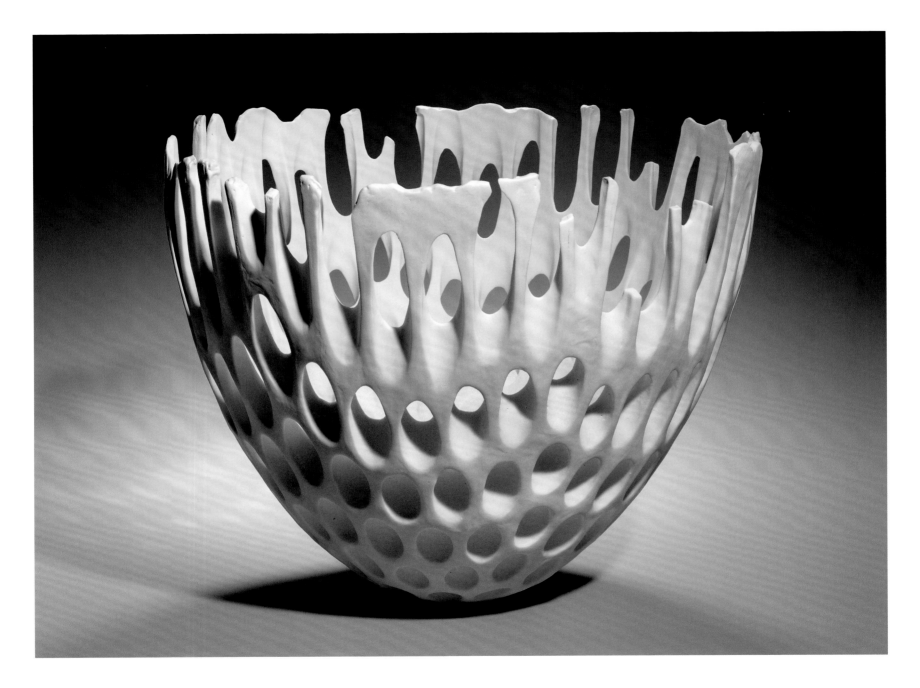

Sakurai Yasuko

Vertical Flower, 2007

45.1 x 38.1 cm

(17¾ x 15 in.)

Kitamura Junko

Vessel, 2005

61 x 17.8 cm

(24 x 7 in.)

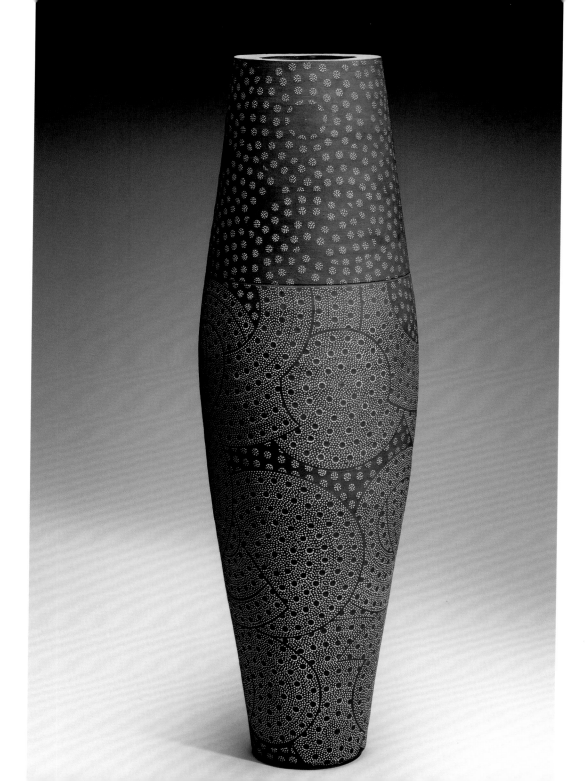

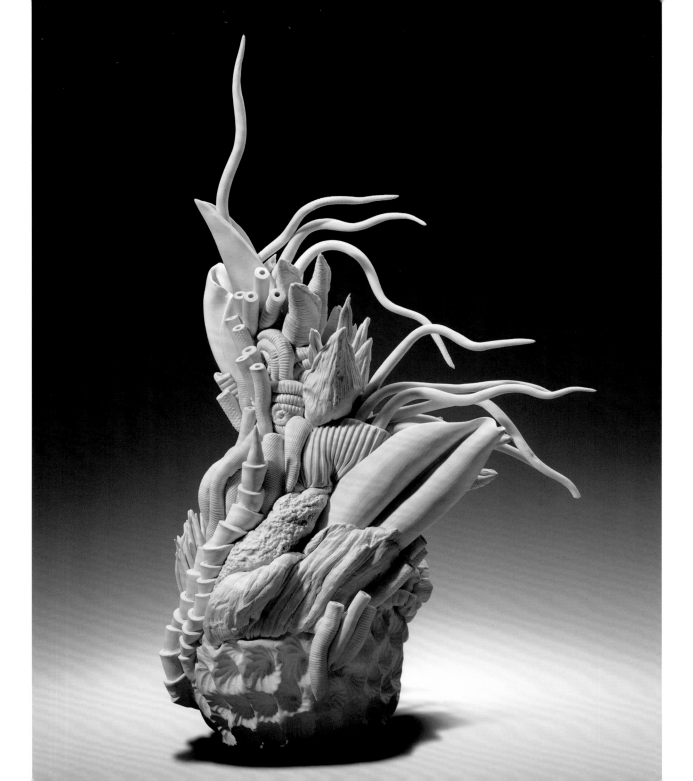

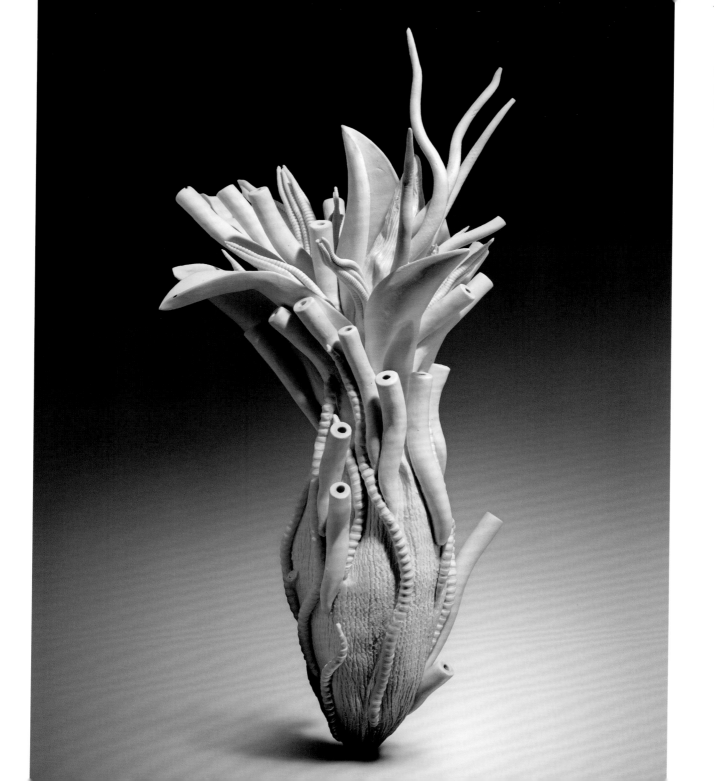

Tokumaru Kyōko
Bud, 2001
38.1 x 19.5 x 19.5 cm
(15 x 7⅝ x 7⅝ in.)

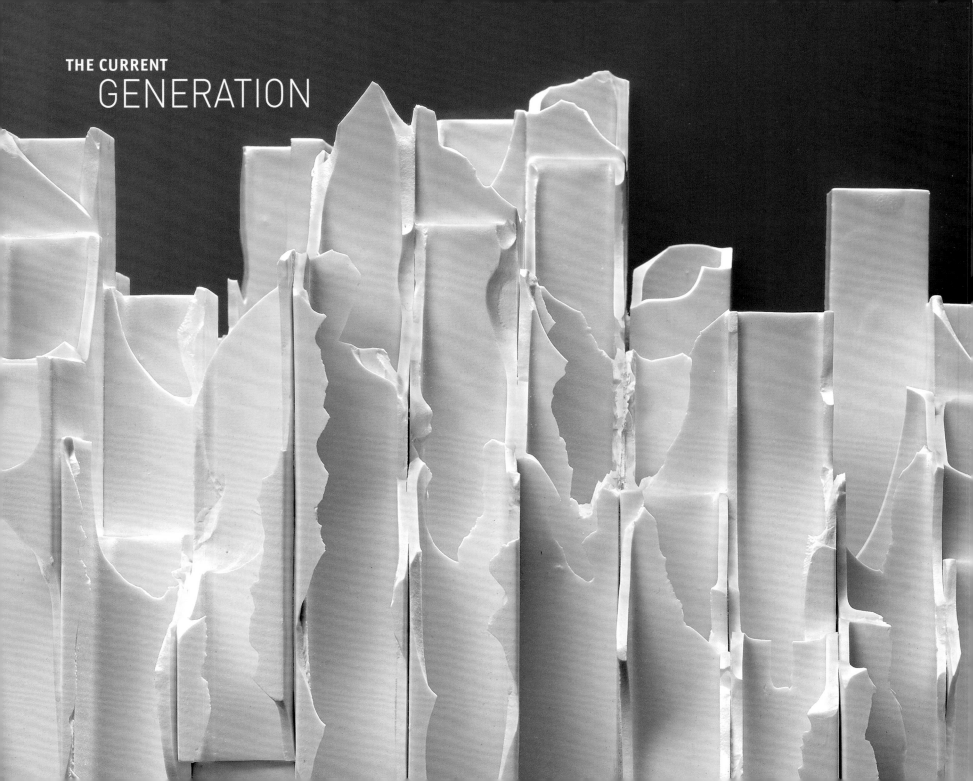

THE CURRENT
GENERATION

Ceramic artists from the generation born after World War II have adopted their own approaches to the free-form appropriation of traditions, and from time to time shattered conventions provocatively as they continue to break new ground in the ceramics world. Among them are artists who intentionally exploit deformations that would be considered defects when fabricating commercial products. Nagae Shigekazu's *Wind* employs as a design element the slumping that occurs during porcelain firing. The artist describes his style as "stemming from discoveries and adjustments made during the course of producing work day to day." Even when his pieces take the form of vessels, they are meant to express an artist's imagination.

Takiguchi Kazuo pointedly calls his sac-shaped abstract forms *Untitled*, to avoid limiting the viewer's imagination. He creates the works by pounding blocks of clay into dense slabs, folding them to envelop the air inside them, and kneading them to form their final shape. According to Takiguchi, "The forms are determined through a back-and-forth between me and the air." Many of them feature what seem to be arms and legs extending in all directions from a central body, like an amoeba feeling out its surroundings as it slithers around.

Kondō Takahiro incorporates the *sometsuke* (cobalt blue underglaze) technique handed down from the time of his grandfather, Kondō Yūzō, who was an Important Intangible Cultural Property Holder. He has also developed his own highly refined and original style—exemplified by *Blue Green Mist*, which employs a mistlike silver overglaze, called *gin-teki*, that he invented in the 1990s and patented in 2004. According to Kondō, "Ceramics have a strong connection to all the natural elements (earth, water, fire, and air). I see myself as working in the medium of earth, but also using fire, in order to express water." Along with the techniques of *sometsuke* and silver overglaze, he sometimes incorporates glass, as in *Mist, Silver Drops*.

Sakiyama Takayuki employs clay slabs to make vessels with a two-ply structure that are based on the motif of the sea. The artist speaks of "undulations from outside being transmitted to the inside, while internal force is radiated out," as seen in *Listening to the Waves*, which features a structure reflecting the interplay and unity of interior and exterior. Mihara Ken's *Folded Sculpture*, by contrast, has a robust form produced by coil-building. The artist says his goal is to express "something like the ambience of my hometown, Izumo"—the site of one of Japan's most important ancient Shinto shrines. The austere surface of the work, eschewing all decoration, seems to embody the primitive beauty of "things as they are."

Born into a venerable ceramics-making household in Minō near Nagoya, Katō Yasukage incorporated knowledge and techniques garnered from his family and community. He employed traditional glazes and skills in Minō wares such as Oribe, Shino, and Seto-guro ("black Seto") styles, developing them into new and idiosyncratic expressions until his untimely death (pp. 100 and 101). Another artist with roots in a ceramic-producing region is Mizukami Katsuo, whose ash glaze techniques reflect the traditions of the Tokoname district in Aichi prefecture (p. 93).

Based in the United States, Mizuno Keisuke creates representational pieces, such as *Standing Yellow Flower*, that depict vegetation and other elements of nature. Their exquisitely executed realism stands apart from the more stylized forms of nature found in Japanese Edo-period handcrafts.

The youngest of these artists, Takeuchi Kōzō, discovered the working method employed in his series *Modern Remains* when he accidentally dropped a piece in progress. Now, after firing agglomerations of square, white porcelain columns, he deliberately smashes them, seeking out "the beauty of things in decay" and "objects that convey the passage of time." In the world of traditional pottery, firing is the final stage in an object's fabrication; intentionally wreaking destruction on a piece after firing is a disruptive and extremely contemporary act.

Nagae Shigekazu
Wind, 2005
33 x 43.2 x 22.9 cm
(13 x 17 x 9 in.)

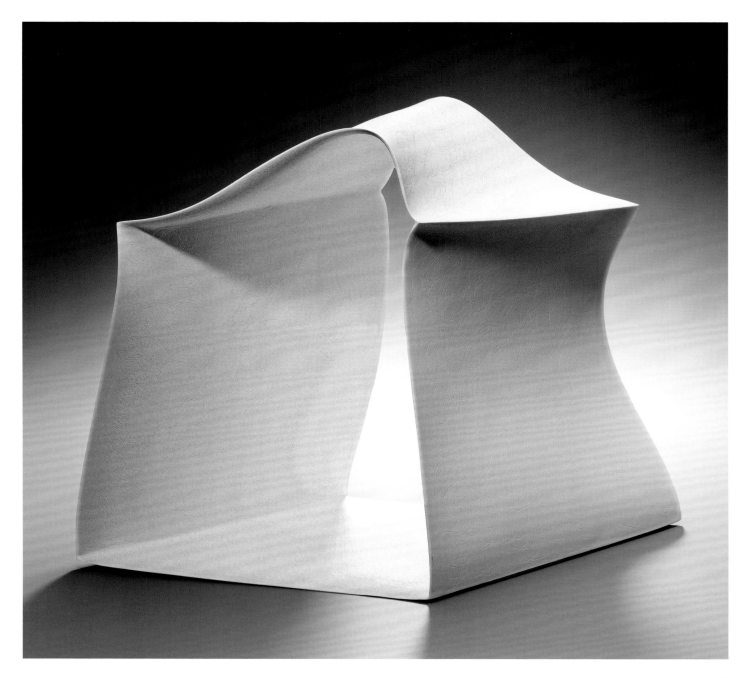

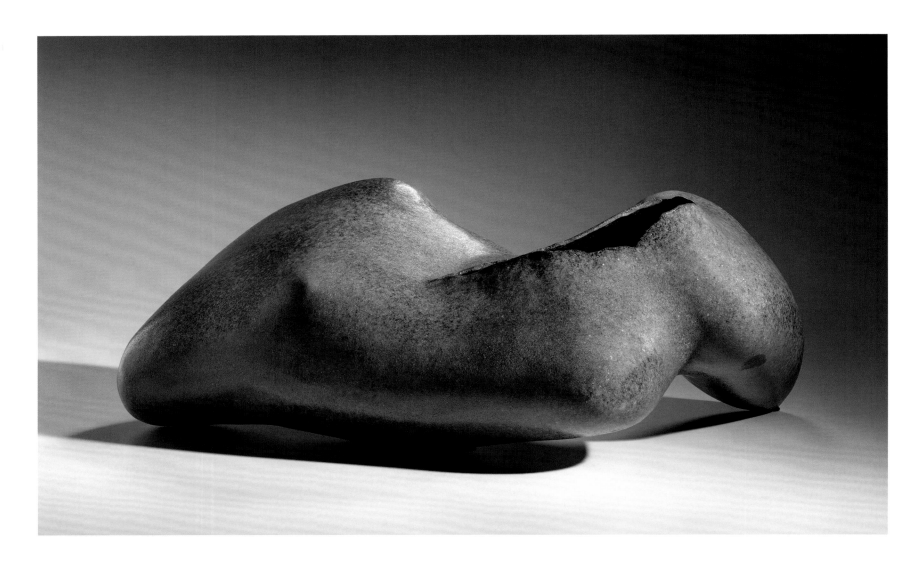

Takiguchi Kazuo
Untitled, 2005
15.2 x 45.7 x 31.8 cm
(6 x 18 x 12½ in.)

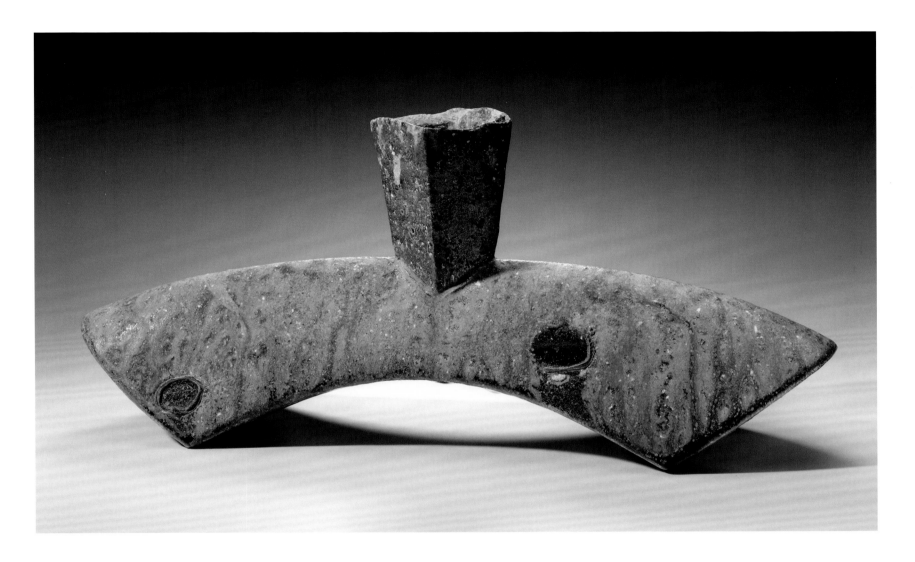

Mizukami Katsuo

Vase, before 2007

19.1 x 40.6 x 8.3 cm

(7½ x 16 x 3¼ in.)

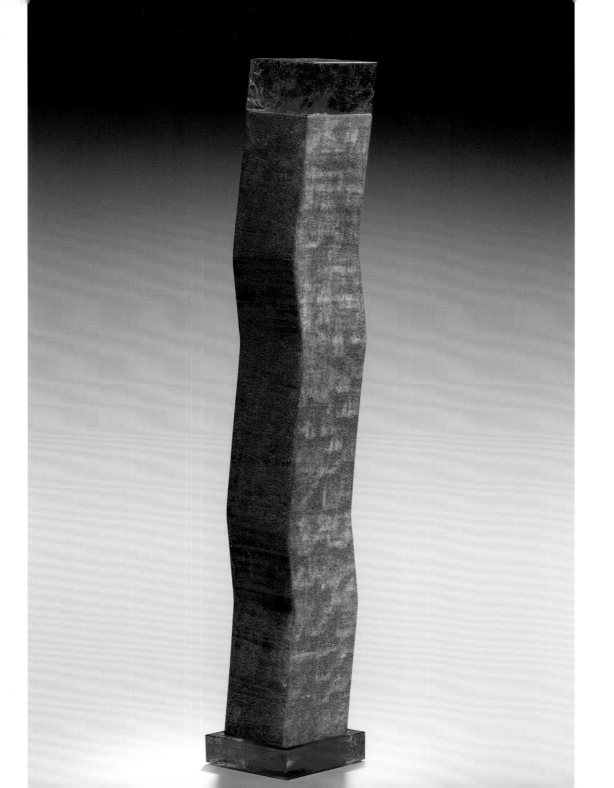

Kondō Takahiro

Blue Green Mist, 2006

74.3 x 16.5 x 11.4 cm

(29¼ x 6½ x 4½ in.)

Kondō Takahiro

Mist, Silver Drops, 2005

12.2 x 19.1 x 8.3 cm

(4⅞ x 7½ x 3¼ in.)

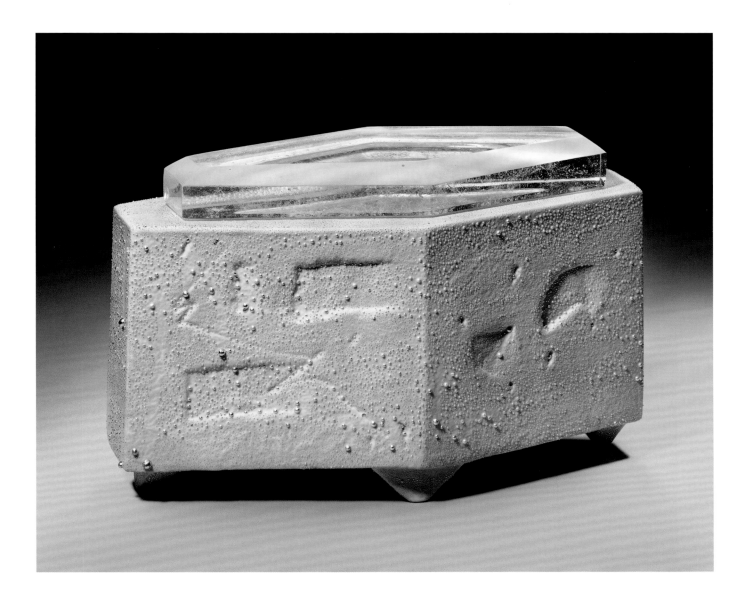

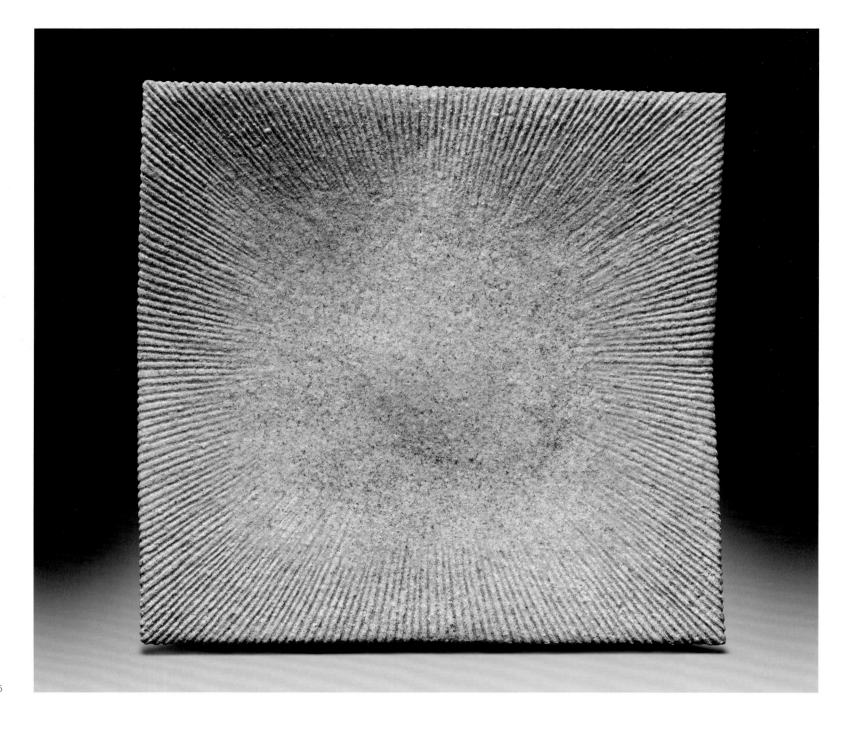

Sakiyama Takayuki
Splash, 2005
7.6 x 43.8 x 44.5 cm
(3 x 17¼ x 17½ in.)

Sakiyama Takayuki
Listening to the Waves, 2006
43.5 x 36.2 x 37.5 cm
(17⅛ x 14¼ x 14¾ in.)

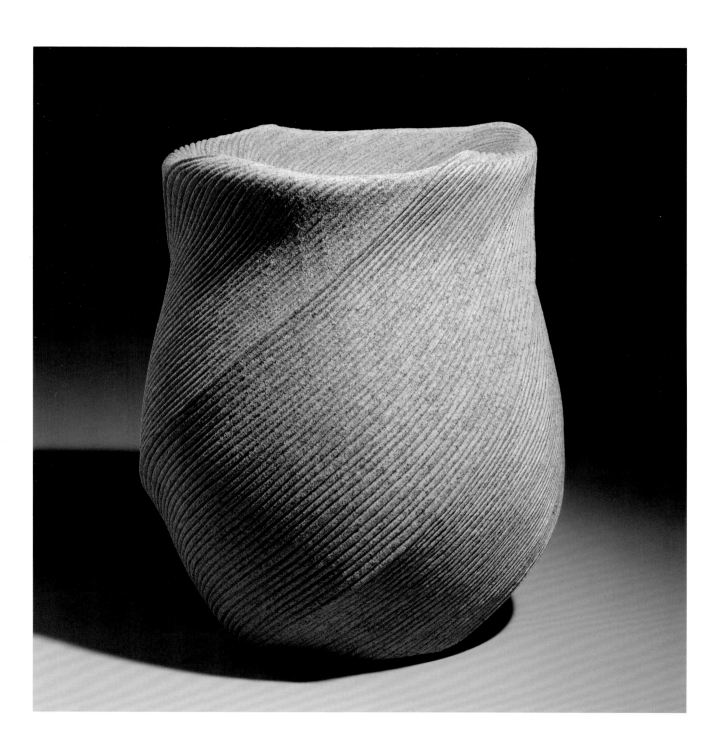

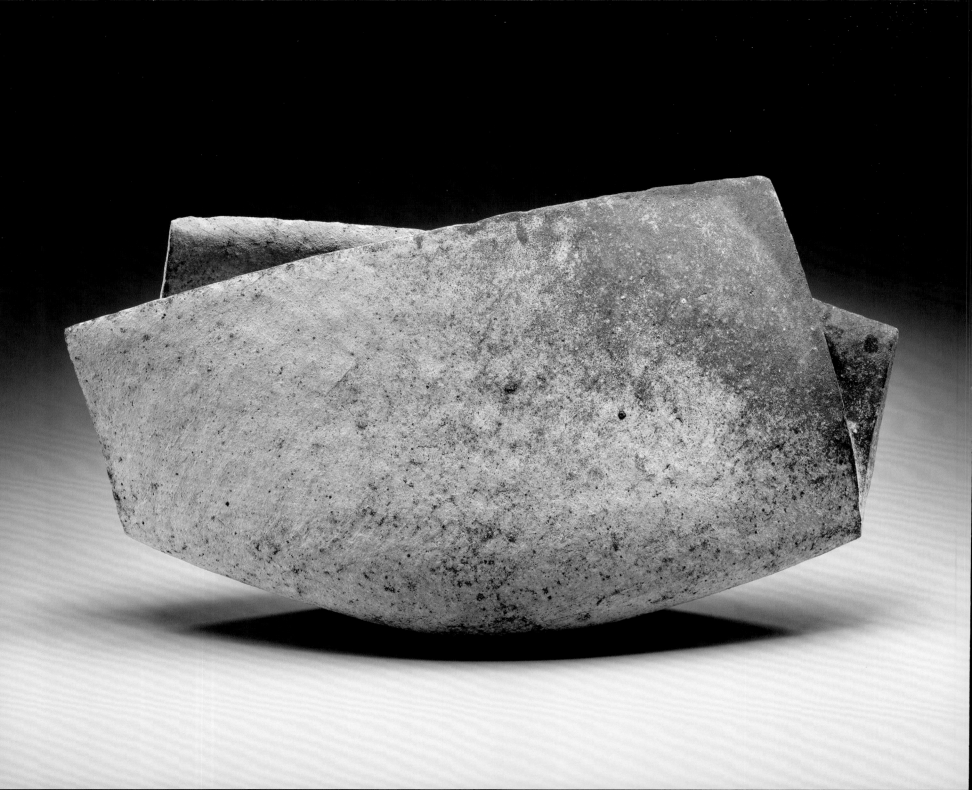

Mihara Ken
Folded Sculpture, 2006
27.3 x 48.9 x 10.8 cm
(10¾ x 19¼ x 4¼ in.)

Mihara Ken
Origin, 2006
49.1 x 49.5 x 30.5 cm
(19⅜ x 19½ x 12 in.)

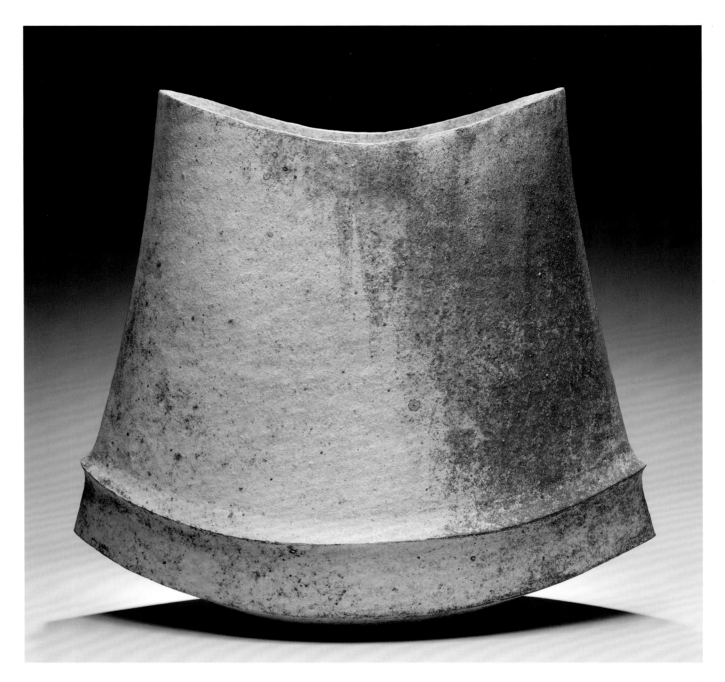

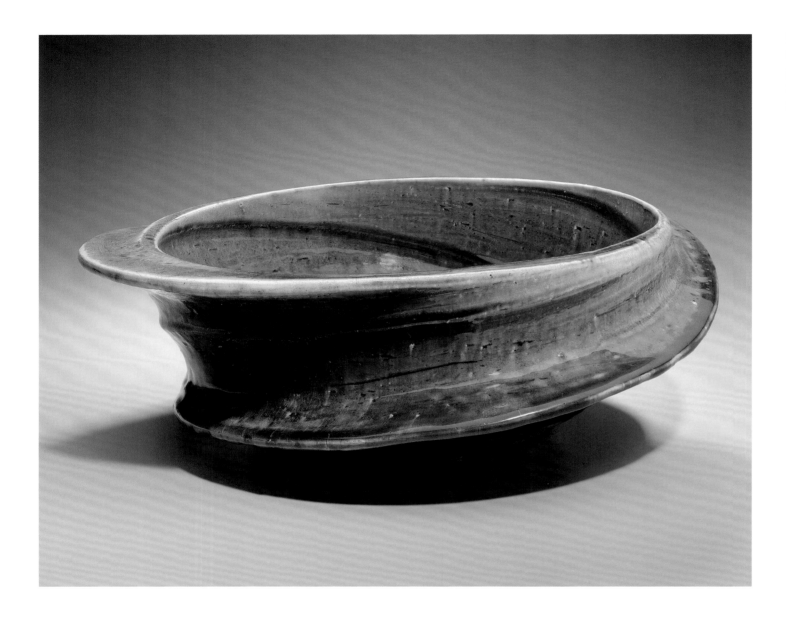

Katō Yasukage
Vase with Oribe-style
glaze, 2006
14.6 x 43.2 x 40.6 cm
(5¾ x 17 x 16 in.)

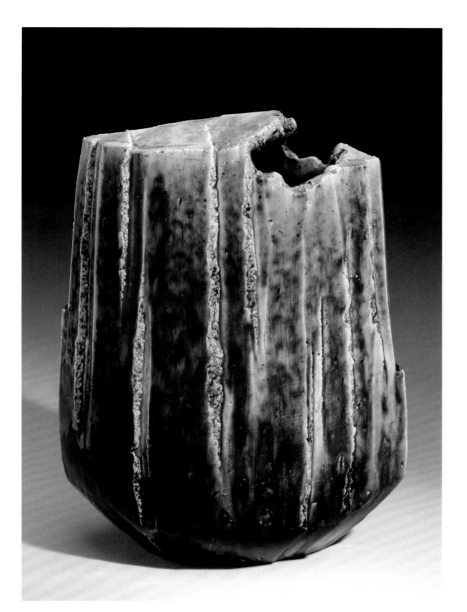

Katō Yasukage
Vase with Oribe-style glaze,
2003
40 x 26.7 x 18.1 cm
(15¾ x 10½ x 7⅛ in.)

Katō Yasukage
Shino-style water jar
(*mizusashi*) with decoration
of grasses, 2003
22.2 x 17.8 x 18.4 cm
(8¾ x 7 x 7¼ in.)

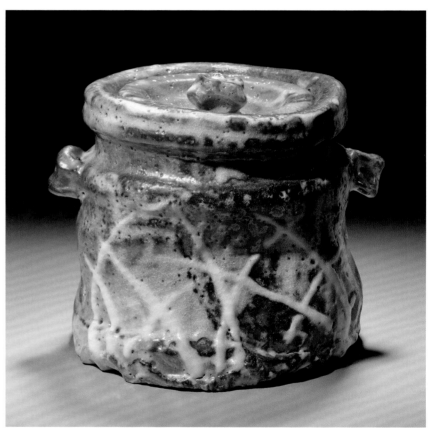

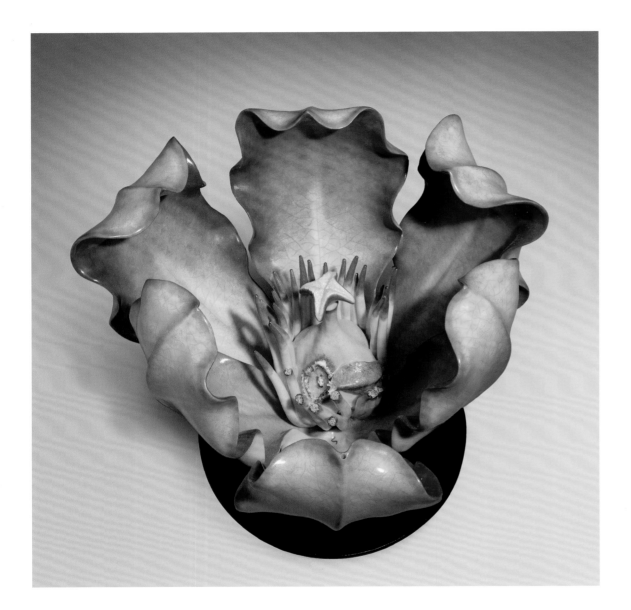

Mizuno Keisuke
Standing Yellow Flower,
2001
24.8 x 27.9 x 22.9 cm
(9¾ x 11 x 9 in.)

Takeuchi Kōzō
Modern Remains, 2009
35.6 x 41.9 x 14.6 cm
(14 x 16½ x 5¾ in.)

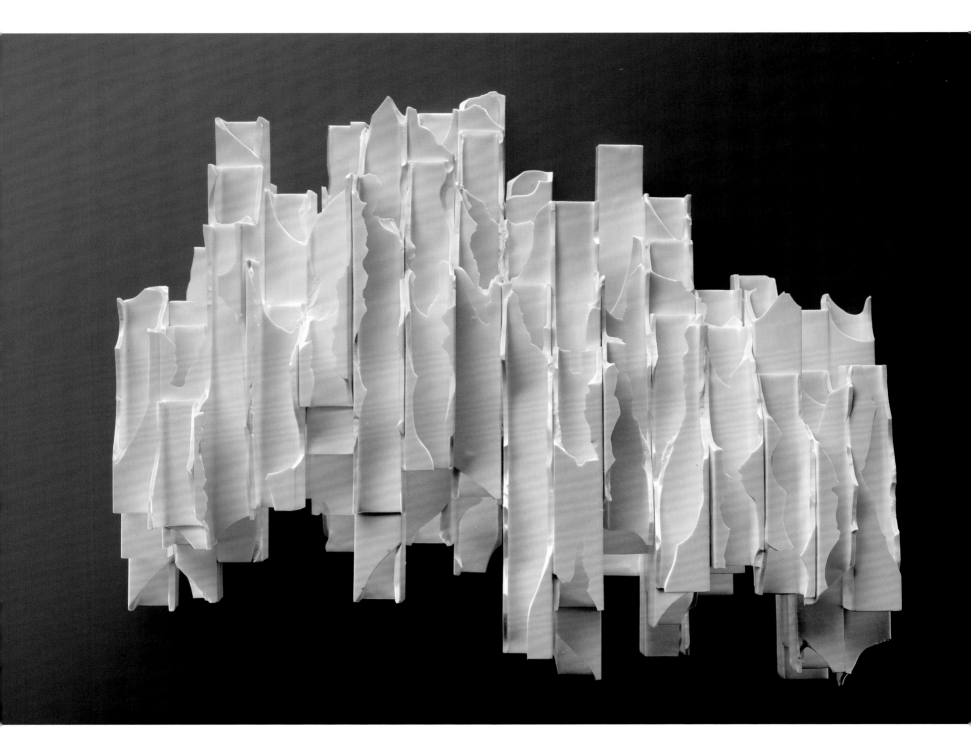

BAMBOO ART

Contemporary bamboo art continues to be dominated by artists trained in facilities or apprenticeships in regions where bamboo work has traditionally flourished, including Oita, Osaka, Shizuoka, Tochigi, and Niigata. Most of the artists whose works are collected here were trained in or are active in these regions. Despite this adherence to tradition, the medium has greatly evolved and diversified over the last century. Because bamboo art focuses not on the application of decoration but on fashioning the form of the object itself, it calls forth more radical originality from artists seeking innovation.

In the late nineteenth and early twentieth centuries, the making of Chinese-style baskets flourished, primarily in Osaka, against a background of *sencha* (steeped tea) ceremony culture. One renowned artist from this era was the Osaka maker Maeda Chikubōsai I, who wove fine strands with exquisite dexterity and made use of the natural curves of bamboo roots, using the Sakai-de method. Soon, as with ceramics and other crafts, those who made bamboo works began to gain recognition as artists rather than merely as craftsmen. By the 1920s, bamboo artists had begun to show their work in public exhibitions such as the Japan Art Exhibition (Nitten), and from the 1950s at the Japan Traditional Art Crafts Exhibition, which demanded originality from participants. The first such exhibitor was Sakaguchi Sōunsai (1899–1967), who in 1929 presented work in the Tenth Imperial Art Exhibition (Teiten). He was followed by other pioneers, such as Tanabe Chikuunsai II and Monden Kōgyoku. Monden, who is still active, has claimed that his originality arose because he was "all thumbs—that's why I have my own personal style." He is known for his proficiency with the *ochimatsuba-ami* technique, which looks like layers of pine needles.

One major stylistic category of bamboo artists is those who participate in the Japan Traditional Art Crafts Exhibition. Artists such as Hatakeyama Seidō, Fujinuma Noboru, Sugita Jōzan, and Yako Hōdō work with containerlike forms such as vessels and baskets and employ their own weaving techniques to produce objects with spatial economy and a high degree of abstraction. An example is Hatakeyama's *Bamboo Shoot*, whose rhythmic design the artist says was "inspired by the multiple layers of skin on a shoot of bamboo." Fujinuma's *Gentle* uses a standard *sukashi-ami* mesh weave technique to convey voluptuous abundance in a piece that "expresses both the vitality and the frailty of bamboo in a single object." Fujinuma says, "The great thing about bamboo art is that you can do every step of the process yourself, from splitting the bamboo to lacquering the finished woven product. I want to express my view of life through form." Kajiwara Aya is a woman bamboo artist from the 1980s. Her *Autumn Memory* is a round vase with a rhythmic zigzag pattern from the bottom to the top,

woven using her altered *yamaji-ami* technique (see p. 23). She says, "The zigzag design conveys a mountain path in Autumn."

Another novelty introduced by artists working in this style, where curving forms predominate, is the appearance of quasi-architectural structures composed of straight lines, such as Yako Hōdō's *Late Autumn*. An artist like Fujitsuka Shōsei, who exhibits in the Japan Traditional Art Crafts Exhibition, sometimes also produces work that does not fit the category of a vessel: his *Fire* instead employs bamboo as a medium for free-form expression. According to Fujitsuka, "Each piece is a new experiment. Pieces like this one differ from baskets, as I create them by intuitively shaping *hōbichiku* [phoenix-tail] bamboo without making preliminary drawings. I strive to produce dynamic forms."

The more daring and experimental work in bamboo is done by artists exhibiting in shows such as the Japan Art Exhibition and the Japan Contemporary Arts and Crafts Exhibition, along with some who are unaffiliated with arts and crafts organizations. Among the artists in this collection who fall into this category are Torii Ippō, Honma Hideaki, Watanabe Chiaki, Yamaguchi Ryūun, Shōno Tokuzō, Honda Shōryū, Morigami Jin, and Mimura Chikuhō. These artists often generate a unique and lyrical sense of movement in their work through the spatial properties of braided structures that make dynamic use of the material's pliability and elasticity. Honma Hideaki, to take one example, creates bamboo sculpture by freely bending long, thin pieces of *nemagaridake* (bent-root bamboo). According to Honma, "The interesting thing about bamboo art is its unpredictability—even when you make a preliminary drawing, build a maquette, and fashion a framework for the final object, it is still necessary to make all kinds of adjustments."

Morigami Jin and Honda Shōryū produce biomorphic forms achievable only in bamboo sculpture. Morigami, in his account of weaving intuitively without using sketches, says, "I begin to weave without any definite image in mind. Whereas most basketry is executed starting at the bottom and working upward, I start at a random point and let things flow naturally from there. It's not a practical art, it's more of a martial art, where I study my opponent—the bamboo—and decide on my next move." His *Red Flame* and *Peerless* are made with the *nawame-ami* twining technique, using extremely slender strips of bamboo. By contrast, the relatively large knots of the *mutsume-ami* hexagonal plaiting in his *Harmony II* and *Harmony III* are ideal for making curved surfaces.

Yamaguchi Ryūun, who studied under the postwar trailblazer Shōno Shōunsai, leaves the ends of strips of bamboo in *Fire* unbound, allowing them to spread out and generate a voluminous form. According to Yamaguchi, "I tried stopping the artisan's standard practice of binding the ends of the strips, after some people in ceramics and other fields suggested to me that it might not be necessary." Shōno Tokuzō is the son of Shōunsai; his *Tail of the Phoenix* conveys the movement of the wind through sharp forms made with the unbound cut ends of the bamboo fibers.

Another radical departure from traditional bamboo art is seen in the work of Nagakura Ken'ichi, who sometimes buries the bamboo form in mudlike material resembling a lacquerwork undercoating and then excavates the material from the surface, creating surfaces like antique reliefs, imbued with the expressiveness of organic form. Nagakura says, "I have a feel for primitivism." The young bamboo artist Sugiura Noriyoshi, in *Dance in Circle*, creates a complex structure of curved surfaces made with strips of bamboo fibers that appears to be dancing lightly.

Maeda Chikubōsai I
Basket with bamboo-root
handle, 1930s
40.6 x 39.4 cm
(16 x 15½ in.)

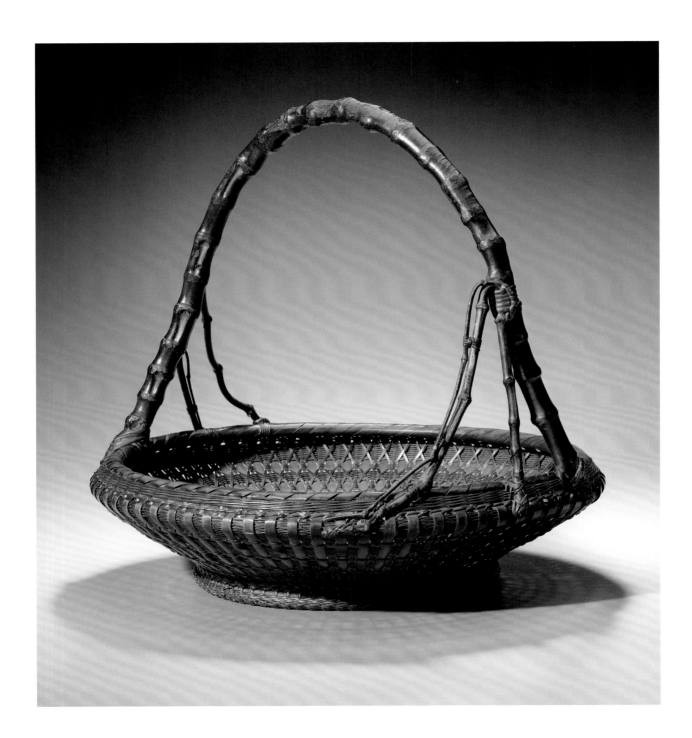

Tanabe Chikuunsai II
Flower basket, after 1945
21 x 40.6 cm (8¼ x 16 in.)

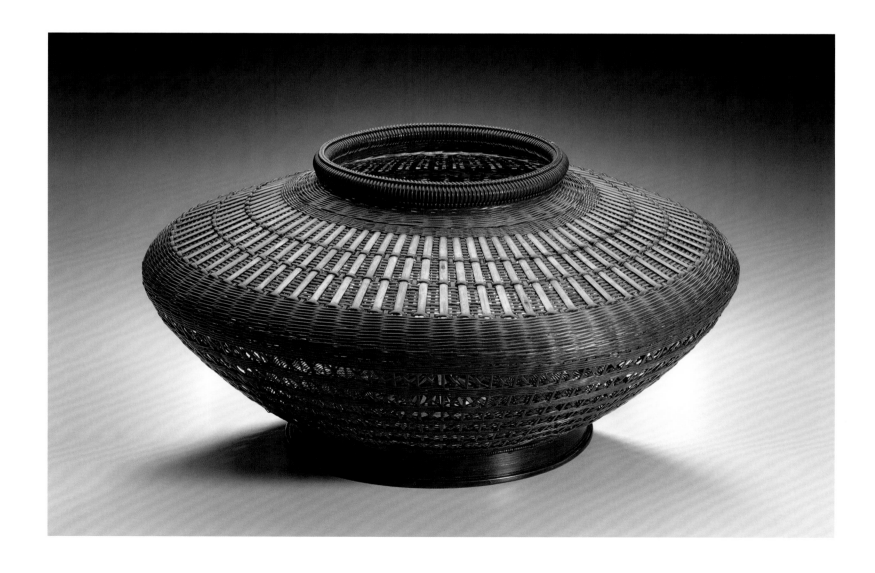

Hatakeyama Seidō

Bamboo Shoot, 2007

35.6 x 25.4 cm

(14 x 10 in.)

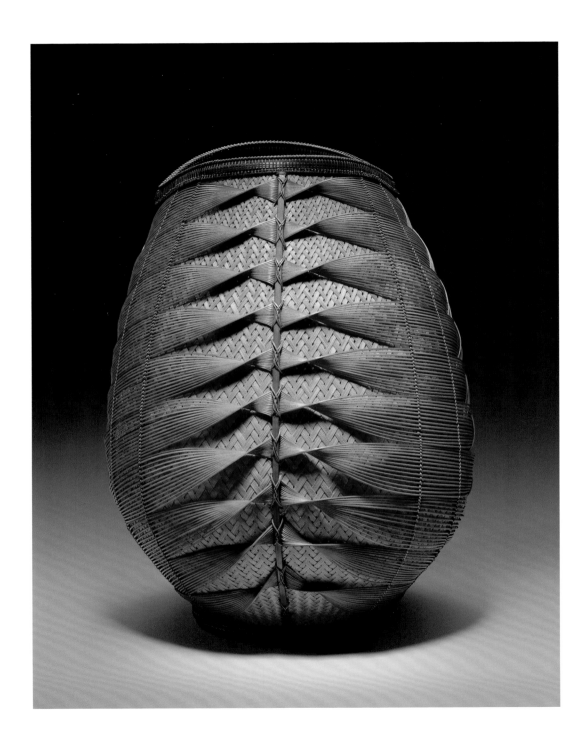

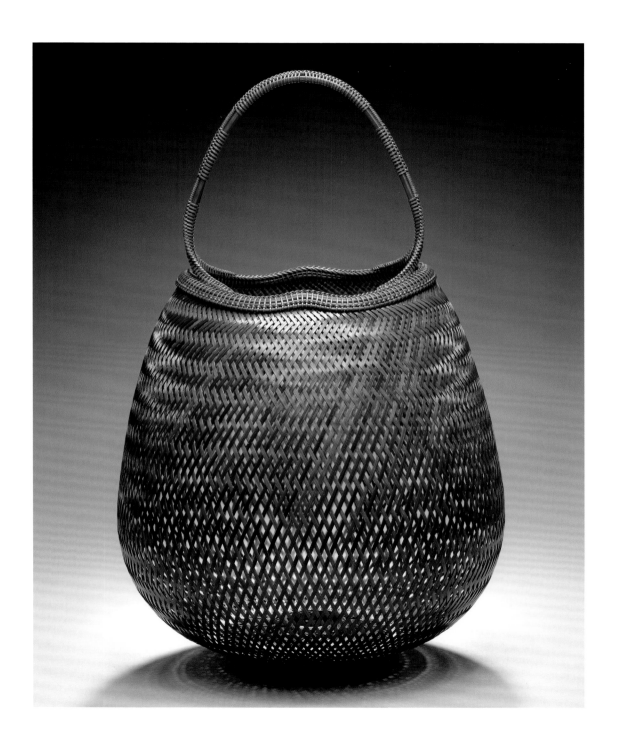

Fujinuma Noboru
Gentle, 2007
40.6 x 22.9 x 21.6 x cm
(16 x 9 x 8½ in.)

Monden Kōgyoku

Undulation, 2005

26.7 x 30.5 x 22.9 cm

(10½ x 12 x 9 in.)

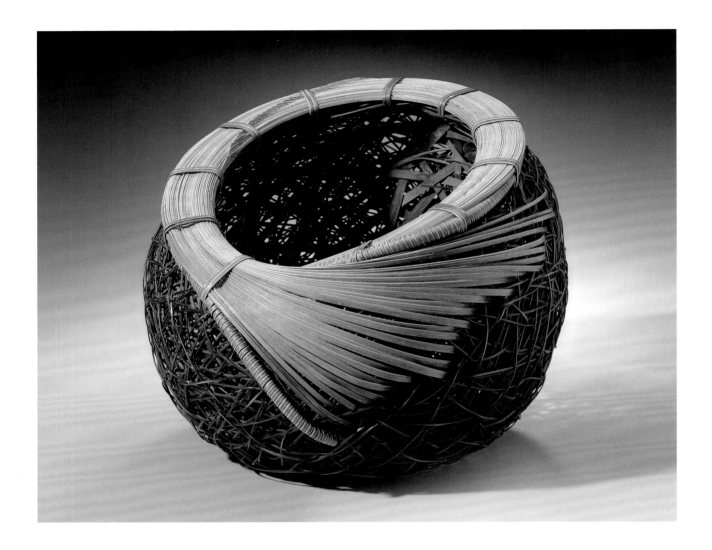

Yako Hōdō

Late Autumn, 2004

38.1 x 20.3 x 13.3 cm

(15 x 8 x 5¼ in.)

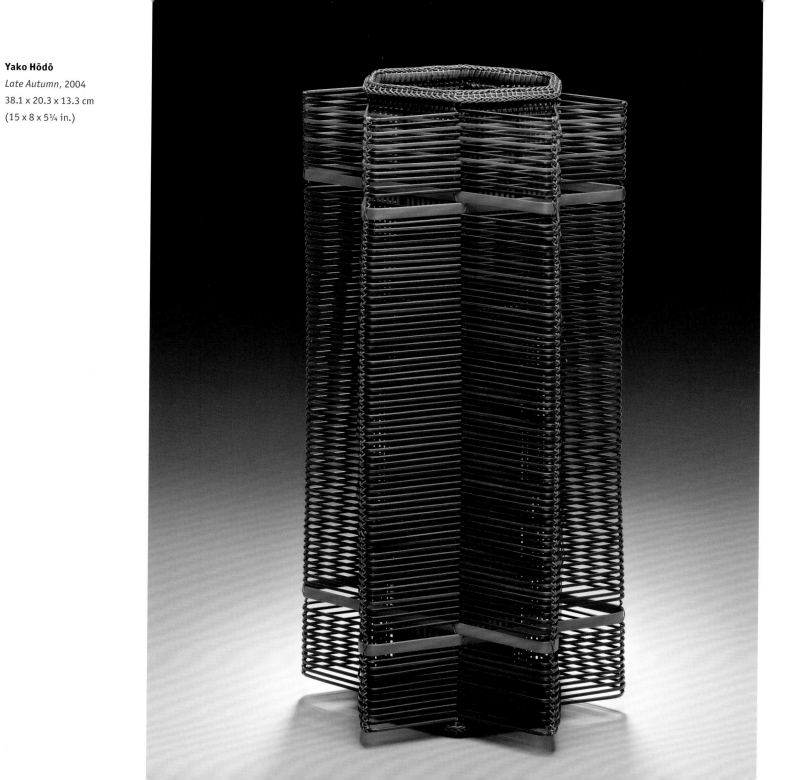

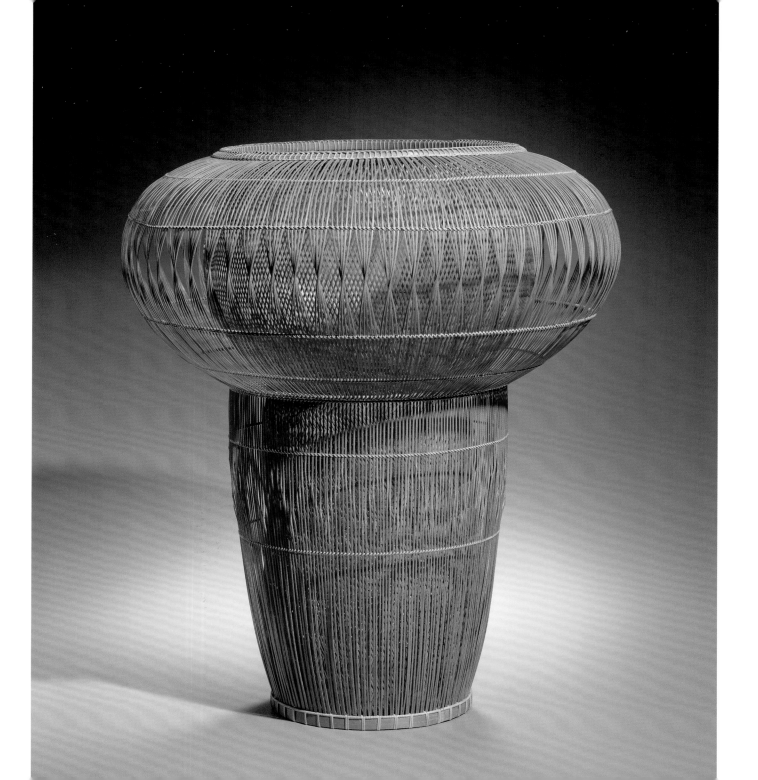

Sugita Jōzan
Morning, 1969
50.8 x 43.2 cm
(20 x 17 in.)

Sugita Jōzan
Eddy, 1993
16.5 x 36.8 cm
(6½ x 14½ in.)

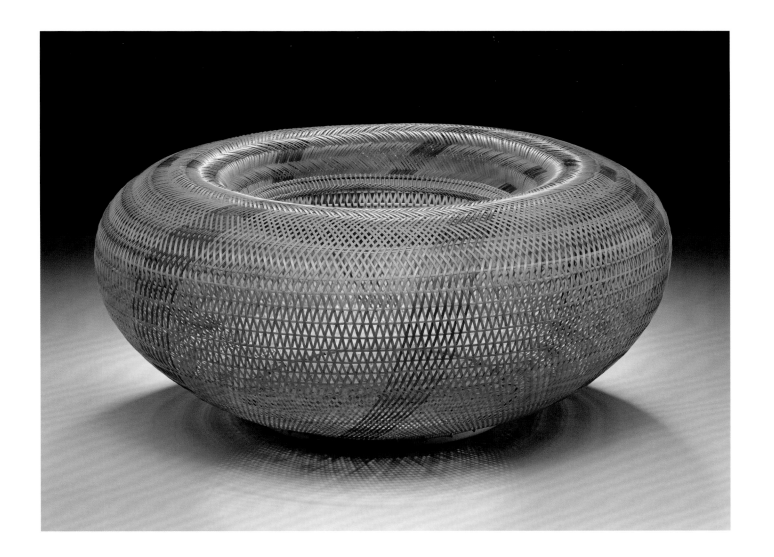

Torii Ippō

Flight, 2003
63.5 x 43.2 x 35.6 cm
(25 x 17 x 14 in.)

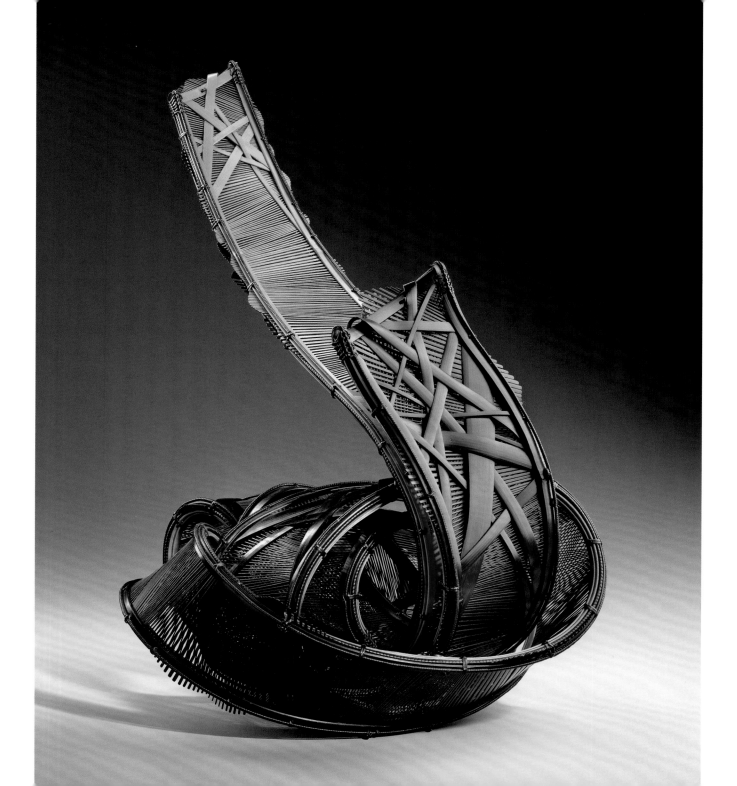

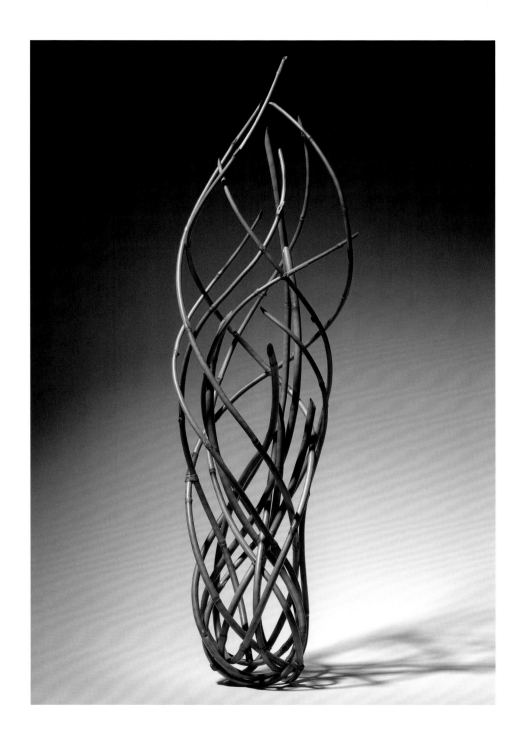

Fujitsuka Shōsei
Fire, 2011
108 x 27.9 x 27.9 cm
(42½ x 11 x 11 in.)

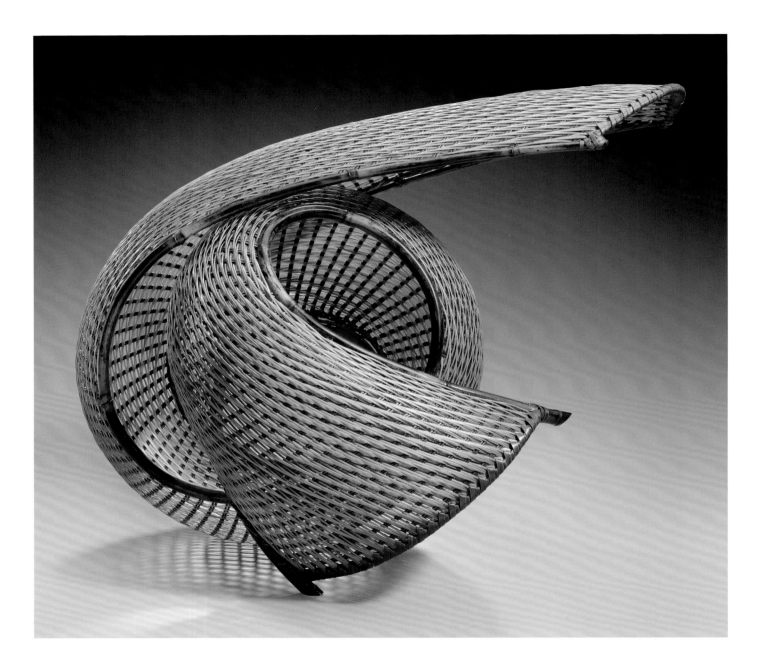

Honma Hideaki
Play, 2007
36.8 x 53.3 x 30.5 cm
(14½ x 21 x 12 in.)

Honma Hideaki

Rolling Shape II, 2007

36.8 x 55.9 x 27.9 cm

(14½ x 22 x 11 in.)

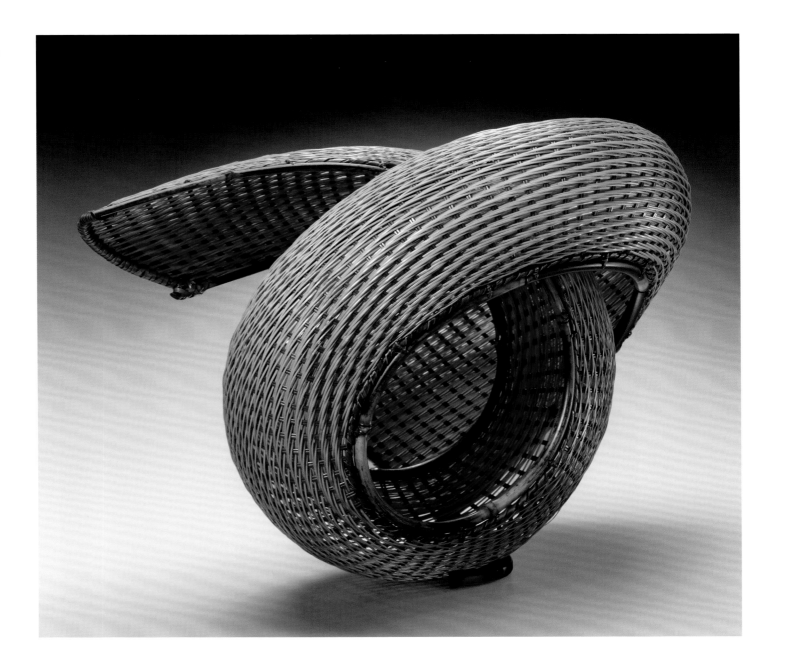

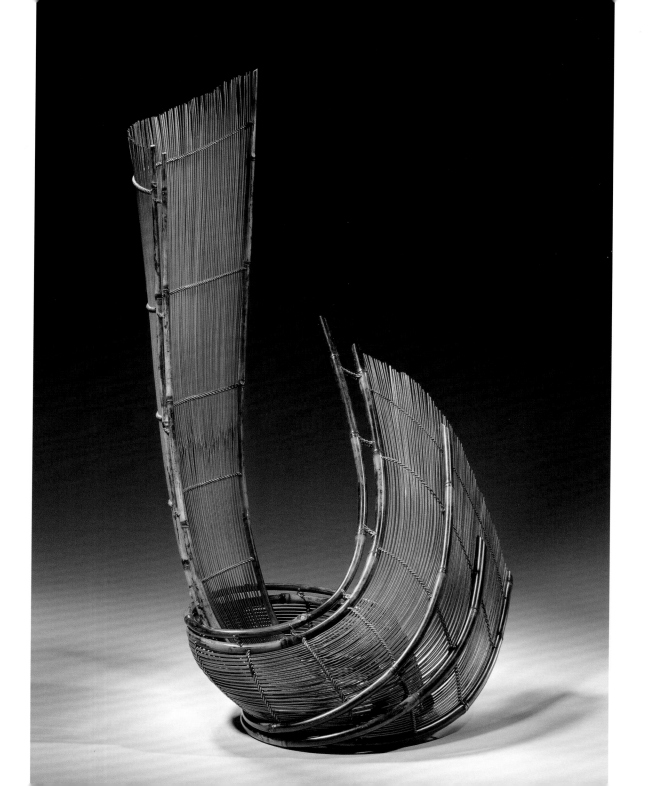

Honma Hideaki

Double Winds, 2006

73.7 x 39.4 x 29.2 x cm

(29 x 15½ x 11½ in.)

Watanabe Chiaki

Vitality, 2011

50.2 x 53.3 x 31.8 cm

(19¾ x 21 x 12½ in.)

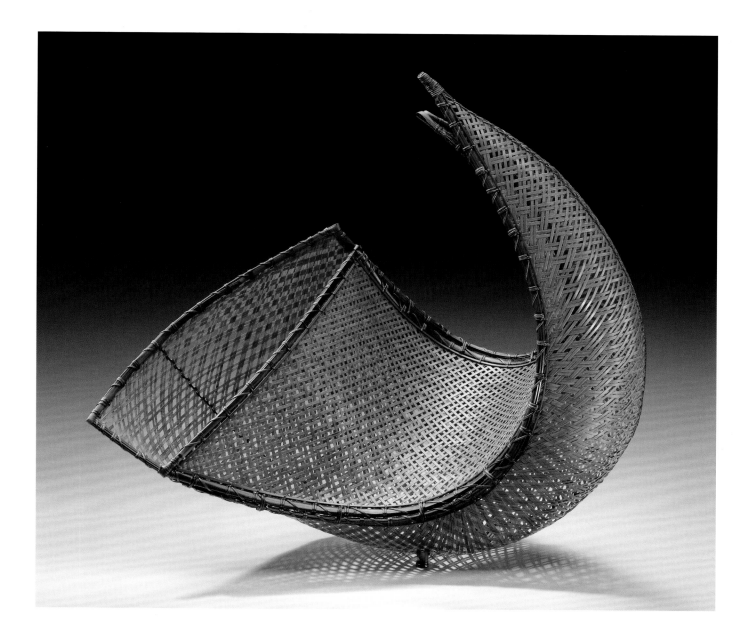

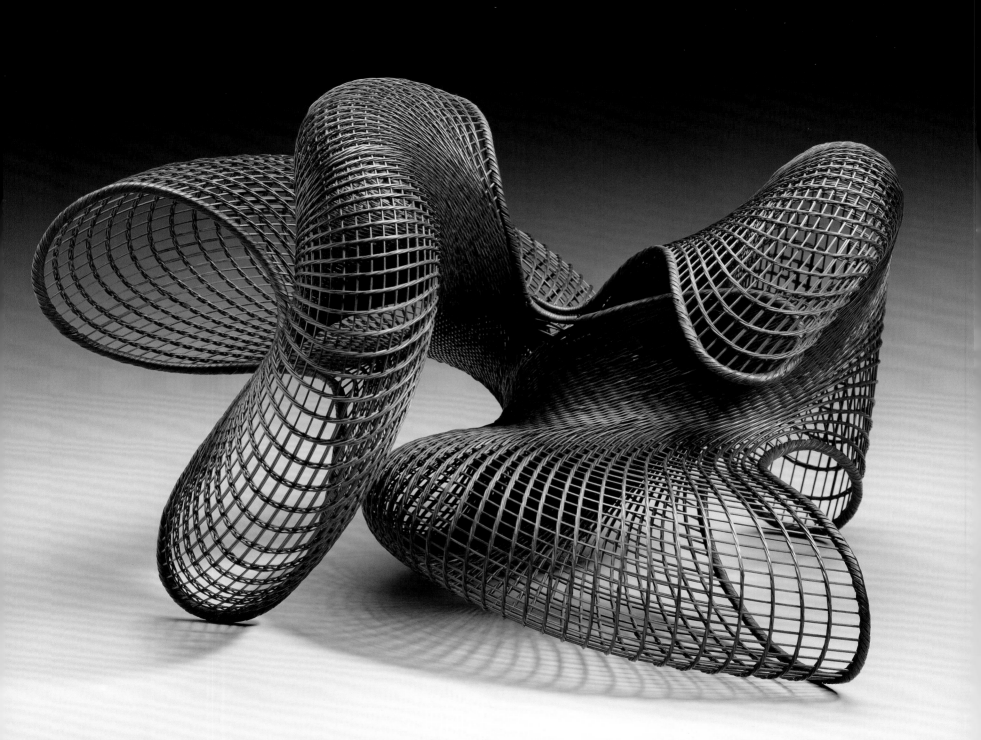

Honda Shōryū
Uplifting, 2006
29.2 x 45.7 x 33 cm
(11½ x 18 x 13 in.)

Morigami Jin
Red Flame, 2007
49.5 x 50.8 x 38.7 cm
(19½ x 20 x 15¼ in.)

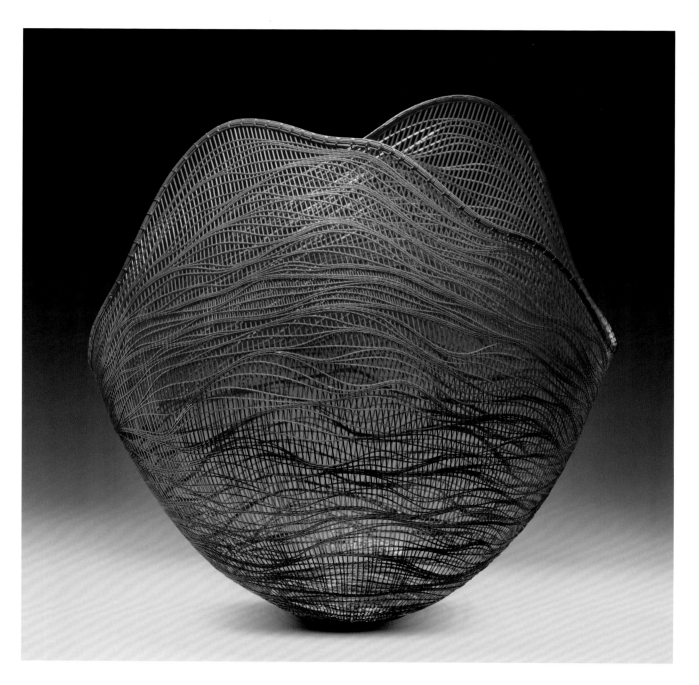

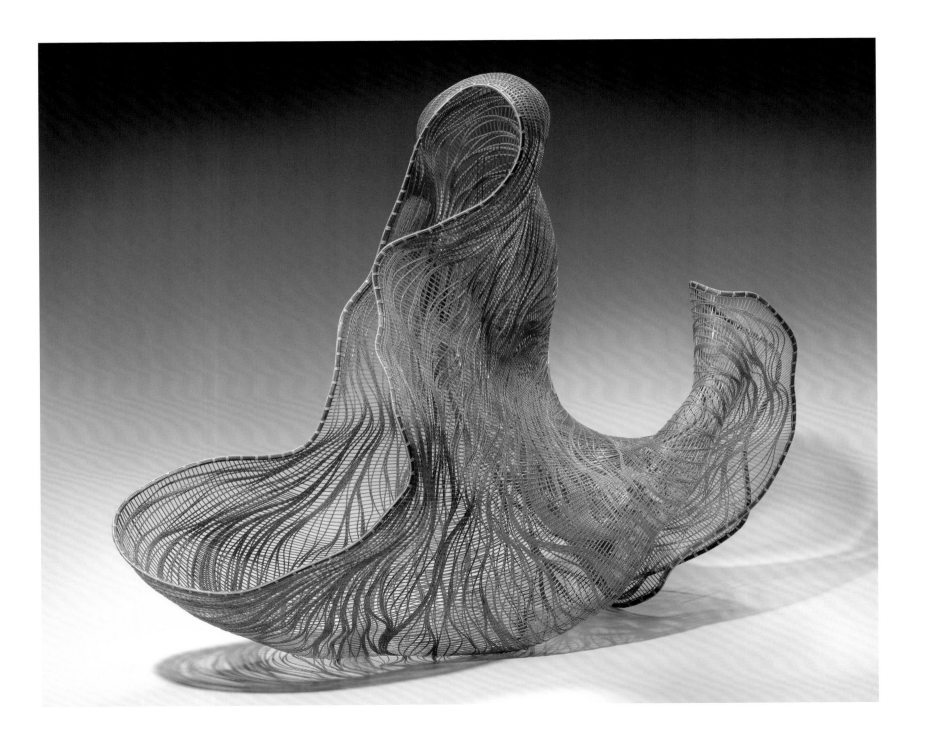

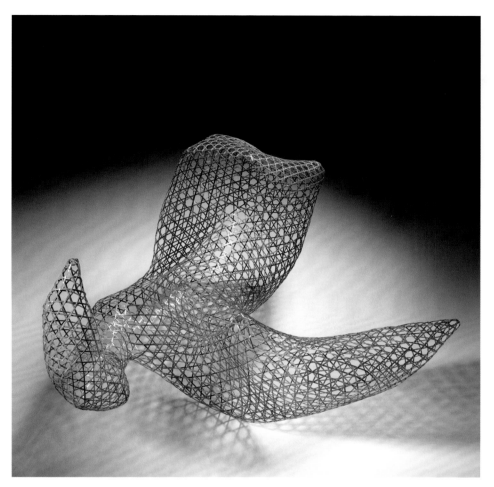

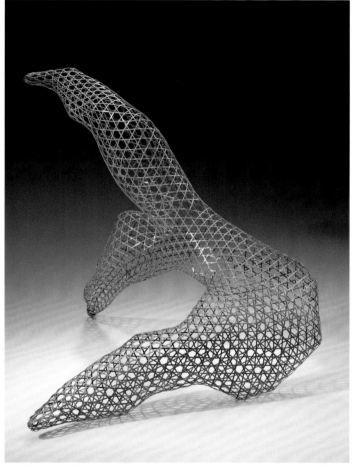

Morigami Jin (facing page)
Peerless, 2008
68.6 x 83.8 x 27.9 cm
(27 x 33 x 11 in.)

Morigami Jin (above)
Harmony III, 2006
33 x 50.8 x 50.2 cm
(13 x 20 x 19¾ in.)

Morigami Jin
Harmony II, 2006
41.3 x 39.4 x 62.9 cm
(16¼ x 15½ x 24¾ in.)

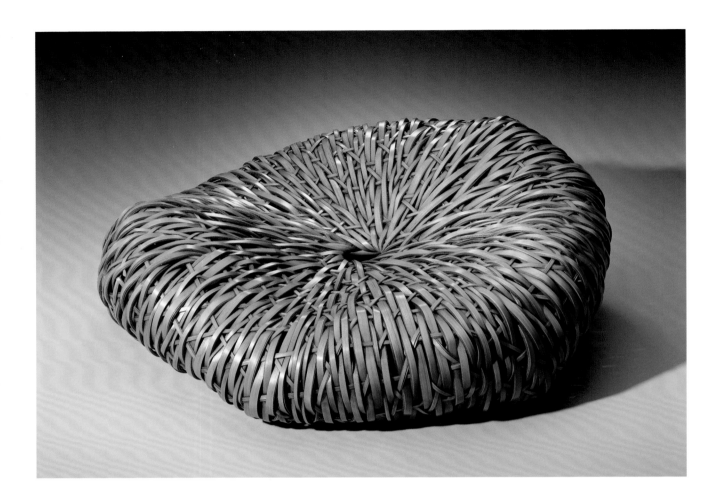

Mimura Chikuhō
Cloud on the Peak, 2006
16.5 x 43.2 x 41.9 cm
(6½ x 17 x 16½ in.)

Yamaguchi Ryūun
Fire, 2011
61 x 61 x 61 cm
(24 x 24 x 24 in.)

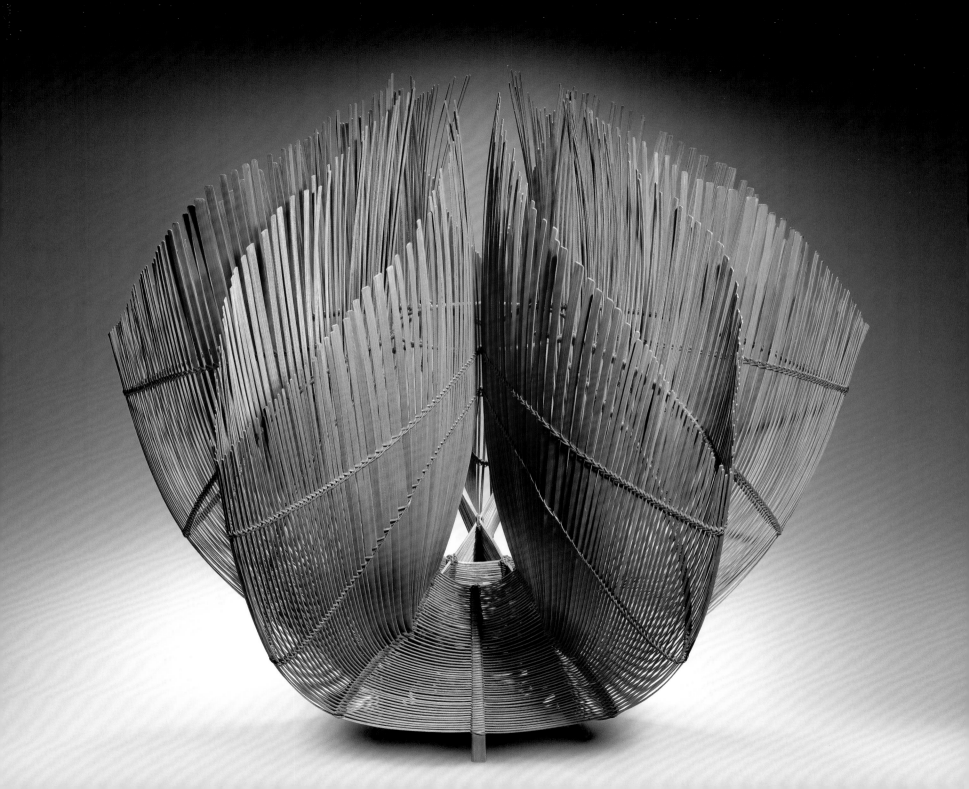

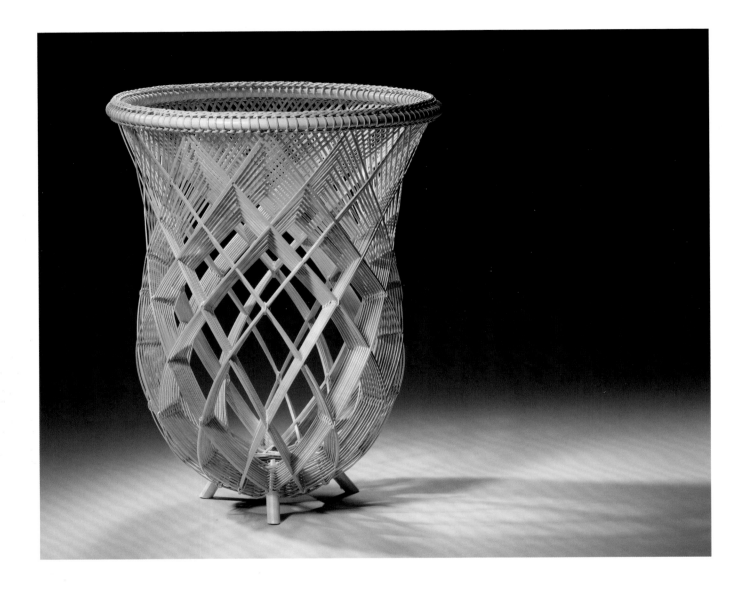

Yamaguchi Ryūun
Open-work basket, 2000
31.1 x 24.1 cm
(12¼ x 9½ in.)

Yamaguchi Ryūun
Abundant Waters, 2007
61 x 59.1 x 40.6 cm
(24 x 23¼ x 16 in.)

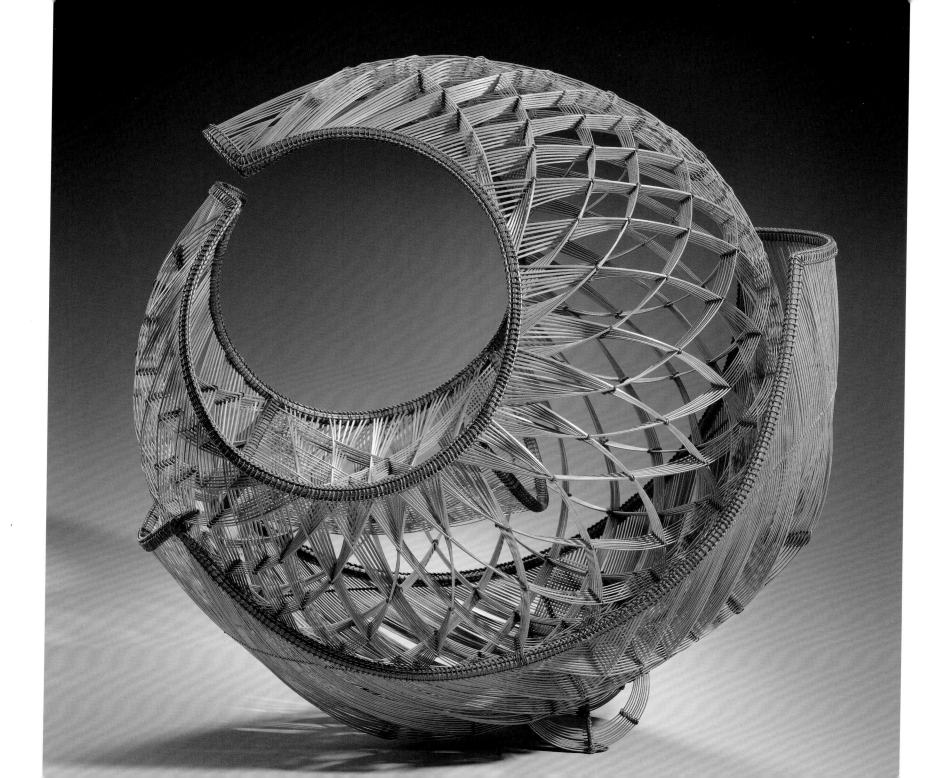

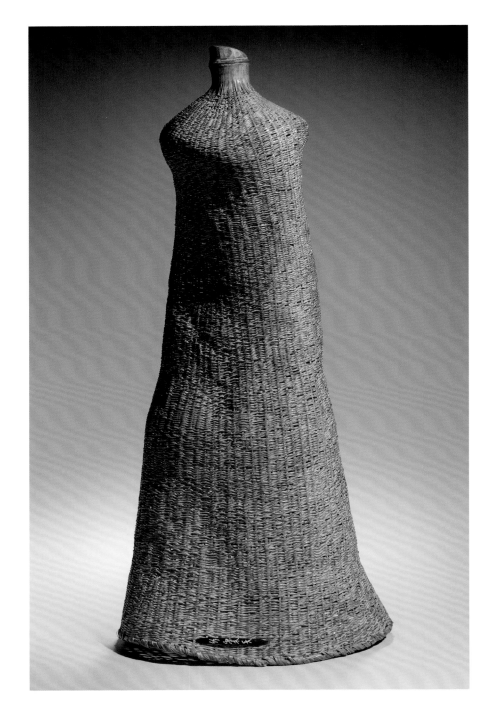

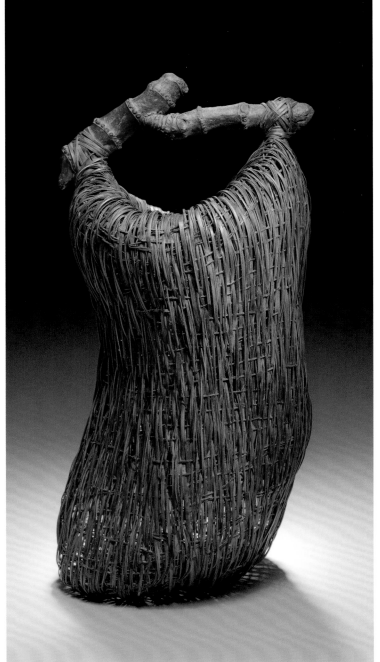

Nagakura Ken'ichi
(facing page, left)
Woman, 2005
59.7 x 24.1 x 21.6 cm
(23½ x 9½ x 8½ in.)

Nagakura Ken'ichi
(facing page, right)
Ikat, 2007
50.8 x 25.4 x 19.1 cm
(20 x 10 x 7½ in.)

Nagakura Ken'ichi
Dancing Star, 2008
27.9 x 43.2 x 21.6 cm
(11 x 17 x 8½ in.)

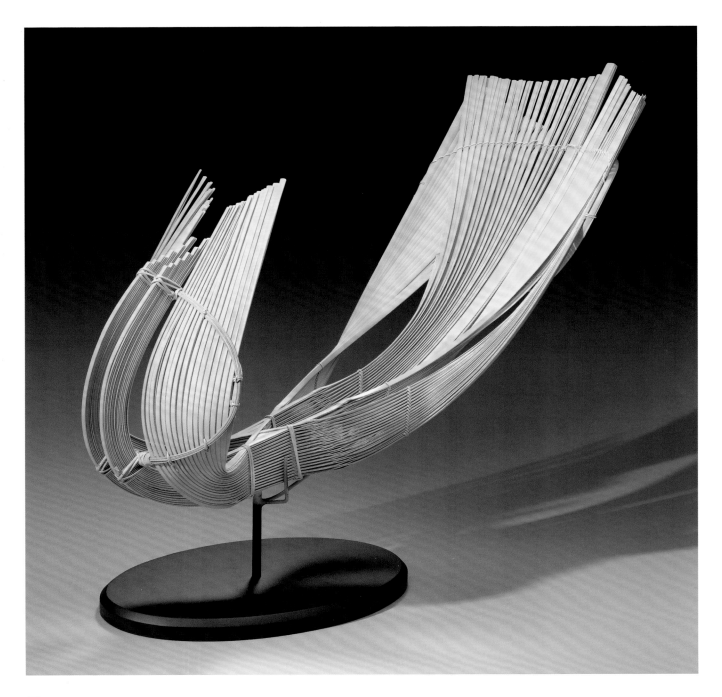

Shōno Tokuzō
Tail of the Phoenix, 2011
44.5 x 63.5 x 26.7 cm
(17½ x 25 x 10½ in.)

Sugiura Noriyoshi
Dance in Circle, 2011
47 x 47 x 31.8 cm
(18½ x 18½ x 12½ in.)

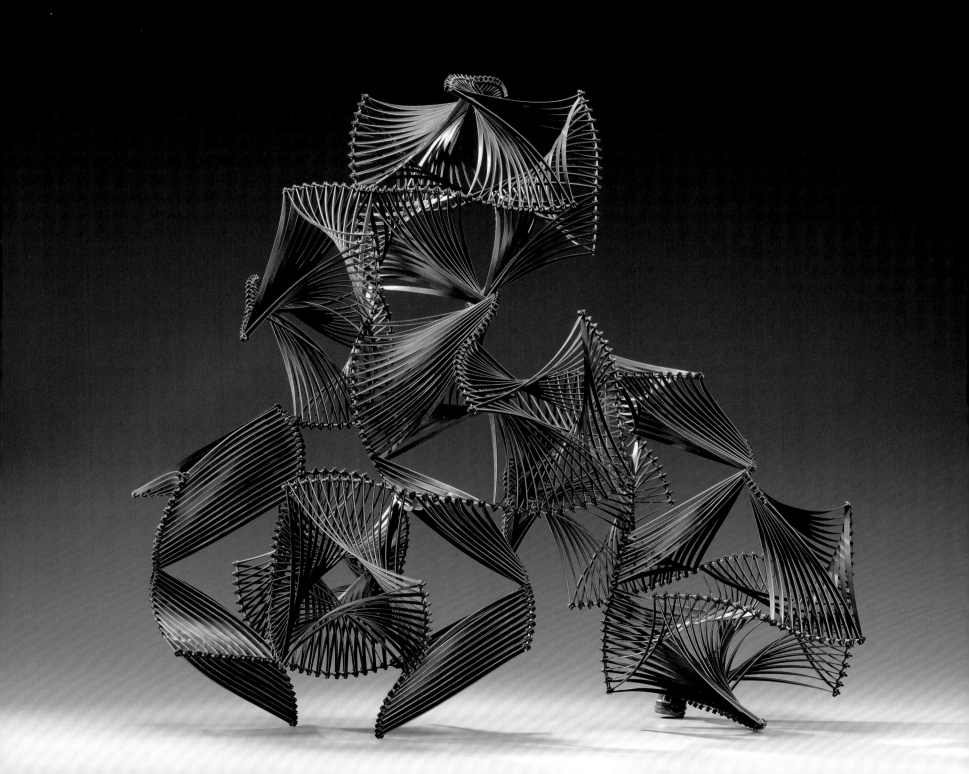

ARTIST
BIOGRAPHIES

AKIYAMA YŌ
秋山 陽
Born 1953, Yamaguchi prefecture

Married to the ceramic artist Kitamura Junko. Receives degree from the graduate school of Kyoto City University of Arts in 1978 and works as a ceramics teacher at a home for handicapped children, where the children's direct reactions to clay influence his work. First single-artist show in 1980. Begins to teach at Kyoto City University of Arts in 1988; currently professor there. Participates in the exhibition *Quintessence of Modern Japanese Ceramics*, Ibaraki Ceramic Art Museum in 2006. Receives the Grand Prize in the Crafts section of the MOA Museum of Art Okada Mokichi Awards in 2010 and the Mainichi Art Award in 2011.

pages 66–67

FUJINO SACHIKO
藤野 さち子
Born 1950, Kyoto prefecture

Wins the Grand Prize at the Women's Association of Ceramic Art Exhibition in 1987 and the Prize of the Minister of Education and Culture in 1991. Receives an Excellence Prize at the Asahi Ceramic Art Exhibition in 1991 and is awarded a Special Prize at the First World Ceramic Biennale 2001 International Competition in Korea.

pages 80–81

FUJINUMA NOBORU
藤沼 昇
Born 1945, Tochigi prefecture

Born in Ōtawara, a city in Tochigi prefecture, one of the traditional basketry-producing regions. Studies with Yagisawa Keizō in 1975 after leaving the Tochigi Nikon Company. First presents his work at the 17th Eastern Japan Traditional Art Crafts Exhibition in 1977 and at the 27th Japan Traditional Art Crafts Exhibition in 1980. Wins a Final Judge Prize at the First Lloyd Cotsen Bamboo Award in 2000 and receives the government-service Purple Ribbon Medal in 2004. Single-artist shows at the Japan Foundation, Los Angeles, in 2005, and at the Art Institute of Chicago in 2011. Designated an Important Intangible Cultural Property Holder in bamboo craft in 2012. Known for exquisite *ajiro-ami* (twill-weave plaiting) and elaborate *tabane-ami* (bundled plaiting) weavings.

page 111

FUJITSUKA SHŌSEI

藤塚 松星

Born 1949, Hokkaido prefecture

Studies with Baba Shōdō in 1972. First presents work at the Japan Contemporary Arts and Crafts Exhibition in 1978. Wins Prize of the Governor of Tokyo at the Japan Traditional Art Crafts Exhibition in 1993 and in 2011. Receives a Final Judge Prize at the Second Lloyd Cotsen Bamboo Award in 2002. Works as a lecturer at Tokyo University of the Arts in 2004. Participates in the exhibition *New Bamboo: Contemporary Japanese Masters* at the Japan Society, New York, in 2008. Works as an instructor at the Traditional Culture and Welfare School, Sado (Niigata prefecture) in 2010. Awarded Purple Ribbon Medal in 2012.

page 117

FUKAMI SUEHARU

深見 陶治

Born 1947, Kyoto prefecture

Son of a kiln master. Graduates in 1965 from Kyoto Arts and Crafts Training Center, the forerunner of the Kyoto Municipal Institute of Industrial Technology and Culture. Participates in the Japan Art Exhibition from 1967 to 1988. Wins the Grand Prize at the 43rd Premio Faenza at the International Museum of Ceramics in Faenza, Italy, in 1985, and serves as a judge at the 47th Premio Faenza in 1991 for the first time. Participates in the exhibition *Quintessence of Modern Japanese Ceramics*, Ibaraki Ceramic Art Museum, in 2006. Receives Japan Ceramic Society Gold Award in 2012.

page 65

HARADA SHŪROKU

原田 拾六

Born 1941, Okayama prefecture

Self-taught, begins to work on ceramics in 1969. Builds a tunnel kiln (*anagama*) in 1971 and a climbing kiln (*noborigama*) in 1972. Makes acquaintance of a researcher of ceramics, Katsura Matasaburō, and starts to study historic Bizen ware in 1975. Receives Japan Ceramic Society award in 1999. Shows two pieces at *Inaugural Exhibition: The Legacy of Modern Ceramic Art* at the Museum of Modern Ceramic Art in Gifu in 2002. Presents six pieces at the exhibition *Captivation of Bizen Unglazed Stoneware* at the Ibaraki Ceramic Art Museum in 2004.

page 56

HATAKEYAMA SEIDŌ
畠山 青堂
Born 1930, Niigata prefecture

Studies with Kosuge Shōchikudō after the Second World War. First presents his work at the 37th Japan Traditional Art Crafts Exhibition in 1990, at the 32nd Japan Traditional Art Crafts New Work Exhibition (forerunner of the Eastern Japan Traditional Art Crafts Exhibition), and at the 5th Japan Traditional Wood and Bamboo Art Crafts Exhibition in 1992. Wins the Mitsukoshi Prize at the 36th Japan Traditional Art Crafts New Work Exhibition in 1996 and the Incentive Prize in 1998. Wins the NHK Prize at the 53rd Japan Traditional Art Crafts Exhibition in 2006.

page 110

HAYASHI YASUO
林 康夫
Born 1928, Kyoto prefecture

Son of the potter Hayashi Mokuu, who made ceramic ornaments and tableware. After studying Japanese-style paintings at Kyoto City Fine Arts Professional School (forerunner of the Kyoto City University of Arts), starts making ceramics under his father in 1946. Participates in the foundation of the Society of Four Harvests collective in 1947. Presents the first nonfunctional Japanese ceramic object at the collective's exhibition in 1948. Another object shown in 1950 at the contemporary ceramic exhibition at the Cernuschi Museum in Paris receives favorable reviews. Participates in the Crawling Through Mud Association collective from 1962 to 1977. Participates in the exhibition *Quintessence of Modern Japanese Ceramics*, Ibaraki Ceramic Art Museum in 2006.

pages 17, 40–41

HIRANO YŪICHI
平野 祐一
Born 1941, Aichi prefecture

Son of a third-generation kiln master. First presents work at the Tōkai Traditional Arts and Crafts Exhibition in 1971. Holds many single-artist shows. Teaches ceramics at the Aichi Prefectural Labor Association Cultural School for four years. Produces vessels based on the clay and with the skills of the traditional Tokoname region. Member of the Tokoname Ceramic Artists Association.

page 59

HONDA SHŌRYŪ
本田 聖流
Born 1951, Kagoshima prefecture

Studied with Kadota Nikō. First presents his work at the Japan Traditional Art Crafts Exhibition in 1988. Wins a Final Judge Prize at the First Lloyd Cotsen Bamboo Award in 2000, and again in 2002 and 2004. First presents work at the Japan Art Exhibition in 2000. Shows for the first time at the Japan Contemporary Arts and Crafts Exhibition in 2001. Participates in the exhibition *New Bamboo: Contemporary Japanese Masters* at the Japan Society, New York, in 2008. Exhibits in *Artists Who Studied in Ōita and Their Great Achievements* at the Ōita Prefectural Art Center in 2012.

page 122

HONMA HIDEAKI
本間 秀昭
Born 1959, Niigata prefecture

Studies with his father, the bamboo artist Honma Kazuaki. First presents his work at the 46th Niigata Prefecture Arts Exhibition in 1990, at the Japan Contemporary Arts and Crafts Exhibition in 1992, and at the Japan Art Exhibition in 1993. Starts showing his work in the United States in 2002. Becomes an instructor at the Traditional Culture and Welfare School in Sado (Niigata prefecture) in 2008. Participates in the exhibition *New Bamboo: Contemporary Japanese Masters* at the Japan Society, New York, in 2008. Wins the Contemporary Arts and Crafts Regular Member Prize at the 50th Japan Contemporary Arts and Crafts Exhibition in 2011.

pages 118–20

HOSHINO KAYOKO
星野 佳代子
Born 1949, Fukuoka prefecture

Married to the ceramic artist Hoshino Satoru. Works at Fujihira Pottery Company, Ltd., in Kyoto, from 1971 to 1973. Participates in the Asahi Modern Craft Exhibition in 1985 and wins the Grand Prize in 1997. Is artist in residence at Hunter College of the City University of New York in 2006, and at Tainan National University of the Arts in Taiwan in 2008. Participates in the Cheongju International Craft Biennale 2009. Exhibits in *Touch Fire: Contemporary Japanese Ceramics by Women Artists*, Smith College Museum of Art, Northampton, Mass., in 2009. She also makes handcrafted tableware; such goods are known as *kurafuto* (a Japanese transliteration of the English word *craft*).

page 82

ISHIGURO MUNEMARO

石黒 宗麿

Born 1893, Toyama prefecture; died 1968

Son of a medical doctor who made ceramics as a hobby. Makes his first *raku* ceramics with his father's kiln in 1917. An indifferent student at school, is inspired to be a ceramicist after seeing by chance a National Treasure, a dark Tenmoku tea bowl with silvery *yuteki* "oil-spot" glaze, in 1918. Moves to Kyoto from Ishikawa prefecture and makes the acquaintance of the ceramic researcher Koyama Fujio in 1927, becoming deeply interested in Chinese antique ceramics, especially of the Song dynasty. Succeeds in making a Tenmoku-type tea bowl with a leaf imprint, in a style called *konoha* ("tree-leaf") Tenmoku, in 1940. In 1955, designated an Important Intangible Cultural Property Holder in iron-glazed pottery.

pages 30–31

KAJIWARA AYA

梶原 彩

Born 1941, Ōita prefecture

Married to the bamboo artist Kajiwara Kōhō. Graduates from Ōita Prefectural Beppu Higher Vocational Training School (later part of the Ōita Prefectural Bamboo Craft and Training Support Center) in 1980. First submits her work to the 39th Japan Traditional Art Crafts Exhibition in 1992 and receives the Japan Craft Association President's Prize at the 41st in 1994. Participates in the exhibition *Artists Who Studied in Ōita and Their Great Achievements* at the Ōita Prefectural Art Center in 2012.

page 23

KAKUREZAKI RYŪICHI

隠崎 隆一

Born 1950, Nagasaki prefecture

Graduates from the design department of Osaka University of Arts in 1973 and works as a designer. From 1979 to 1986, studies with Isezaki Jun, who holds the title of Important Intangible Cultural Property in Bizen ware. Builds a tunnel kiln (*anagama*) and studio in Osafune-chō (one of the pottery-producing regions of Bizen), in Okayama prefecture, in 1982. Becomes a regular member of the Japan Craft Association in 1990. Receives the Japan Ceramic Society Award in 1995. Presents four pieces at the exhibition *Captivation of Bizen Unglazed Stoneware*, Ibaraki Ceramic Art Museum, 2004. Participates in *Generational Crossroads: Bizen Evolution* exhibition at Tenmaya Gallery, Okayama, in 2010.

page 75

KATŌ YASUKAGE

加藤 康景

Born 1964, Gifu prefecture; died 2012

Son of Katō Kagekiyo XIII, who is considered a groundbreaking artist in the pottery-producing Mino region of Gifu prefecture. In 1982, studies with Yamamoto Tōshū, who holds the title of Important Intangible Cultural Property in Bizen ware. Graduates from the Sculpture Course, Nagoya University of Arts, in 1987. Wins the Grand Prize at the Mino Ceramics Competition in 1999. Dies in a traffic accident in 2012.

pages 100–101

KAWAI KANJIRŌ

河井 寛次郎

Born 1890, Shimane prefecture; died 1966

Impressed by a show of ceramic vessels by Bernard Leach, makes his acquaintance in 1911. After graduating in 1914 from the kilnwork course at Tokyo Higher Technical School (forerunner of the Tokyo Institute of Technology), works at the Kyoto Municipal Ceramics Laboratory (forerunner of the Kyoto Municipal Institute of Industrial Technology and Culture). Coins the word *mingei* (folkcraft) with Yanagi Muneyoshi (Sōetsu) and Hamada Shōji in 1925 and participates in the Mingei movement. Abandons the elaborate Chinese style to create stronger and more original work under the influence of the Mingei style.

pages 32–33

KISHI EIKO

岸 映子

Born 1948, Nara prefecture

Graduates from the Tekisui Museum of Art's Ceramic Art Research Institute in Ashiya, Hyōgō prefecture, in 1980. Graduates from Kyoto Seika University in 1998. Wins the Mainichi Newspaper Prize at the Women's Association of Ceramic Art Exhibition in 1980. Awarded the Prize of the Minister of Education, Culture, and Sports in 1985, and participates in the Women's Ceramic Art Exhibition through 1989. Receives the Grand Prize at the Asahi Ceramic Art Exhibition in 1985 and the Chōza Grand Prize at the 20th Chōza Prize Exhibition of Ceramic Art in 1991. In residence at Northern Clay Center, Minneapolis, Minn., in 1999. Begins to work in her original *saiseki-zōgan* method of making forms from clay slabs with colored chamotte in 1984.

page 83

KITAMURA JUNKO
北村 純子
Born 1956, Kyoto

Married to the ceramic artist Akiyama Yō. Wins the Mayor's Prize at the Graduation Works Exhibition of Kyoto City University of Arts in 1980. First single-artist show in 1980. Receives degree from the graduate school of Kyoto City University of Arts in 1982. Participates in *Soaring Voices: Contemporary Japanese Women Ceramic Artists* at the Shigaraki Ceramic Central Park in 2007 (touring overseas). Exhibits at *Touch Fire: Contemporary Japanese Ceramics by Women Artists*, Smith College Museum of Art, Northampton, Mass., in 2009.

page 85

KITAŌJI ROSANJIN
北大路 魯山人
Born 1883, Kyoto prefecture; died 1959

Starts his career in the realm of calligraphy in Tokyo in 1904. Interested in cuisine, opens the restaurant Bishoku kurabu (Gourmets' Club) above his gallery in 1921 and begins making ceramic tableware through interaction with Suda Seika, a ceramicist in Ishikawa prefecture, in 1923. In 1925 moves his restaurant to another part of Tokyo, renames it Hoshigaoka saryō (Hoshigaoka Tea-Ceremony Hut), and becomes head chef. In 1926 builds his kiln in Kamakura and begins providing tableware for the restaurant, developing his designs by studying antique techniques and styles.

pages 34–35

KIYOMIZU ROKUBEY VII
七 代清水 六兵衞
[Kiyomizu Kyūbey 清水 九兵衞]
Born 1922, Aichi prefecture; died 2006

Birth name Tsukamoto Hiroshi. Adopted by the Kiyomizu family in 1951 and starts making ceramic works. Graduates from the metal-casting program at Tokyo University of the Arts in 1953. Exhibits first sculpture in 1966. Specializes in aluminum sculptures, many created for outdoor sites. Succeeds to the name Kiyomizu Rokubey VII in 1980 and begins to make ceramics again. After his elder son, Kiyomizu Masahiro, succeeds to the name Rokubey VIII in 2000, dedicates himself to sculpture.

page 45

KOHYAMA YASUHISA

神山 易久

Born 1936, Shiga prefecture

Graduates from the Shiga Prefectural Job Training School and studies with Hineno Sakuzō, a ceramic designer in 1955. Builds a tunnel kiln (*anagama*) and begins to research natural glaze and ancient Sue ware in 1968. Single-artist show at the Takashimaya Department Store from 1979 onward. Artist in residence at the European Ceramic Workcenter in the Netherlands in 1992. Invited to the Cleveland Institute of Art and the University of Kent in 1994. Exhibits *Tōji: Avant-garde et tradition de la céramique japonaise* at the National Museum of Ceramics, Sèvres, France, in 2006. Creates handbuilt forms based on Shigaraki traditional methods using rough clay and *anagama* firing.

pages 68–71

KOIKE SHŌKO

小池 頌子

Born 1943, Beijing, China

Married to the ceramic artist Kawasaki Tsuyoshi. Receives degree from the graduate school of Tokyo University of the Arts and has a studio in Tokyo in 1969. First single-artist show in 1983. *From Beyond Ultramarine: Koike Shōko Exhibition* at the Musée Tomo in Tokyo, 2007. Participates in *Soaring Voices: Contemporary Japanese Women Ceramic Artists*, Shigaraki Ceramic Central Park in 2007 (touring overseas). Receives the Japan Ceramic Society Award in 2008. Exhibits at *Touch Fire: Contemporary Japanese Ceramics by Women Artists*, Smith College Museum of Art, Northampton, Mass., in 2009.

page 79

KOINUMA MICHIO

肥沼 美智雄

Born 1936, Tokyo

Studies economics at Osaka University and Waseda University. Builds a kiln in Mashiko. Wins the Prize for Excellence at the Northern Kantō Art Exhibition, Tochigi Prefectural Museum of Fine Arts, in 1974. Exhibits in single-artist shows from 1975 onward. Receives the Tochigi Maronie Cultural Award in 1991.

page 58

KONDŌ TAKAHIRO

近藤 髙弘

Born 1958, Kyoto prefecture

Grandson of Kondō Yūzō, a holder of the title of Important Intangible Cultural Property in underglazed cobalt porcelains. His father, Kondō Hiroshi, is also a ceramicist. Graduates from the Kyoto Industrial Research Institute in 1986. Single-artist show at the São Paulo Museum of Art in 1990. Given Kyoto City Young Artists Award in 1994. Receives degree from Edinburgh College of Art, Edinburgh University; awarded Inglis Allen Masters of Design Award in 2003. Exhibitions include *Kondō Takahiro: Metamorphose*, Paramita Museum, Mie prefecture, 2007 (touring exhibition); *Kondō Takahiro: Self Portrait*, Museum of Arts and Crafts, Itami, 2010.

pages 94–95

KOYAMA FUJIO

小山 富士夫

Born 1900, Okayama prefecture; died 1975

After being discharged from the military, starts to study ceramics in the 1920s. After training in ceramics in Seto and Kyoto and visiting China and Korea, establishes a kiln in Kyoto in 1926. Becomes friends with Ishiguro Munemaro there. In 1930, moves to Tokyo to research antique Chinese and Japanese ceramics. Discovers and excavates Ding ware site in China in 1941. In 1950, starts working at the National Commission for the Protection of Cultural Properties, yet resigns in 1961 because of a controversy regarding the mistaken attribution of a fake ceramic as an antique. He deals with various traditional Japanese styles such as *kohiki*, Karatsu, and overglazed enamels. In 1972, builds his final kiln in Gifu prefecture, producing representative pieces during the last ten years of his life.

page 37

MAEDA CHIKUBŌSAI I

初代 前田 竹房斎

Born 1872, Osaka prefecture; died 1950

Begins his self-taught bamboo-crafting career around the age of fourteen. Becomes renowned as a master craftsman, and often offers his baskets to the Emperor and the Imperial family from the 1910s to 1920s.

page 108

MIHARA KEN

三原 研

Born 1958, Shimane prefecture

Studies with Funaki Kenji in 1981. First participates in the *Tea Ceremony Forms Exhibition*, Tanabe Museum of Art, 1985. First single-artist show in 1989. Stays in Italy, supported by a Kikuchi Foundation overseas research grant in 2005–6. Wins second prize at the First Paramita Ceramic Competition in 2006. Receives the Japan Ceramic Society award in 2007. Wins the Grand Prize, *Tea Ceremony Forms Exhibition*, Tanabe Museum of Art, in 2001 and 2008.

pages 98–99

MIMURA CHIKUHŌ

三村 竹萌

Born 1973, Tokyo prefecture

Graduates from the Ōita Prefectural Beppu Higher Technical School (later part of the Ōita Prefectural Bamboo Craft and Training Support Center) in 1999. Graduates from the Beppu Advanced Industrial Arts and Technology Institute (also part of the Ōita Prefectural Bamboo Craft and Training Support Center) in 2000. Studies with Yufu Shōhaku and Honda Shōryū in the traditional basketry-producing area of Beppu in 2001. Given the artist name Chikuhō ("Bamboo Sprout") by his teacher Yufu. In 2001, starts showing his work in the United States, at the first SOFA contemporary crafts fair, Chicago, and also shows his work at *The Next Generation*, University of Arkansas, Little Rock. Participates in the exhibition *Twelve Artists in Beppu Bamboo Craft* at the B-Con Plaza, Beppu, in 2007. Participates in *New Bamboo: Contemporary Japanese Masters* exhibition, Japan Society, New York, in 2008.

page 126

MIYASHITA ZENJI

宮下 善爾

Born 1939, Kyoto prefecture; died 2012

Son of Miyashita Zenju, a ceramicist. Attends Kyoto City University of Art, where he is influenced by Kiyomizu Rokubey VII (also known as Kiyomizu Kyūbey). Completes his studies in 1966, then works at the same university as a lecturer. Begins to show his work at the Japan Art Exhibition in the same year.

page 49

MIZUKAMI KATSUO
水上 勝夫
Born 1955, Tokoname, in Aichi prefecture

Son of a kiln master. Graduates from the Kanazawa College of Art in 1979. Studies with Imai Masayuki, a member of the Japan Art Academy in Kyoto. Returns to Tokoname in 1987. Wins the Excellence Prize at the Asahi Ceramic Art Exhibition in 1990. First single-artist show in 1991. Wins the Judge's Prize at the 30th Chōza Prize Exhibition of Ceramic Art in Tokoname in 2001, Incentive Award in 2009. Builds a tunnel kiln (*anagama*) in 2005. Produces a ceramic wall in Segi Hall, Tokoname, in 2007.

page 93

MIZUNO KEISUKE
水野 圭介
Born 1969, Aichi prefecture

Studies at State University of New York, Buffalo, in 1988–89, and then at Community College of Allegheny County, Pittsburgh, Penn. in 1989–90. Attends Indiana University, Bloomington, Ind. as a science major, graduating in 1993. Studies at Kansas City Art Institute, Kansas City, Mo., 1993–94. Completes graduate school at Arizona State University in 1997. Wins the Bronze Award at the Fifth International Ceramics Festival, Mino, Japan, in 1998.

page 102

MONDEN KŌGYOKU
門田 皇玉
Born 1916, Hiroshima prefecture

Studies basketry in Beppu at the age of seventeen. Moves back to Fukuyama city, Hiroshima prefecture, and starts producing baskets as an independent artist in 1945. First presents work at the Japan Traditional Art Crafts Exhibition in 1987. Starts showing his work in the United States in the late 1990s.

page 112

MORIGAMI JIN
森上 仁
Born 1955, Ōita prefecture

First presents work at the Japan Art Exhibition in 1981. Wins a Final Judge's Prize at the Third Lloyd Cotsen Bamboo Awards in 2004. Presents work for the first time at the Japan Contemporary Arts and Crafts Exhibition in 2005. Participates in the exhibition *New Bamboo: Contemporary Japanese Masters* at the Japan Society, New York, in 2008. Exhibits in *Artists Who Studied in Ōita and Their Great Achievements* at the Ōita Prefectural Art Center in 2012.

pages 123–25

MORINO HIROAKI TAIMEI
森野 泰明
Born 1934, Kyoto prefecture

Son of Morino Kakō, a famous ceramicist in Kyoto. Father of the ceramic artist Morino Akito. First presents work in the Japan Art Exhibition in 1957. Graduates from the Kyoto City College of Fine Arts (forerunner of the Kyoto City University of Arts) in 1958. Teaches ceramics at the University of Chicago in 1962 and 1966. Participates in the exhibition *Quintessence of Modern Japanese Ceramics*, Ibaraki Ceramic Art Museum, in 2006. Becomes a recipient of the Japan Ceramic Society's Gold Award in 2009. Becomes a member of the Japan Art Academy in 2010.

pages 50–51

NAGAE SHIGEKAZU
長江 重和
Born 1953, Aichi prefecture

Son of a kiln master. Graduates from the Ceramic Art Advanced Course at the Aichi Prefectural Seto Ceramic Industry High School in 1974. Wins the Grand Prize at the Asahi Ceramic Art Exhibition in 1992. Wins the Grand Prize at the Triennale de la Porcelaine, Nyon, Switzerland, and the Grand Prize at the International Ceramics Festival, Mino, Japan, in 1998. Becomes a member of the International Academy of Ceramics in 2002. Receives the Cultural Prize, Art Selection, of Aichi prefecture in 2004. Participates in the exhibition *Quintessence of Modern Japanese Ceramics*, Ibaraki Ceramic Art Museum, in 2006.

page 91

NAGAKURA KEN'ICHI

長倉 健一

Born 1952, Shizuoka prefecture

Studies with his grandfather, Nagakura Katsuzō. First single-artist show in 1982. His main activities are solo exhibitions; does not belong to any crafts organization. Wins the Grand Prize at the First Lloyd Cotsen Bamboo Award in 2000. Participates in the exhibition *New Bamboo: Contemporary Japanese Masters* at the Japan Society, New York, in 2008. Exhibits in *Inheritance and Innovation in Bamboo Art* at the Oita Prefectural Art Center in 2012.

pages 130–131

NISHIHATA TADASHI

西端 正

Born 1948, Hyōgo prefecture

Studies ceramics including wheel-building with his father, Nishihata Sueharu, from 1969. First presents work at the Japan Traditional Art Crafts Exhibition in 1986 and wins the Japan Craft Association President Prize at the same exhibition in 1989. First single-artist show in the United States in 2004. Fires his works in a tunnel kiln (*anagama*) or a climbing kiln (*noborigama*).

pages 60–61

ŌTANI SHIRŌ

大谷 司朗

Born 1936, Shiga prefecture

Studies at the Kyoto Municipal Institute of Industrial Technology and Culture. Presents his Shigaraki-style work at the Japan Traditional Art Crafts Exhibition from 1969 onward. Comes to the United States as an artist in the Japanese government's Overseas Study Program in 1980. Returns to Shigaraki in 1981 and continues making ceramics there.

pages 54–55

SAKIYAMA TAKAYUKI
崎山 隆之
Born 1958, Shizuoka prefecture

Graduates from Osaka University of Arts in 1981. Has a studio in Nishi'izu, Shizuoka prefecture, in 1987. Wins the Grand Prize at the Japan Ceramics Exhibition in 2005. First single-artist show in 2007. Receives Shizuoka Prefectural Cultural Incentive Award in 2009 and wins an incentive award at the Kikuchi Biennale IV in 2011. Participates in *Touch Vessels* exhibition at Higashi Hiroshima City Museum of Art in 2012.

pages 96–97

SAKURAI YASUKO
櫻井 靖子
Born 1969, Kyoto prefecture

Graduates from Kyoto Seika University in 1991. Graduates from the ceramics course at the Kyoto Industrial Research Institute in 1993. Around 1997 begins to build work from tubelike porcelain forms. Artist in residence at the Shigaraki Ceramic Cultural Park in 1993 and 1998, and at the National School of Decorative Arts, Limoges, supported by a scholarship from the French government in 1999. Works as a lecturer at the Kyoto University of Arts and Design from 2008 onward. Wins a Bronze Prize at the Fourth World Ceramic Biennale 2007, International Competition, Korea, in 2007. Receives the Kyoto City Young Artists Award in 2011.

page 84

SHŌNO TOKUZŌ
生野 徳三
Born 1942, Ōita prefecture

After graduating from the sculpture department of Musashino Art University, begins to study with his father, Shōno Shōunsai, in 1964. At first, works on vessels for everyday use as a craftsman at Shōunsai's workshop. After the death of Shōunsai in 1974, becomes an independent bamboo artist. First single-artist show in 1975. Submits his works to the Japan Art Exhibition from 1979 onward; wins a Special Prize in 1998. Starts showing his works at the Second Japan New Crafts Exhibition, 1980. A retrospective exhibition is held at the Ōita City Museum in 2001. Begins to show his works in the United States in 2003. Participates in the exhibition *New Bamboo: Contemporary Japanese Masters* at the Japan Society, New York, in 2008. Exhibits at *Inheritance and Innovation in Bamboo Art* at the Ōita Prefectural Art Center in 2012.

page 132

SUGITA JŌZAN

杉田 静山

Born 1932, Osaka prefecture

Moves to Shiga prefecture in 1945 and starts to make basketry. Graduates from Musashino Art University in 1962. First presents work at the Japan Art Exhibition in 1969. First presents work at the Japan Traditional Art Crafts Exhibition in 1973; wins Incentive Award in 1994, and the Minister of Education, Culture, Sports, Science and Technology Prize at the same exhibition in 1996. Shiga Prefectural Kusatsu Culture Art Hall holds the exhibition *Beauty in Life: Bamboo Craft of Sugita Jōzan* in 1998. Twenty pieces by Sugita Jōzan were acquired by the Museum of Modern Art, Shiga, in 1999.

pages 114–15

SUGIURA NORIYOSHI

杉浦 功悦

Born 1964, Miyagi prefecture

Graduates from the Ōita Prefectural Beppu Higher Technical School (later part of the Ōita Prefectural Bamboo Craft and Training Support Center) in 1998, and then studies with Watanabe Chikusei II. First submits his work to the Japan Traditional Art Crafts Exhibition in 2004. Received the Special Judge's Prize at the 16th National Bamboo Art Exhibition in 2011, and the Excellence Prize at the 17th in 2012. Participates in the *Artists Who Studied in Ōita and Their Great Achievements* exhibition at the Ōita Prefectural Art Center in 2012.

page 133

SUZUKI GORŌ

鈴木 五郎

Born 1941, Aichi prefecture

Begins to produce ceramic works in 1957. First presents his work at the Japan Art Exhibition in 1962. Wins the Grand Prize at the Asahi Ceramic Art Exhibition in 1966. After working as a designer at Kasen-tōen, a ceramics factory in Seto (a pottery-producing region), goes to Los Angeles and makes the acquaintance of the ceramic artist Kaneko Jun in 1969. Invited as a lecturer at a workshop at the Rhode Island School of Design in 1975 and at the Cranbrook Academy of Art in 1982.

pages 52–53

SUZUKI OSAMU

鈴木 治

Born 1926, Kyoto prefecture; died 2001

Studies with his father, Suzuki Ugenji. Participates in the foundation of the Crawling Through Mud Association collective in 1948. Beginning in the mid-1950s, creates not only vessels but also other ceramic objects, as well as functional daily tableware from the second half of the 1950s onward. From the 1960s to 1970s, calls his three-dimensional works, often coated in red clay, *deizō* (clay figures), and from the 1980s onward, *deisho* (clay objects). Also works with bluish white porcelain starting in the 1970s, and tries using Shigaraki clay and a tunnel kiln (*anagama*) in 1988. Works as a professor at the Kyoto City University of Arts from 1979 to 1992. Receives the 69th Asahi Prize in 1999. In the same year the National Museum of Modern Art, Tokyo, presents the exhibition *Ceramics of Suzuki Osamu*, which tours to Fukushima, Kyoto, Hiroshima, and Kurashiki.

not illustrated

TAKEGOSHI JUN (Takegoshi Taizan IV)

武腰 潤 (四代武腰泰山)

Born 1948, Ishikawa prefecture

Studies with his father, Takegoshi Taizan III. Graduates from the Japanese-style painting course at Kanazawa College of Art in 1970. Studies with Kitade Fujio in 1972. Shows his ceramic works at the Japan Art Exhibition from 1974 to 1987. First presents work at the Japan Traditional Art Crafts Exhibition in 1988; wins the Asahi Shinbun Company Prize in 2002 and the Incentive Award in 2004. Receives the Japan Ceramic Society award in 2006.

page 57

TAKEUCHI KŌZŌ

竹内 紘三

Born 1977, Hyōgo prefecture

Graduates from Osaka University of Arts in 2001 and from the Tajimi City Pottery Design and Technical Center in 2003. Participates in the 22nd Asahi Modern Craft Exhibition, and the 45th Japan Craft Exhibition in 2004. First single-artist show in 2005. Wins an Incentive Award at the 27th Chōza Prize Exhibition of Ceramic Art in 2005. Participates in a workshop at the Harvard University Ceramic Program, Office for the Arts, in 2007.

page 103

TAKIGUCHI KAZUO

滝口 和男

Born 1953, Kyoto prefecture

Son of a wholesaler of tablewares in Gojōzaka, an area of Kyoto famous for ceramics. Leaves Kyoto City University of Arts and studies with Kiyomizu Rokubey VI in 1978, participating in the Japan Art Exhibition from that year up to 1990, except for 1980–81. Wins the Foreign Minister's Prize at the Japan Ceramic Exhibition in 1985, and the Grand Prize in 1989. Goes to London to study at the Royal College of Art in 1991.

page 92

TAMURA KŌICHI

田村 耕一

Born 1918, Tochigi prefecture; died 1987

Graduates from Tokyo Fine Arts School (forerunner of the Tokyo University of the Arts) in 1941. Studies with Tomimoto Kenkichi in Kyoto in 1946. Works at the Tochigi Prefectural Ceramic Institute, with the recommendation of Hamada Shōji, an Important Intangible Cultural Property Holder in Mingei-style pottery, in 1950. Resigns from the institute and builds his own climbing kiln (*noborigama*) to start his career as a ceramicist in 1953. First exhibits and wins the Incentive Award at the Seventh Japan Traditional Art Crafts Exhibition in 1960. Becomes a professor at Tokyo University of the Arts in 1977. Designated as an Important Intangible Cultural Property Holder working in iron brush painting (*tetsu-e*) in 1986.

page 36

TANABE CHIKUUNSAI II

二代 田辺 竹雲斎

Born 1910, Osaka prefecture; died 2000

Studies with his father, Tanabe Chikuunsai I. First presents work using his former name, Shōchikuunsai ("Small Chikuunsai"), in the Twelfth Imperial Art Exhibition in 1931. Succeeds to the artist name of Tanabe Chikuunsai II in 1937, when his father dies. Wins the Special Prize at the Eighth Japan Art Exhibition in 1952. Participates in the foundation of the Japan Contemporary Arts and Crafts Artists Association in 1961, and of the Japan New Crafts Artists Association in 1978. Gives his name to his eldest son in 1991 and calls himself Itchikusai.

page 109

TOKUMARU KYŌKO

徳丸 鏡子

Born 1963, Tokyo prefecture

Wins the Grand Prize at the 19th Chōza Prize Exhibition of Ceramic Art in 1990. Receives a degree from the graduate school of Tama Art University in 1992. First single-artist show in 1994. Wins the Bronze Prize at the Izushi Porcelain Competition in 2000. Artist's residency at the Contemporary Craft Museum, Portland, Ore., in 2001; at Arizona State University with a fellowship from the Agency for Cultural Affairs, Japan, in 2003; and at Yingge Ceramics Museum, Taipei, Taiwan, in 2012.

pages 86–87

TOMIMOTO KENKICHI

富本 憲吉

Born 1886, Nara prefecture; died 1963

After graduating from the design course at the Tokyo Fine Arts School (forerunner of the Tokyo University of the Arts) in 1909, studies at the Central School of Arts and Crafts in London and is impressed by craft pieces at the Victoria and Albert Museum. In 1913, begins to make ceramics with his own *raku* kiln in Nara prefecture. Starts to create white porcelain and underglazed cobalt pieces in 1919. Moves to Tokyo in 1926. From around 1930, works with overglaze enamels, and especially from the 1950s, enamel-glazed porcelains decorated with gold and silver. Becomes an invited professor at the Kyoto Municipal Fine Arts Specialty School (forerunner of the Kyoto City University of Arts) in 1949, regular professor in 1950. In 1955, designated an Important Intangible Cultural Property Holder in enamel-overglazed porcelain.

pages 12, 29

TORII IPPŌ

鳥居 一峯

Born 1930, Aichi prefecture; died 2011

Studies with his father, Torii Hōunsai. Wins the Prize of the Governor of Tokyo at the Japan Vase and Tea Utensil Exhibition in 1957. First presents his work at the 19th Japan Contemporary Arts and Crafts Exhibition in 1980, and at the 13th Japan Art Exhibition in 1981. Wins the Contemporary Arts and Crafts Prize at the 26th Japan Contemporary Arts and Crafts Exhibition in 1987, a prize for members of the Contemporary Arts and Crafts Artists Association in 1991, and the Hasuda Shūgorō Prize in 2001. Starts showing his work in the United States from the beginning of this century. Wins a Special Prize at the 38th Japan Art Exhibition in 2006. Participates in the exhibition *New Bamboo: Contemporary Japanese Masters* at the Japan Society, New York, in 2008. Around 1980, changes from making flower baskets for the tea ceremony to nonfunctional art objects.

page 116

WADA MORIHIRO

和田 守卑良

Born 1944, Hyōgo prefecture; died 2008

Graduates from the Kyoto City College of Fine Arts (forerunner of the Kyoto City University of Arts) in 1967. During his university years, he makes the acquaintance of Hamada Shōji and Kamoda Shoji. First single-artist show in 1968. Stays and produces ceramics in Kōchi prefecture from 1967 to 1975. Moves to Ibaraki prefecture, which contains the pottery-producing region of Kasama. Wins the Gold Prize at the 30th Premio Faenza, International Museum of Ceramics in Faenza, Italy, and first presents his work at the Japan Traditional Art Crafts Exhibition in 1980. Tsukuba Museum of Art, Ibaraki, hosts the touring exhibition *Wada Morihiro Exhibition: Endless Story of Ceramics* in 1998.

pages 72–74

WATANABE CHIAKI

渡辺 千明

Born 1969, Yamanashi prefecture

Moves to the basketry-producing region of Sado Island, Niigata prefecture, in 2008; studies basketry there. First presents his work at the 64th Niigata Prefecture Arts Exhibition in 2009. In 1992, presents his work for the first time at the 50th Japan Contemporary Arts and Crafts Exhibition. Wins the prize for Excellent Work at the 16th National Bamboo Craft Exhibition in 2011. His work ranges from functional baskets to autonomous objects.

page 121

YAKO HŌDŌ

八子 鳳堂

Born 1940, Niigata prefecture

Learns the basics of bamboo technique at vocational school in 1959 and studies with Nakajima Hōsō in 1960. Moves to Tokyo; studies with Nakamura Yūkōsai in 1964, then with Baba Shōdō in 1965. First presents work at the Japan Art Exhibition in 1973 and moves to Saitama prefecture. Shows work at the Japan Contemporary Arts and Crafts Exhibition for the first time in 1978. First single-artist show at the Yagihashi department store, Saitama, in 1982. Presents work at the Japan Traditional Art Crafts Exhibition for the first time in 1994. In 1997, starts showing his work in the United States, at the SOFA contemporary crafts fair, Chicago. Participates in the exhibition *New Bamboo: Contemporary Japanese Masters* at the Japan Society, New York, in 2008.

page 113

YAMADA HIKARU

山田 光

Born 1923, Tokyo; died 2001

Son of the potter Yamada Tetsu. Graduates from the Kyoto Industrial Specialty School (forerunner of the Kyoto Institute of Technology) in 1945. Participates in founding the Crawling Through Mud Association collective in 1948. Creates ceramic objects as well as other vessels from the mid-1950s. Begins to make thin forms with *irabo* glaze at the end of the 1950s, then gradually starts to use Oribe and other glazes as well as making unglazed wares. Works on functional daily tableware from the early 1960s onward. At the beginning of the 1970s creates forms suggesting walls with windows to viewers. Starts using silver on his forms in 1987. His *Screen* series appears in 1993, followed by the *Pipe* series.

pages 42–43

YAMAGUCHI RYŪUN

山口 龍雲

Born 1940, Saga prefecture

Graduates from the Ōita Prefectural Beppu Handicapped People Professional Training School (later part of the Ōita Prefectural Bamboo Craft and Training Support Center) in 1957. In 1963, studies with Shōno Shōunsai, holder of the title of Important Intangible Cultural Property in bamboo craft. Wins a special prize at the *Third New Bamboo Products* competition in Beppu, 1967. First presents his work at the Japan New Crafts Exhibition in 1982, and at the Japan Art Exhibition in 1994. Participates in the exhibitions *New Bamboo: Contemporary Japanese Masters*, at the Japan Society in New York in 2008, and *Artists Who Studied in Ōita and Their Great Achievements* at the Ōita Prefectural Art Center in 2012. He is also a swordsmith.

pages 127–29

Bunten (Ministry of Education Art Exhibition)

Chanoyu no zōkeiten (Tea Ceremony Forms Exhibition)

Crawling Through Mud Association (Sōdeisha)

Creative Ceramics Exhibition (Sōsaku tōjiten)

East Ceramics Association (Tōtōkai)

Eastern Japan Traditional Art Crafts Exhibition (Higashi Nihon dentō kōgeiten)

Higashi Nihon dentō kōgeiten (Eastern Japan Traditional Art Crafts Exhibition)

Imperial Art Exhibition (Teiten)

Japan Art Academy (Nihon geijutsuin)

Japan Art Exhibition (Nitten)

Japan Ceramic Society (Nihon tōji kyōkai)

Japan Contemporary Arts and Crafts Artists Association (Nihon gendai kōgei bijutsuka kyōkai)

Japan Contemporary Arts and Crafts Exhibition (Nihon gendai kōgei bijutsuten)

Japan Craft Association (Nihon kōgeikai)

Japan New Crafts Artists Association (Nihon shin kōgeika renmei)

Japan New Crafts Exhibition (Nihon shin kōgeiten)

Japan Traditional Art Crafts Exhibition (Nihon dentō kōgeiten)

Japan Traditional Art Crafts New Work Exhibition (Nihon dentō kōgei shin sakuten)

Japan Traditional Wood and Bamboo Art Crafts Exhibition (Nihon dentō kōgei mokuchikuten)

Joryū tōgei (Women's Association of Ceramic Art)

Kokuga sōsaku kyōkai (National Painting Creation Association)

Ministry of Agriculture, Forestry and Commercial Design and Applied Work Exhibition (Nōten)

Ministry of Education Art Exhibition (Bunten)

National Painting Creation Association (Kokuga sōsaku kyōkai)

New Crafts Artists Association (Shinshōkai)

Nihon dentō kōgei mokuchikuten (Japan Traditional Wood and Bamboo Art Crafts Exhibition)

Nihon dentō kōgei shin sakuten (Japan Traditional Art Crafts New Work Exhibition)

Nihon dentō kōgeiten (Japan Traditional Art Crafts Exhibition)

Nihon geijutsuin (Japan Art Academy)

Nihon gendai kōgei bijutsuka kyōkai (Japan Contemporary Arts and Crafts Artists Association)

Nihon gendai kōgei bijutsuten (Japan Contemporary Arts and Crafts Exhibition)

Nihon kōgeikai (Japan Craft Association)

Nihon shin kōgeika renmei (Japan New Crafts Artists Association)

Nihon shin kōgeiten (Japan New Crafts Exhibition)

Nihon tōji kyōkai (Japan Ceramic Society)

Nitten (Japan Art Exhibition)

Nōten (Ministry of Agriculture, Forestry and Commercial Design and Applied Work Exhibition)

Red Clay (Sekido)

Sekido (Red Clay)

Seven Persons' Society (Shichininsha)

Shichininsha (Seven Persons' Society)

Shikōkai (Society of Four Harvests)

Shinshōkai (New Crafts Artists Association)

Society of Four Harvests (Shikōkai)

Sōdeisha (Crawling Through Mud Association)

Sōsaku tōjiten (Creative Ceramics Exhibition)

Tea Ceremony Forms Exhibition (Chanoyu no zōkeiten)

Teiten (Imperial Art Exhibition)

Tōtōkai (East Ceramics Association)

Women's Association of Ceramic Art (Joryū tōgei)

CHECKLIST

p. 29
Tomimoto Kenkichi (1886–1963)
Box with decoration of wild grapes
1928
Stoneware
7.6 x 18 cm (3 x 7⅛ in.)
2012.680a–b
© Kaido Ryukichi

p. 30
Ishiguro Munemaro (1893–1968)
Lidded vessel
1940s–1950s
Stoneware
16.1 x 15.2 cm (6⅜ x 6 in.)
2012.638a–b

p. 31
Ishiguro Munemaro (1893–1968)
Jar with incised decoration of birds
1930s–1940s
Stoneware
27.9 x 76.2 cm (11 x 30 in.)
2012.639

p. 32
Kawai Kanjirō (1890–1966)
Vase in the shape of a flask
1950s
Stoneware
20 x 15 x 14 cm (7⅞ x 5⅞ x 5½ in.)
2012.644

p. 33
Kawai Kanjirō (1890–1966)
Hexagonal pedestal vase
1930s–1940s
Stoneware
23 x 18 x 11 cm (9 x 7⅛ x 4⅜ in.)
2012.645

pp. 34–35
Kitaōji Rosanjin (1883–1959)
Yellow Seto-style plates with design of iris
About 1951
Stoneware
Each: 7 x 20 x 20 cm (1¼ x 7⅞ x 7⅞ in.)
Promised gift of the Stanley and Mary Ann Snider Collection

p. 36
Tamura Kōichi (1918–1987)
Box
About 1970
Stoneware
8.9 x 15.2 x 12.7 cm (3½ x 6 x 5 in.)
2012.678a–b

p. 37
Koyama Fujio (1900–1975)
Square iron-slip flower vessel
1986
Stoneware
19 x 16 x 15.2 cm (7½ x 6¼ x 6 in.)
Promised gift of the Stanley and Mary Ann Snider Collection

p. 40
Hayashi Yasuo (b. 1928)
Slant and Front
1989
Stoneware
32 x 36.8 x 35.6 cm (12⅝ x 14½ x 14 in.)
2012.634

p. 41
Hayashi Yasuo (b. 1928)
Screen
1995
Stoneware
35.6 x 30.5 x 12.7 cm (14 x 12 x 5 in.)
2012.635

p. 42
Yamada Hikaru (1923–2001)
Silver-glazed screen
About 1993
Stoneware
39.7 x 61 x 8.9 cm (15⅝ x 24 x 3½ in.)
Promised gift of the Stanley and Mary Ann Snider Collection

p. 43
Yamada Hikaru (1923–2001)
Smoke-blackened screen
1983
Stoneware
47.9 x 41.3 x 7 cm (18⅞ x 16¼ x 2¾ in.)
2012.684

p. 45
Kiyomizu Rokubey VII (Kiyomizu Kyūbey) (1922–2006)
Untitled
1998
Stoneware
30.5 x 30.5 x 10.2 cm (12 x 12 x 4 in.)
2012.648
© Kiyomizu Rokubey VII

p. 49
Miyashita Zenji (1939–2012)
The Indication of Ascension
2003
Stoneware
56.5 x 28.6 x 14.6 cm (22¼ x 11¼ x 5¾ in.)
2012.657
© Estate of Miyashita Zenji

p. 50
Morino Hiroaki Taimei (b. 1934)
Floating Cloud
2005
Stoneware
43.2 x 29.2 x 15.9 cm (17 x 11½ x 6¼ in.)
2012.660

p. 51
Morino Hiroaki Taimei (b. 1934)
Crest of a Wave
2003
Stoneware
19.1 x 16.5 x 5.7 cm (7½ x 6½ x 2¼ in.)
2012.661

p. 52
Suzuki Gorō (b. 1941)
Plate with Oribe-style decoration
1980s
Stoneware
5.5 x 32 x 33 cm (2⅛ x 12⅝ x 13 in.)
2012.671

p. 53
Suzuki Gorō (b. 1941)
Shigaraki-style flower container
1980s
Stoneware
26 x 19.1 x 24.1 cm (10¼ x 10¾ x 9½ in.)
2012.672

p. 53
Suzuki Gorō (b. 1941)
Shigaraki-style flower container
1980s
Stoneware
27 x 17.8 x 14 cm (10⅝ x 7 x 5½ in.)
2012.673

p. 54
Ōtani Shirō (b. 1936)
Vase
Before 2006
Shigaraki ware; stoneware
31.8 x 19.1 x 13.3 cm (12½ x 7½ x 5¼ in.)
2012.665

p. 54
Ōtani Shirō (b. 1936)
Vase
Before 2006
Shigaraki ware; stoneware
31.8 x 16.5 x 13.3 cm (12½ x 6½ x 5¼ in.)
2012.666

p. 55
Ōtani Shirō (b. 1936)
Vase
Before 2006
Shigaraki ware; stoneware
40.6 x 35.6 x 25.4 cm (16 x 14 x 10 in.)
2012.667

p. 56
Harada Shūroku (b. 1941)
Vase
2006
Bizen ware; stoneware
25.4 x 12.7 x 14 cm (10 x 5 x 5½ in.)
2012.685
© Harada Shūroku

p. 57
Takegoshi Jun (Takegoshi Taizan IV) (b. 1948)
Box with decoration of sparrows perched on a branch
2010
Porcelain
6.4 x 20.6 x 9.8 cm (2½ x 8⅛ x 3⅞ in.)
2012.675a–b

p. 58
Koinuma Michio (b. 1936)
Archaic Vessel
2011
Stoneware
34.6 x 15.2 x 12.7 cm (13⅝ x 6 x 5 in.)
2012.653
© Koinuma Michio

p. 59
Hirano Yūichi (b. 1941)
Vase
2006
Stoneware
43.2 x 38.1 x 31.8 cm (17 x 15 x 12½ in.)
2012.636

p. 60
Nishihata Tadashi (b. 1948)
Vase
2002
Stoneware
28.3 x 32.7 x 29.8 cm (11⅛ x 12⅞ x 11¾ in.)
2012.663

p. 61
Nishihata Tadashi (b. 1948)
Red slip-glazed vase
2005
Stoneware
32.4 x 24.1 cm (12¾ x 9½ in.)
2012.664

p. 65
Fukami Sueharu (b. 1947)
The Moment (Shun)
1998
Porcelain
42.5 x 101 x 20 cm (16¾ x 39¾ x 7⅞ in.)
2012.633

p. 66
Akiyama Yō (b. 1953)
Untitled T-610
2006
Stoneware
33 x 46 cm (13 x 18⅛ in.)
2012.631

p. 67
Akiyama Yō (b. 1953)
Untitled MV-1019 from the *Metavoid* series
2010
Stoneware
20.3 x 32.1 cm (8 x 12⅝ in.)
2012.632

p. 68
Kohyama Yasuhisa (b. 1936)
Wind Form #1
2009
Shigaraki ware; stoneware
43.8 x 43.2 x 14 cm (17¼ x 17 x 5½ in.)
2012.650

p. 69
Kohyama Yasuhisa (b. 1936)
Sculptural Form #2
2007
Shigaraki ware; stoneware
35 x 46.6 x 12.4 cm (13¾ x 18⅜ x 4⅞ in.)
2012.651

p. 70
Kohyama Yasuhisa (b. 1936)
Carved with Moon
2010
Shigaraki ware; stoneware
31.8 x 16.5 x 14 cm (12½ x 6½ x 5½ in.)
2012.649

p. 71
Kohyama Yasuhisa (b. 1936)
Slice of Earth
2010
Shigaraki ware; stoneware
15.2 x 84.8 x 24.9 cm (6 x 33⅜ x 9⅞ in.)
Promised gift of the Stanley and Mary Ann Snider Collection

p. 72
Wada Morihiro (1944–2008)
Vase
1993
Stoneware
34.9 x 14 x 15.2 cm (13¾ x 5½ x 6 in.)
2012.682
© Wada Morihiro

p. 73
Wada Morihiro (1944–2008)
Vessel with abstract motifs in red
1997
Stoneware
23.5 x 22.2 x 11.1 cm (9¼ x 8¾ x 4⅜ in.)
2012.681
© Wada Morihiro

p. 74
Wada Morihiro (1944–2008)
Vessel with decoration of curvilinear
patterns
2006
Stoneware
57.2 x 35.6 x 21 cm (22½ x 14 x 8¼ in.)
2012.683
© Wada Morihiro

p. 75
Kakurezaki Ryūichi (b. 1950)
Vase
2006
Bizen ware; stoneware
27.9 x 27.6 x 15.9 cm (11 x 10⅞ x 6¼ in.)
2012.640

p. 79
Koike Shōko (b. 1943)
Shell 95
1995
Stoneware
57.2 x 52.1 x 54.6 cm (22½ x 20½ x
21½ in.)
2012.652
© Koike Shōko

p. 80
Fujino Sachiko (b. 1950)
White Hour
2006
Stoneware

30.5 x 35.6 x 15.2 cm (12 x 14 x 6 in.)
Promised gift of the Stanley and
Mary Ann Snider Collection
© Fujino Sachiko

p. 81
Fujino Sachiko (b. 1950)
Bud Casing II
2011
Stoneware
39.1 x 60.3 x 39.1 cm
(15⅜ x 23¾ x 15⅜ x in.)
2012.686
© Fujino Sachiko

p. 82
Hoshino Kayoko (b. 1949)
Untitled
2006
Stoneware
38.1 x 41.3 x 25.4 cm (15 x 16¼ x 10 in.)
2012.637
© Hoshino Kayoko

p. 83
Kishi Eiko (b. 1948)
No. 4
2004
Stoneware
47.6 x 66.7 x 8.5 cm (18¾ x 26¼ x
3⅜ in.)
2012.646
© Kishi Eiko

p. 84
Sakurai Yasuko (b. 1969)
Vertical Flower
2007
Porcelain
45.1 x 38.1 cm (17¾ x 15 in.)
2012.670
© Sakurai Yasuko

p. 85
Kitamura Junko (b. 1956)
Vessel
2005
Stoneware
61 x 17.8 cm (24 x 7 in.)
2012.647
© Kitamura Junko

p. 86
Tokumaru Kyōko (b. 1963)
Germination
2001
Porcelain
61 x 45.7 x 30.5 cm (24 x 18 x 12 in.)
2012.679

p. 87
Tokumaru Kyōko (b. 1963)
Bud
2001
Porcelain
38.1 x 19.5 x 19.5 cm (15 x 7⅝ x 7⅝ in.)
2012.710

p. 91
Nagae Shigekazu (b. 1953)
Wind
2005
Porcelain
33 x 43.2 x 22.9 cm (13 x 17 x 9 in.)
2012.662

p. 92
Takiguchi Kazuo (b. 1953)
Untitled
2005
Stoneware
15.2 x 45.7 x 31.8 cm (6 x 18 x
12½ in.)
2012.677

p. 93
Mizukami Katsuo (b. 1955)
Vase
Before 2007
Stoneware
19.1 x 40.6 x 8.3 cm (7½ x 16 x 3¼ in.)
2012.658

p. 94
Kondō Takahiro (b. 1958)
Blue Green Mist
2006
Porcelain with glass
74.3 x 16.5 x 11.4 cm (29¼ x 6½ x
4½ in.)
2012.655

p. 95
Kondō Takahiro (b. 1958)
Mist, Silver Drops
2005
Porcelain with glass
12.2 x 19.1 x 8.3 cm (4⅞ x 7½ x 3¼ in.)
2012.654

p. 96
Sakiyama Takayuki (b. 1958)
Splash
2005
Stoneware
7.6 x 43.8 x 44.5 cm (3 x 17¼ x 17½ in.)
2012.668
© Sakiyama Takayuki

p. 97
Sakiyama Takayuki (b. 1958)
Listening to the Waves
2006
Stoneware
43.5 x 36.2 x 37.5 cm (17⅛ x 14¼ x
14¾ in.)
2012.669
© Sakiyama Takayuki

p. 98
Mihara Ken (b. 1958)
Folded Sculpture
2006
Stoneware
27.3 x 48.9 x 10.8 cm (10¾ x 19¼ x 4¼ in.)
Promised gift of the Stanley and Mary Ann Snider Collection

p. 99
Mihara Ken (b. 1958)
Origin
2006
Stoneware
49.1 x 49.5 x 30.5 cm (19⅜ x 19½ x 12 in.)
2012.656

p. 100
Katō Yasukage (1964–2012)
Vase with Oribe-style glaze
2006
Stoneware
14.6 x 43.2 x 40.6 cm (5¾ x 17 x 16 in.)
2012.641

p. 101
Katō Yasukage (1964–2012)
Vase with Oribe-style glaze
2003
Stoneware
40 x 26.7 x 18.1 cm (15¾ x 10½ x 7⅛ in.)
2012.642

p. 101
Katō Yasukage (1964–2012)
Shino-style water jar (*mizusashi*) with decoration of grasses
2003
Stoneware
22.2 x 17.8 x 18.4 cm (8¾ x 7 x 7¼ in.)
2012.643

p. 102
Mizuno Keisuke (b. 1969)
Standing Yellow Flower
2001
Porcelain
24.8 x 27.9 x 22.9 cm (9¾ x 11 x 9 in.)
2012.659

p. 103
Takeuchi Kōzō (b. 1977)
Modern Remains
2009
Porcelain
43.8 x 38.1 x 14 cm (17¼ x 15 x 5½ in.)
2012.676

p. 108
Maeda Chikubōsai I (1872–1950)
Basket with bamboo-root handle
1930s
Japanese timber bamboo (*madake*) and rattan
40.6 x 39.4 cm (16 x 15½ in.)
Promised gift of the Stanley and Mary Ann Snider Collection

p. 109
Tanabe Chikuunsai II (1910–2000)
Flower basket
After 1945
Japanese timber bamboo (*madake*), arrow bamboo (*yadake*), and rattan
21 x 40.6 cm (8¼ x 16 in.)
2012.703
© Tanabe Chikuunsai II

p. 110
Hatakeyama Seidō (b. 1930)
Bamboo Shoot
2007
Japanese timber bamboo (*madake*) and rattan
35.6 x 25.4 cm (14 x 10 in.)
2012.688

p. 111
Fujinuma Noboru (b. 1945)
Gentle
2007
Japanese timber bamboo (*madake*) and rattan
40.6 x 22.9 x 21.6 x cm (16 x 9 x 8½ in.)
Promised gift of the Stanley and Mary Ann Snider Collection

p. 112
Monden Kōgyoku (b. 1916)
Undulation
2005
Japanese timber bamboo (*madake*)
26.7 x 30.5 x 22.9 cm (10½ x 12 x 9 in.)
2012.694

p. 113
Yako Hōdō (b. 1940)
Late Autumn
2004
Japanese timber bamboo (*madake*) and rattan
38.1 x 20.3 x 13.3 cm (15 x 8 x 5¼ in.)
2012.705

p. 114
Sugita Jōzan (b. 1932)
Morning
1969
Japanese timber bamboo (*madake*) and rattan
50.8 x 43.2 cm (20 x 17 in.)
Promised gift of the Stanley and Mary Ann Snider Collection

p. 115
Sugita Jōzan (b. 1932)
Eddy
1993
Japanese timber bamboo (*madake*)

and rattan
16.5 x 36.8 x 36.8 cm (6½ x 14½ x 14½ in.)
2012.702

p. 116
Torii Ippō (1930–2011)
Flight
2003
Japanese timber bamboo (*madake*) and rattan
63.5 x 43.2 x 35.6 cm (25 x 17 x 14 in.)
2012.704

p. 117
Fujitsuka Shōsei (b. 1949)
Fire
2011
Smoked bamboo (*hobichiku*) and rattan
108 *x* 27.9 x 27.9 cm (42½ x 11 x 11 in.)
2012.687

p. 118
Honma Hideaki (b. 1959)
Play
2007
Dwarf bamboo (*nemagaridake*), Japanese timber bamboo (*madake*), and rattan
36.8 x 53.3 x 30.5 cm (14½ x 21 x 12 in.)
2012.691

p. 119
Honma Hideaki (b. 1959)
Rolling Shape II
2007
Bamboo (*men'yadake*) and dwarf bamboo (*nemagaridake*)
36.8 x 55.9 x 27.9 cm (14½ x 22 x 11 in.)
2012.692

p. 120
Honma Hideaki (b. 1959)
Double Winds
2006
Japanese timber bamboo (*madake*)
and rattan
73.7 x 39.4 x 29.2 x cm (29 x 15½ x
11½ in.)
2012.690

p. 121
Watanabe Chiaki (b. 1969)
Vitality
2011
Japanese timber bamboo (*madake*),
bamboo (*men'yadake*), and rattan
50.2 x 53.3 x 31.8 cm (19¾ x 21 x
12½ in.)
2012.709

p. 122
Honda Shōryū (b. 1951)
Uplifting
2006
Japanese timber bamboo (*madake*)
and rattan
45.7 x 33 x 29.2 cm (18 x 13 x 11½ in.)
2012.689

p. 123
Morigami Jin (b. 1955)
Red Flame
2007
Japanese timber bamboo (*madake*)
49.5 x 50.8 x 38.7 cm (19½ x 20 x
15¼ in.)
2012.695

p. 124
Morigami Jin (b. 1955)
Peerless
2008
Japanese timber bamboo (*madake*)
68.6 x 83.8 x 27.9 cm (27 x 33 x 11 in.)
2012.698

p. 125
Morigami Jin (b. 1955)
Harmony III
2006
Japanese timber bamboo (*madake*)
and rattan
33 x 50.8 x 50.2 cm (13 x 20 x 19¾ in.)
2012.697

p. 125
Morigami Jin (b. 1955)
Harmony II
2006
Japanese timber bamboo (*madake*)
and rattan
41.3 x 39.4 x 62.9 cm (16¼ x 15½ x
24¾ in.)
2012.696

p. 126
Mimura Chikuhō (b. 1973)
Cloud on the Peak
2006
Japanese timber bamboo (*madake*)
16.5 x 43.2 x 41.9 cm (6½ x 17 x 16½ in.)
2012.693

p. 127
Yamaguchi Ryūun (b. 1940)
Fire
2011
Japanese timber bamboo (*madake*)
61 x 61 x 61 cm (24 x 24 x 24 in.)
2012.706

p. 128
Yamaguchi Ryūun (b. 1940)
Open-work basket
2000
Japanese timber bamboo (*madake*)
and rattan
31.1 x 24.1 cm (12¼ x 9½ in.)
2012.708

p. 129
Yamaguchi Ryūun (b. 1940)
Abundant Waters
2007
Japanese timber bamboo (*madake*)
and rattan
61 x 59.1 x 40.6 cm (24 x 23¼ x
16 in.)
2012.707

p. 130
Nagakura Ken'ichi (b. 1952)
Woman
2005
Japanese timber bamboo (*madake*)
59.7 x 24.1 x 21.6 cm (23½ x 9½ x
8½ in.)
2012.700

p. 130
Nagakura Ken'ichi (b. 1952)
Ikat
2007
Japanese timber bamboo (*madake*)
and bamboo root
50.8 x 25.4 x 19.1 cm (20 x 10 x 7½ in.)
2012.699

p. 131
Nagakura Ken'ichi (b. 1952)
Dancing Star
2008
Japanese timber bamboo (*madake*)
and rattan
27.9 x 43.2 x 21.6 cm (11 x 17 x 8½ in.)
2012.701

p. 132
Shōno Tokuzō (b. 1942)
Tail of the Phoenix
2011
Japanese timber bamboo (*madake*)
and rattan
44.5 x 63.5 x 26.7 cm (17½ x 25 x 10½ in.)
Promised gift of the Stanley and Mary Ann
Snider Collection

p. 133
Sugiura Noriyoshi (b. 1964)
Dance in Circle
2011
Japanese timber bamboo (*madake*)
and rattan
47 x 47 x 31.8 cm (18½ x 18½ x 12½ in.)
Promised gift of the Stanley and Mary Ann
Snider Collection

not illustrated
Suzuki Osamu (1926–2001)
Winter Day
1988
Stoneware
31.8 x 30.5 x 13.3 cm (12½ x 12 x 5¼ in.)
2012.674

FIGURE ILLUSTRATIONS

1
Katō Mokuzaemon II (1832–1900)
Large lantern with underglaze and
flower arabesque, around 1878
Porcelain
H. 191 cm (75¼ in.)
Collection of Setogura Museum,
Seto, Japan

2
Tomimoto Kenkichi (1886–1963)
Ornamental jar with decoration of
four-petaled flowers, 1960
Porcelain with overglaze enamels,
gold, and silver
23 x 27 x 27 cm (9 x 10⅝ x 10⅝ in.)
Museum of Modern Ceramic Art, Gifu
Courtesy Kaido Ryukichi
Photograph: Saiki Taku

3
Hayashi Yasuo (b. 1928)
Cloud, 1948
Stoneware
33.7 x 33 x 27.5 cm (13¼ x 13 x
10⅞ in.)
Misho Ryu Nakayama Bunpo kai
Courtesy Hayashi Yasuo

4
Yagi Kazuo (1918–1979)
Mr. Samsa's Walk, 1954
Stoneware
27.5 x 27 x 14 cm (10¹⁄₁₆ x 10⅝ x 5½ in.)
Private collection
Courtesy Yagi Akira

5
Shōno Shōunsai (1904–1974)
Sōzen-style flower basket, 1955–65
27.9 x 19.1 x 29.2 cm (11 x 7½ x 11½ in.)
Japanese timber bamboo (*madake*)
and rattan
Museum of Fine Arts, Boston
Museum purchase with funds by exchange
from the William Sturgis Bigelow Collection
2005.624

6
Kajiwara Aya (b. 1941)
Autumn Memory, 2009
Japanese timber bamboo (*madake*)
and rattan
36.8 x 30.5 cm (14½ x 12 in.)
Museum of Fine Arts, Boston
Gift of Robert T. Coffland in honor of Stanley
and Mary Ann Snider and in memory of Mary
Hunt Kahlenberg 2012.1166

mfa BOSTON

MFA Publications
Museum of Fine Arts, Boston
465 Huntington Avenue
Boston, Massachusetts 02115
www.mfa.org/publications

Published in conjunction with the exhibition *Fired Earth, Woven Bamboo: Contemporary Japanese Ceramics and Bamboo Art*, organized by the Museum of Fine Arts, Boston, from November 12, 2013, to September 8, 2014

© 2013 by Museum of Fine Arts, Boston
ISBN 978-0-87846-805-8 (softcover)
ISBN 978-0-87846-823-2 (hardcover)
Library of Congress Control Number: 2013944117

The Museum of Fine Arts, Boston, is a nonprofit institution devoted to the promotion and appreciation of the creative arts. The Museum endeavors to respect the copyrights of all authors and creators in a manner consistent with its nonprofit educational mission. If you feel any material has been included in this publication improperly, please contact the Department of Rights and Licensing at 617 267 9300, or by mail at the above address.

While the objects in this publication necessarily represent only a small portion of the MFA's holdings, the Museum is proud to be a leader within the American museum community in sharing the objects in its collection via its website. Currently, information about more than 330,000 objects is available to the public worldwide. To learn more about the MFA's collections, including provenance, publication, and exhibition history, kindly visit *www.mfa.org/collections*.

For a complete listing of MFA publications, please contact the publisher at the above address, or call 617 369 3438.

Front cover: Sakurai Yasuko, *Vertical Flower*, 2007 (p. 84)
Back cover: Morigami Jin, *Red Flame*, 2007 (p. 123)

All illustrations in this book were photographed by the Imaging Studios, Museum of Fine Arts, Boston, except where otherwise noted.

Japanese personal names appear in the text in traditional order, with family names preceding given names.

Grateful acknowledgment is made to the following artists and copyright holders who have granted permission to reproduce works illustrated in this publication: Fujino Sachiko, Fujinuma Noboru, Fujitsuka Shōsei, Fukami Sueharu, Harada Shūroku, Hatakeyama Seidō, Hayashi Yasuo, Hirano Yūichi, Honda Shōryū, Honma Hideaki, Hoshino Kayoko, Ishiguro Munemaro, Kaido Ryukichi, Kakurezaki Ryūichi, Katō Yasukage, Kawai Kanjirō, Kishi Eiko, Kitamura Junko, Kiyomizu Rokubey VII, Koike Shōko, Koinuma Michio, Kondō Takahiro, Koyama Yasuhisa, Mihara Ken, Estate of Miyashita Zenji, Mizukami Katsuo, Mizuno Keisuke, Monden Kōgyoku, Morigami Jin, Morino Hiroaki Taimei, Nagae Shigekazu, Nagakura Ken'ichi, Nishihata Tadashī, Ōtani Shirō, Sakiyama Takayuki, Sakurai Yasuko, Shōno Tokuzō, Sugita Jōzan, Sugiura Noriyoshi, Suzuki Gorō, Takegoshi Jun, Takeuchi Kōzō, Tanabe Chikuunsai II, Tokumaru Kyōko, Torii Ippō, Wada Morihiro, Watanabe Chiaki, Yako Hōdō, Yamada Hikaru, and Yamaguchi Ryūun

Edited by Jennifer Snodgrass
Copyedited by Dawn Carelli
Proofread by Judy Loeven

Designed by Cynthia Rockwell Randall
Production by Terry McAweeney
Typeset in Officina Sans and Dinot
Printed on Gardamatt 150 gsm
Printed and bound at Graphicom, Verona, Italy

Available through ARTBOOK | D.A.P.
155 Sixth Avenue, 2nd floor
New York, New York 10013
Tel.: 212 627 1999 · Fax: 212 627 9484
www.artbook.com

FIRST EDITION
Printed and bound in Italy
This book was printed on acid-free paper.